Blue Dog Speaks

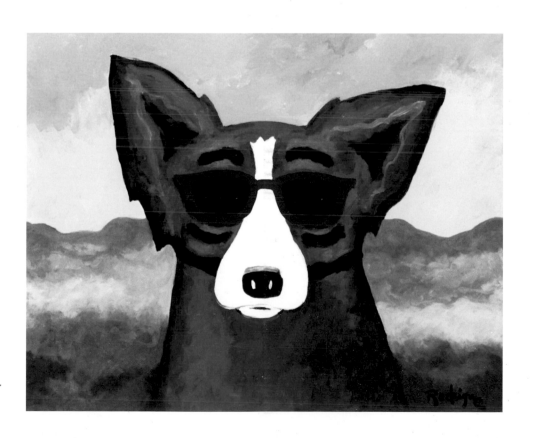

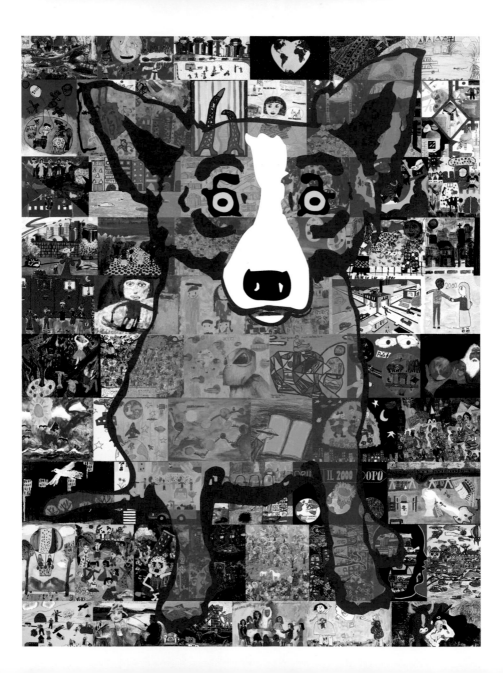

Blue Dog Speaks

George Rodrigue

STERLING
New York

STERLING
New York

An Imprint of Sterling Publishing
387 Park Avenue South
New York, NY 10016

Blue Dog works on half title: Shades of Hollywood
opposite title page: Honesty

STERLING and the distinctive Sterling logo are registered trademarks of Sterling Publishing Co., Inc.

ISBN 978-1-4549-1342-9

Distributed in Canada by Sterling Publishing
℅ Canadian Manda Group, 165 Dufferin Street
Toronto, Ontario, Canada M6K 3H6
Distributed in the United Kingdom by GMC Distribution Services
Castle Place, 166 High Street, Lewes, East Sussex, England BN7 1XU
Distributed in Australia by Capricorn Link (Australia) Pty. Ltd.
P.O. Box 704, Windsor, NSW 2756, Australia

For information about custom editions, special sales, and premium and corporate purchases, please
contact Sterling Special Sales at 800-805-5489 or specialsales@sterlingpublishing.com.

Manufactured in China

2 4 6 8 10 9 7 5 3 1

www.sterlingpublishing.com

To Brother Edward Scanlan,
who threw me out of class for drawing

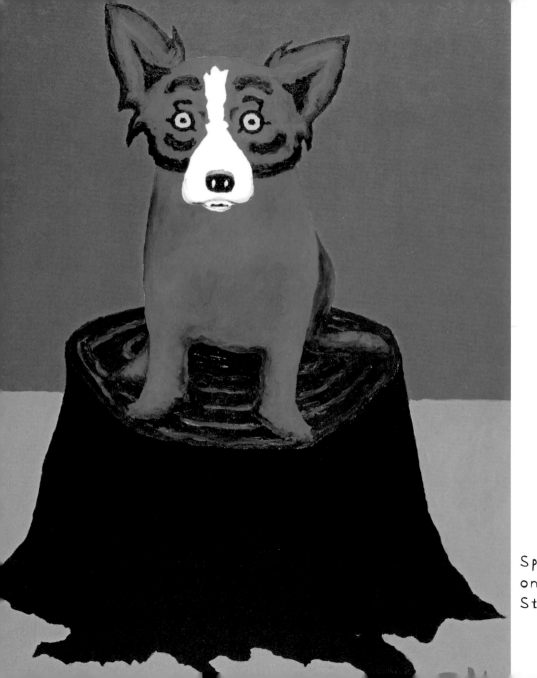

Speaking
on the
Stump

CONTENTS

INTRODUCTION

f I were to make a FAQ list, at the top would have to be, "How do you come up with the titles?" and "Do you know what you're going to paint before you start?"

Truth is I usually have *no idea* what the title or subject matter is going to be when I pick up the paintbrush. t's all about keeping things fresh. If I don't know exactly where I'm going with a painting, I have more fun; the creative process is more exciting.

These days, one thing I do know is that it will be a Blue Dog. When I began the series of Blue Dog paintings in 984, I had no idea that they would consume the greater part of my life for over two decades. The original concept of a Blue Dog was not what it is today. The idea came from a Cajun childhood story that was brought over from France by the Acadians. It simply stated that if you were not good today, the *loup-garou* would get you tonight. remember my mother relating this story many times to me as I was growing up. The legend said nothing about a dog or the color blue. But it did link this spooky werewolf creature to cemeteries and sugar cane fields and dark night skies. I thought that same sky would cast a blue-grey shade on the creature; and the red eyes of those early paintings removed any link to Tiffany, my studio dog-turned-model.

My early Blue Dog paintings were a reflection of this childhood idea and meant little beyond their connection to a ghost story. The titles, such as *Cosmos Dog*, *Missing My Master*, or *I Went to the Graveyard to Hide from the Blues*, reflected the dog's position on tombstones and under dark trees at midnight. The whole concept changed for me during an exhibition of my work in Los Angeles in the late 1980s when I overheard people call this wolfish-type *loup-garou* "Blue Dog."

Returning to my Louisiana studio, I painted Blue Dog images that reflected ideas in the present. I changed the eyes to yellow and dared to take the bayou legend out of the bayou! The titles were an important part of this transition.

Before the Blue Dog, the titles of my Cajun landscapes merely reflected a place, such as *Broussard's Barber Shop* or *Sugar Bridge Over Coulee*. They did not express a concept about contemporary life or add any extra insight to the work. But in these new paintings, I used the titles as a tool to convey further meaning. This Blue Dog could now travel in time and space away from Louisiana, away from the landscapes of the bayou, and into places where it had never gone before. I enhanced these visual ideas with titles such as *Right Place*, *Wrong Time* and *Tiffany Remembers the '70s*, and later more abstract concepts such as *All by Myself with My Happiness* and *You Would Think We Are the Same*. After twenty-five years of painting the Cajuns of the past, these new Blue Dog paintings became a vehicle for me to say things about *today*.

I feel like I'm on a journey to find an answer to each painting. Usually about halfway to completion which could take anywhere from four hours to two weeks) a title and a concept evolve. From then on. I make

the painting to reinforce that title. Yet even though the title is important to the idea of the painting, an enigma—a sense of mystery—remains, and the painting invites the viewer to fill in the blanks according to his or her own needs and experiences.

A simple Blue Dog is the obvious visual subject of every painting. However, the title combines with the paint on the canvas to convey a deeper meaning: one that in the end rarely alludes to that animal we know as "dog," but instead provides insight—whether humorous or nostalgic or sad—into the human condition. I have always said, ever since my earliest Cajun landscapes and genre works, that my work is meant to make people stop and pause, to speculate and ponder. My hope is that this process allows the viewer to become an integral part of the work's meaning. In this book you will see a broad range of subjects and titles and ideas, and I hope it helps you understand the infinite concepts possible.

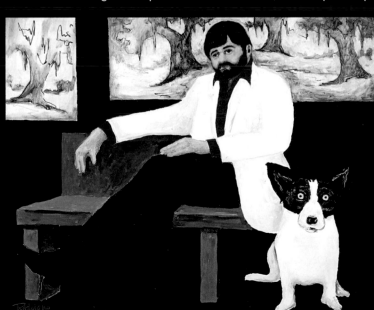

Blue Dog Speaks is the first book to emphasize my titles alongside the works. In previous books, the titles were relegated to small italicized lines or indexes—or worse, not included at all. The mere fact that this book gives the titles the same prominence and space as the paintings, gives the reader a new understanding of the titles' importance.

—George Rodrigue

1

BoRN on the BaYou

Dreaming of Evangeline

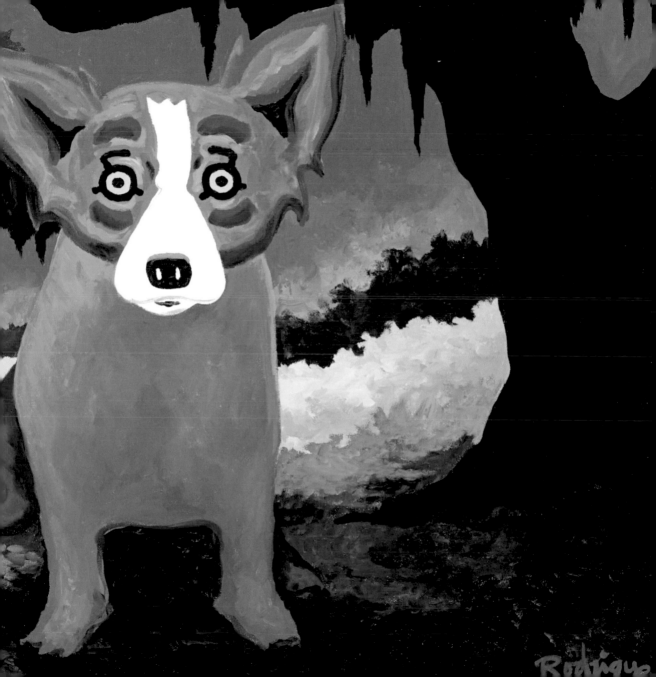

I Live BY MY ROOTS

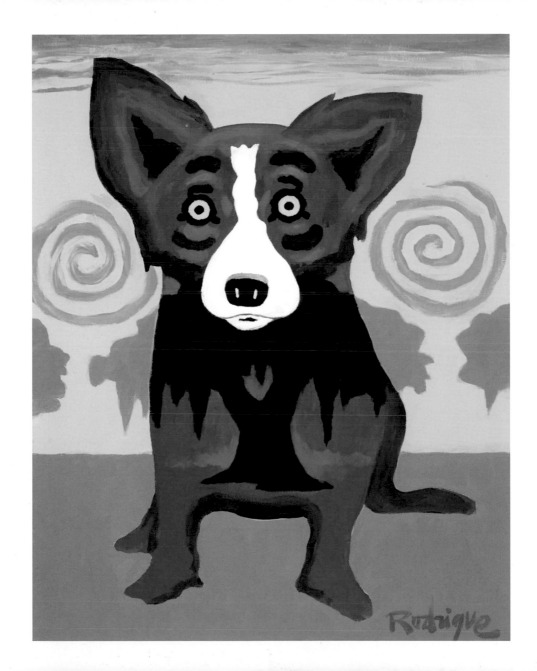

13

MY
AcaDian
HeritaGe

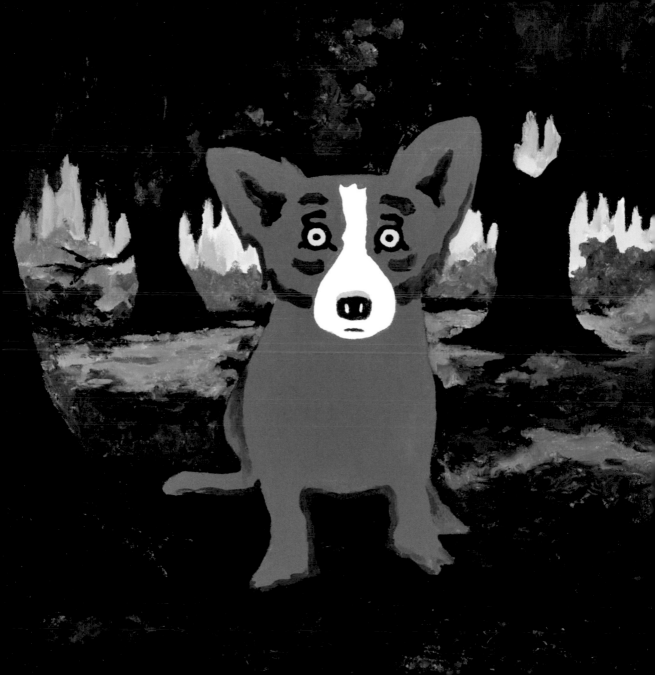

The

Tree

My

MaMa

Slept

Under

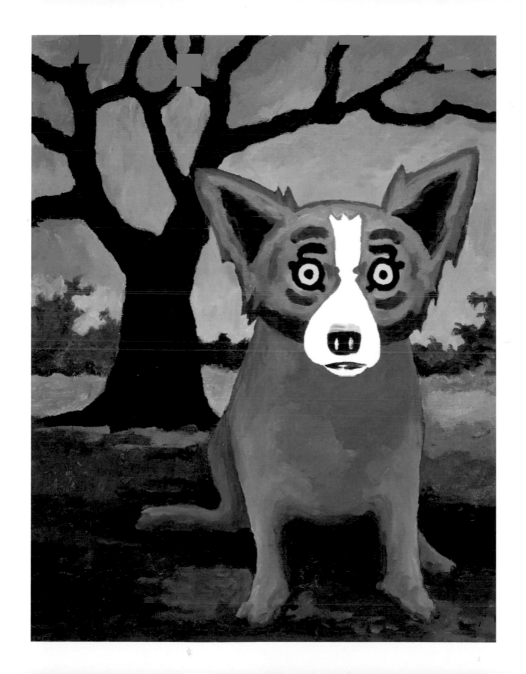

17

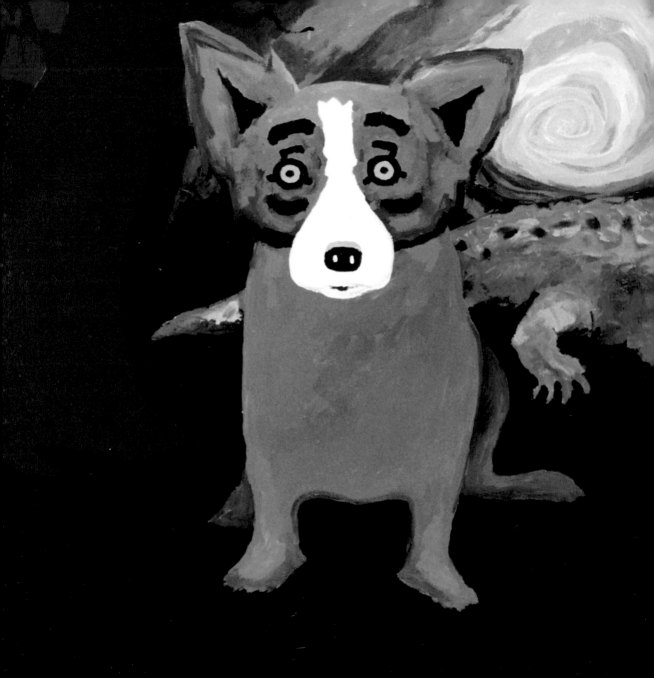

A
Voo
doo
Night

Tee

Paul's

HouSe

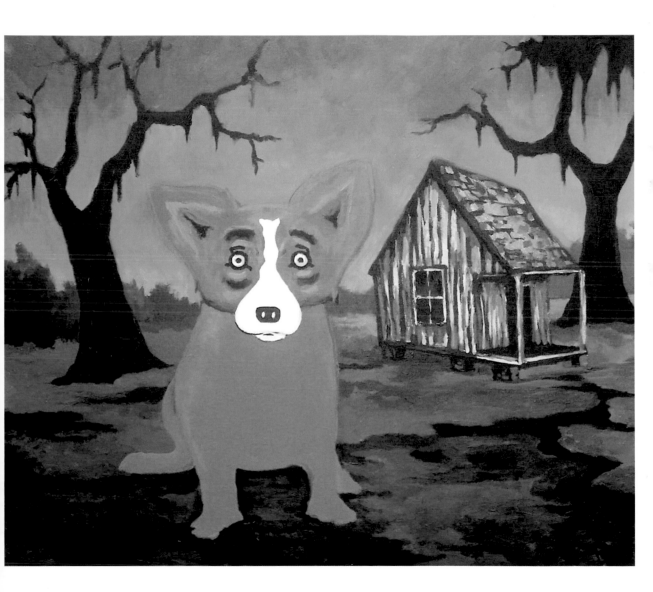

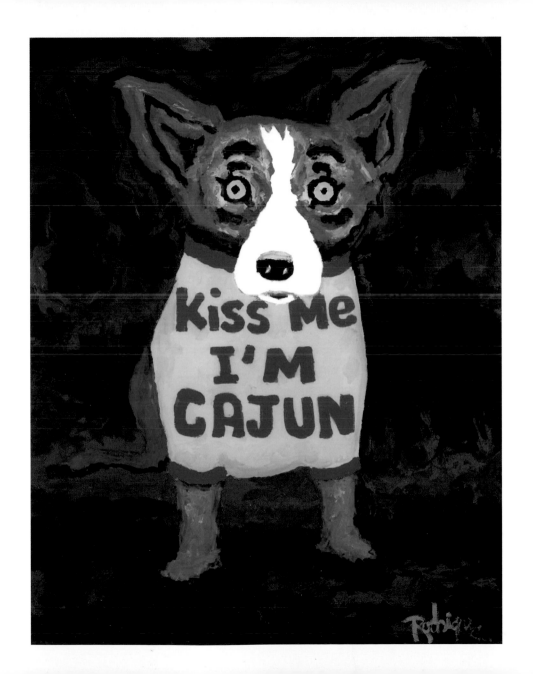

23

Come BAck and Lighten UP on My BluEs

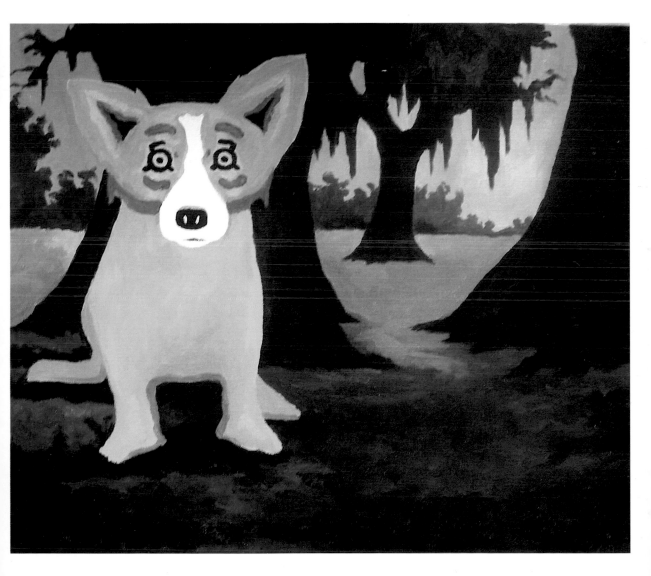

Paint
Me Back
Into
YouR
Life

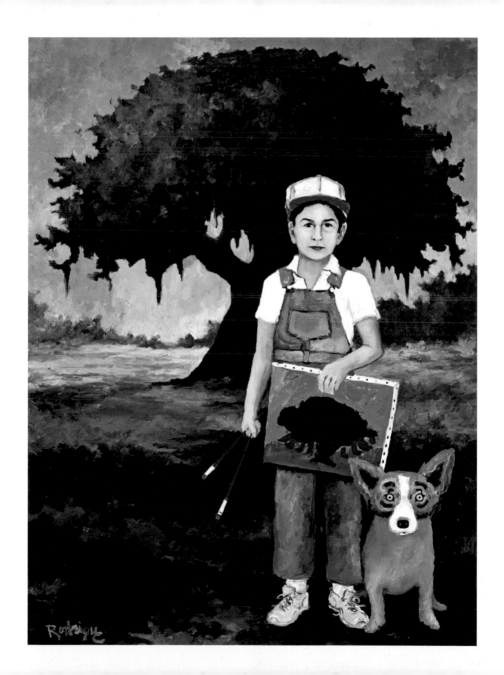

A

DoWn

Deep

Blue Midnight

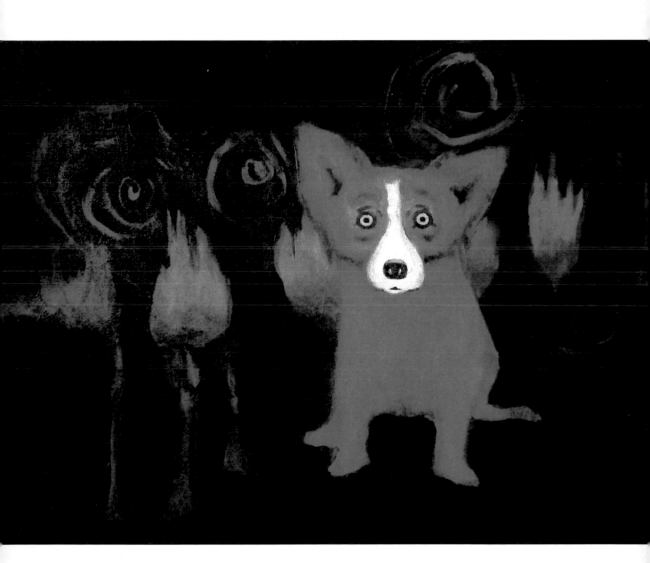

It's Greek to Me

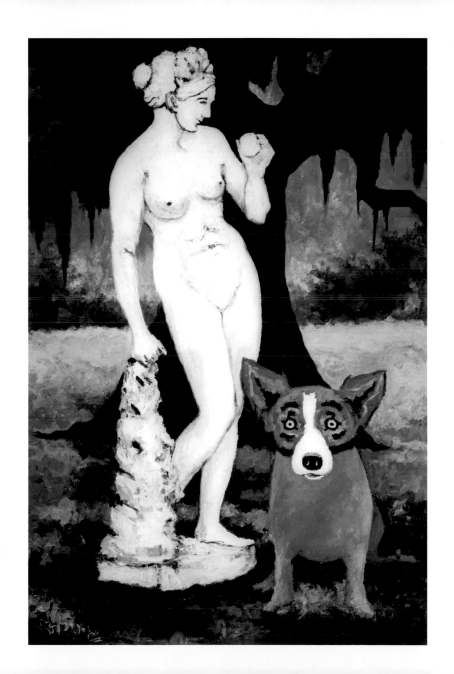

Again

I'm

Alone

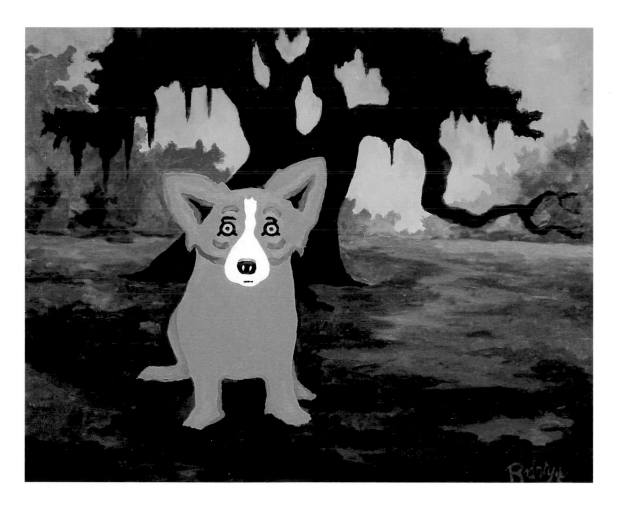

33

Take Five

Take Five

Take Five

Take Five

Take Five

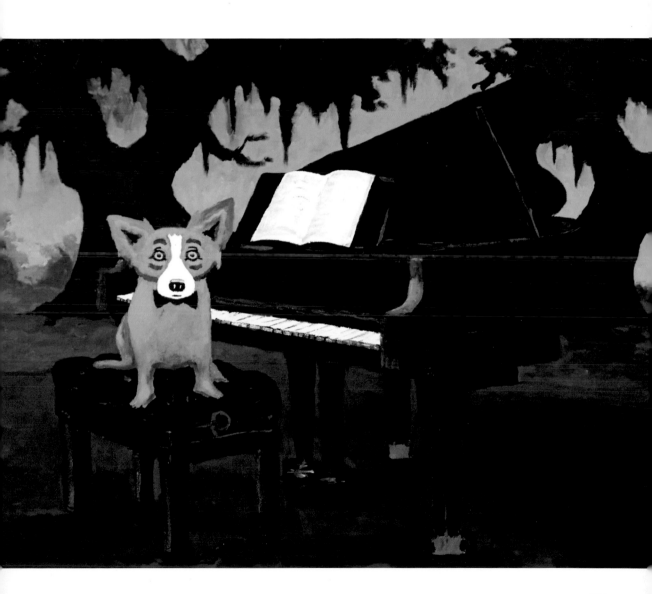

When She
Left Me
My

Blues

Got

Deeper

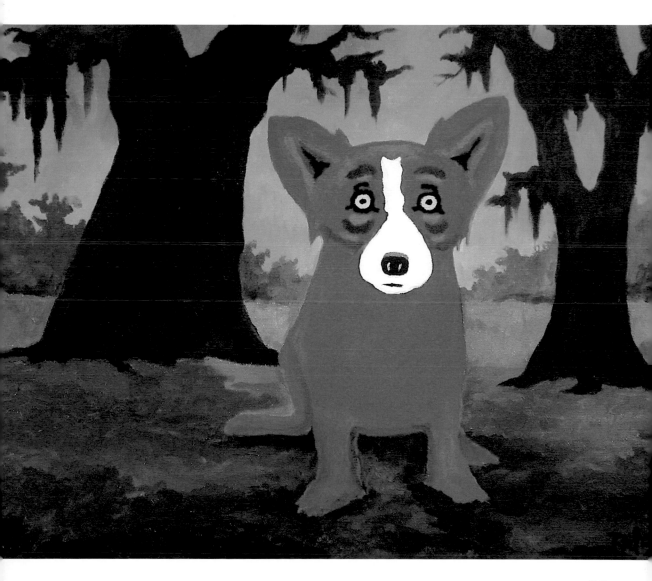

Valentino's
Revenge

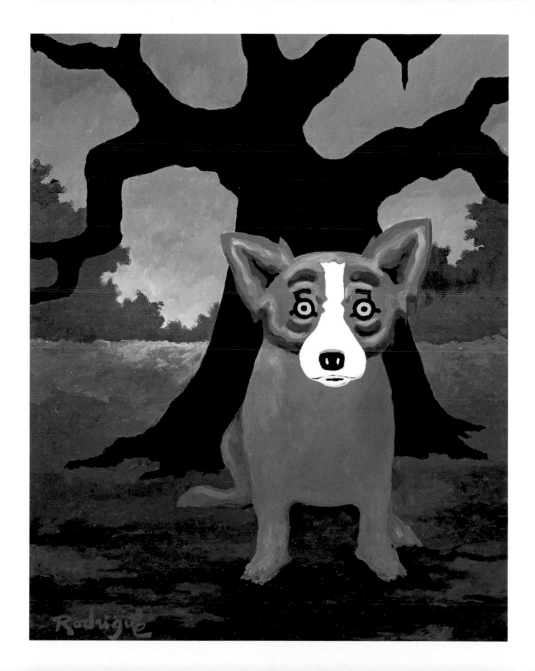

A **Pack** of Oak Groves

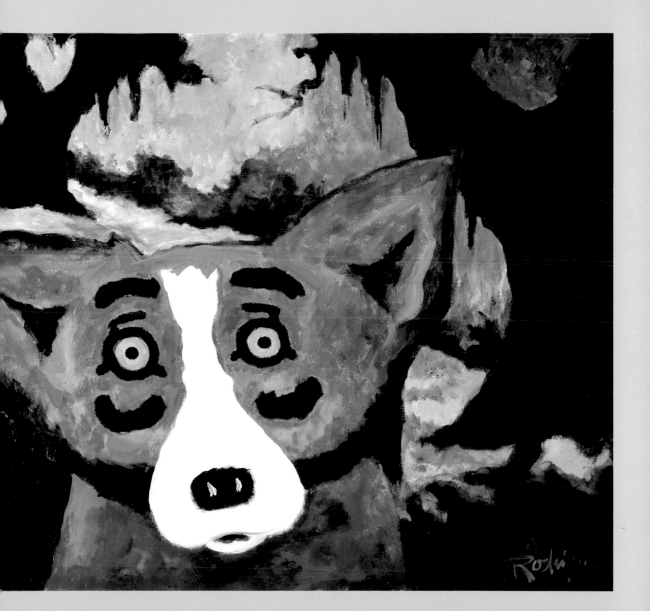

A Pack of Trees

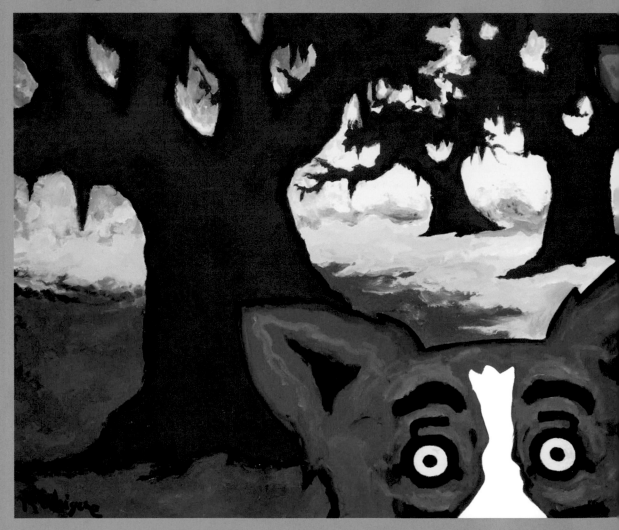

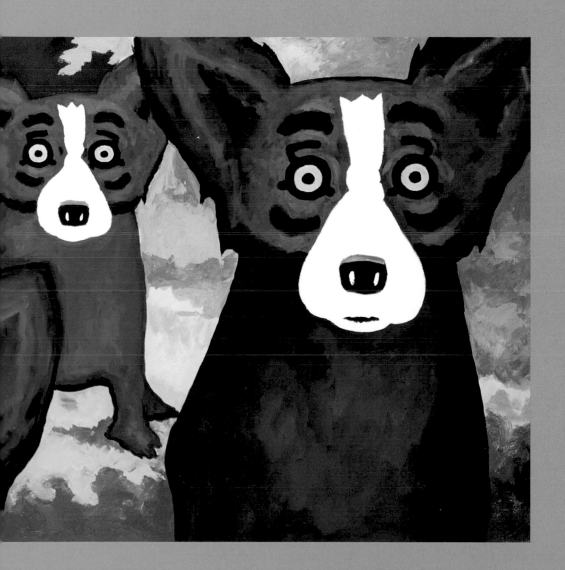

43

The Limb I Swung On

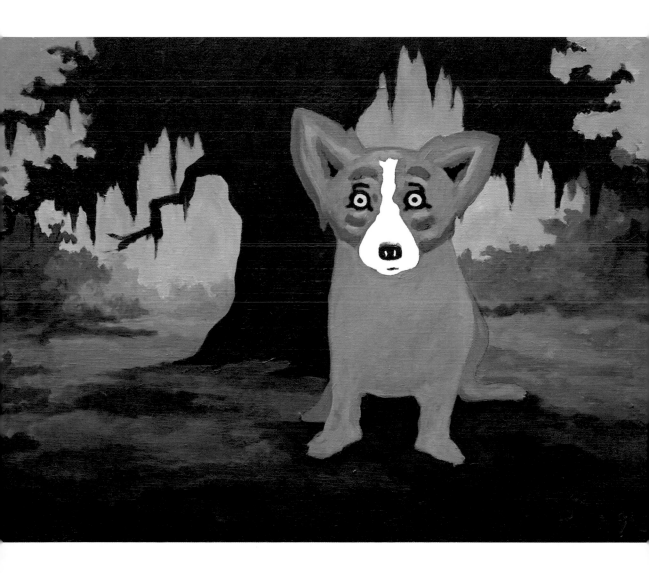

45

Rollin' on the River

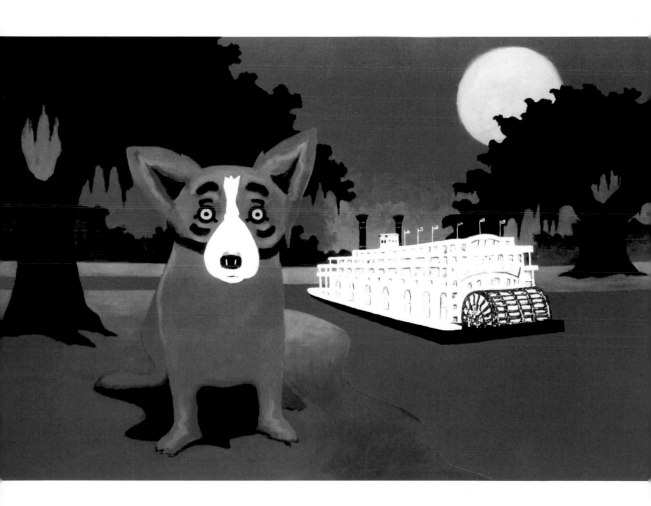

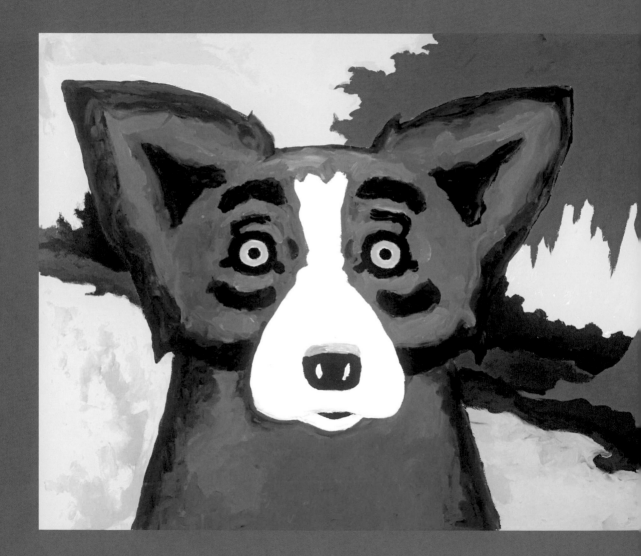

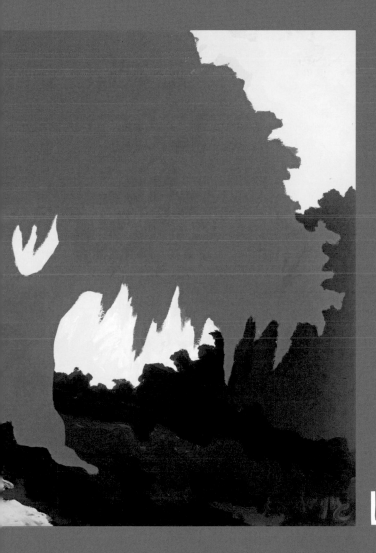

A SLICE
of
Louisiana

Little Joe

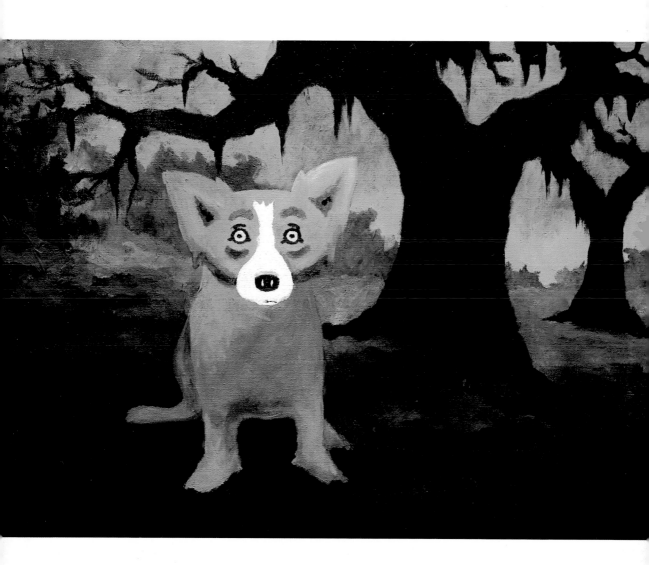

I Remember This

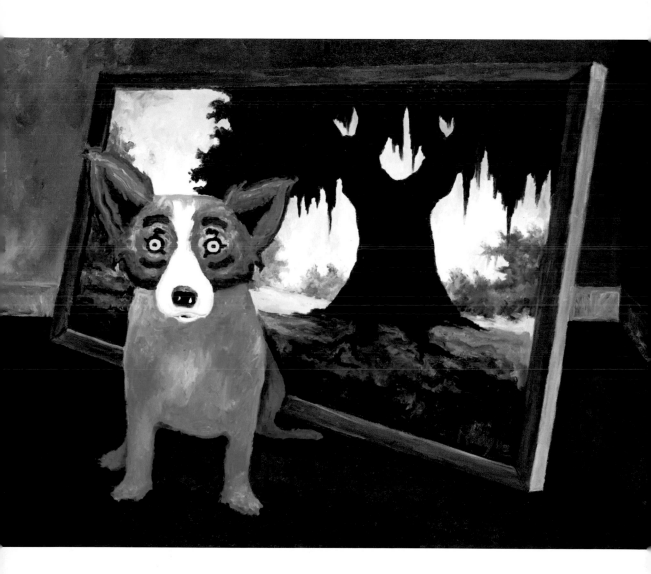

Take

the

Picture

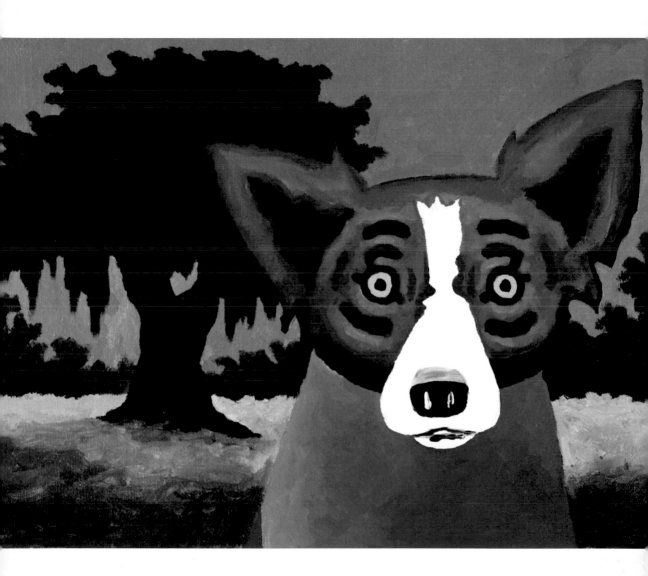

2

The
Other
SiDe

Resting Between the Trees

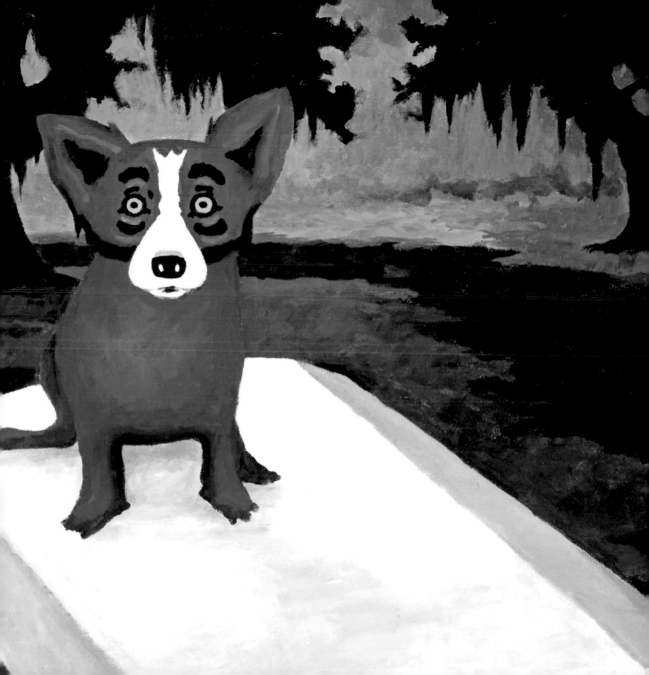

The

Re-Birth

of

TiffaNy

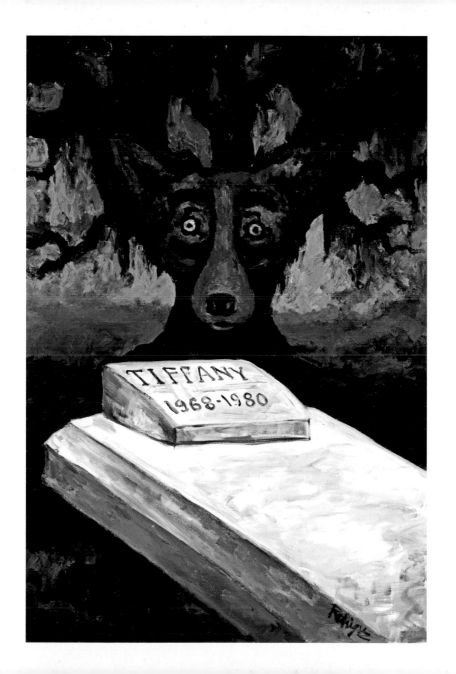

A Novena for Me

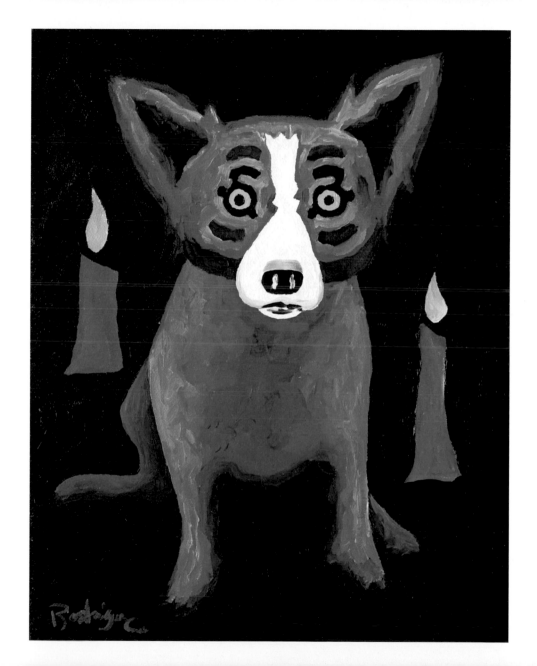

Missing

My

Master

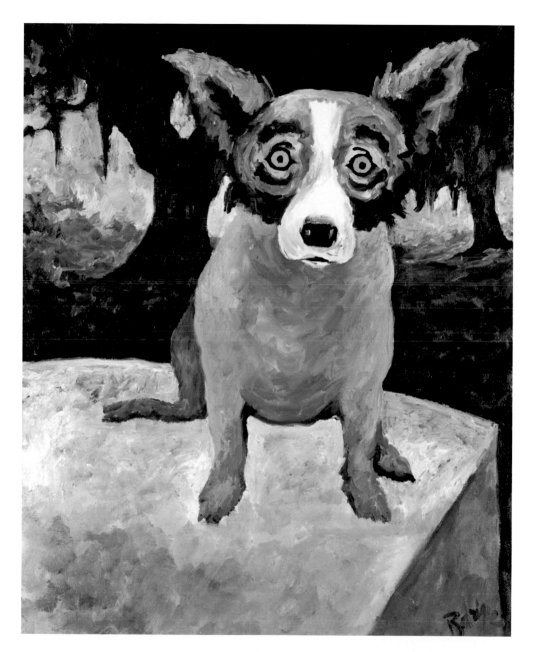

63

Voodoo Will Get Me Back to You

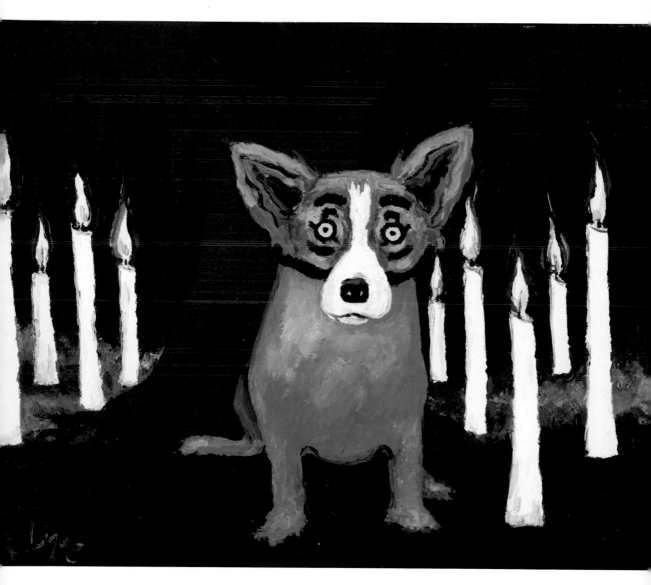

Don't GroW Grass on Me

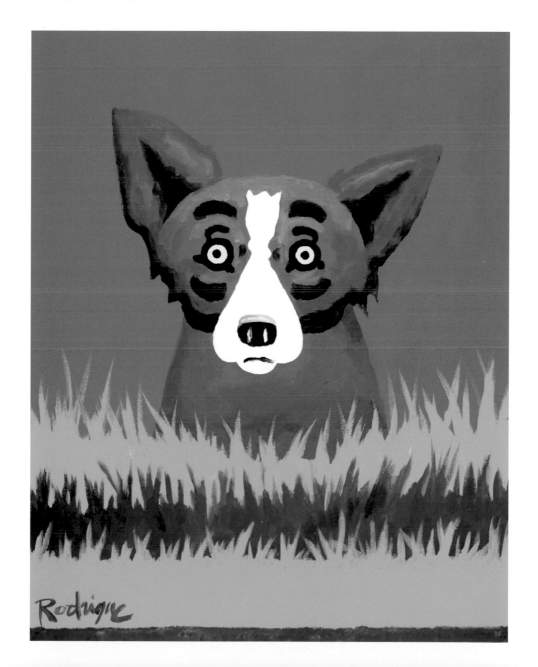

Don't
Step
on
my
StoNes

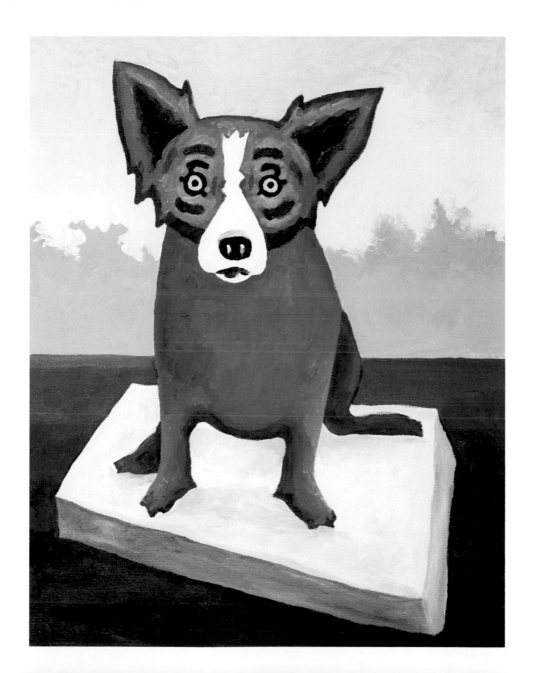

Dog iN a Box

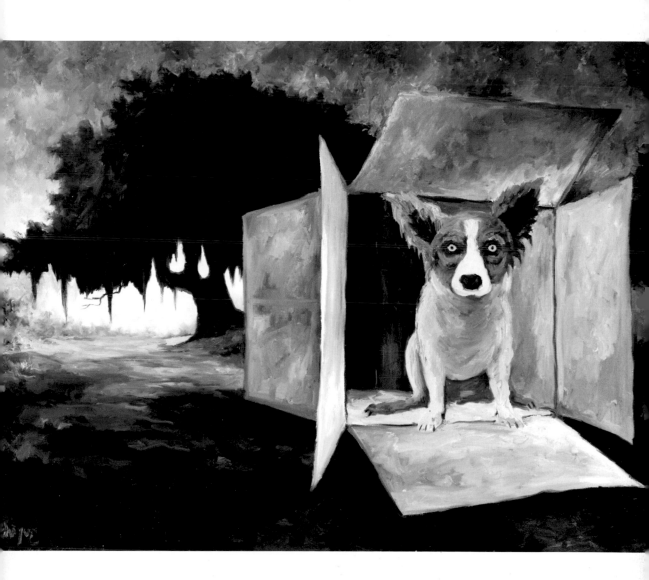

The Path of the Candles

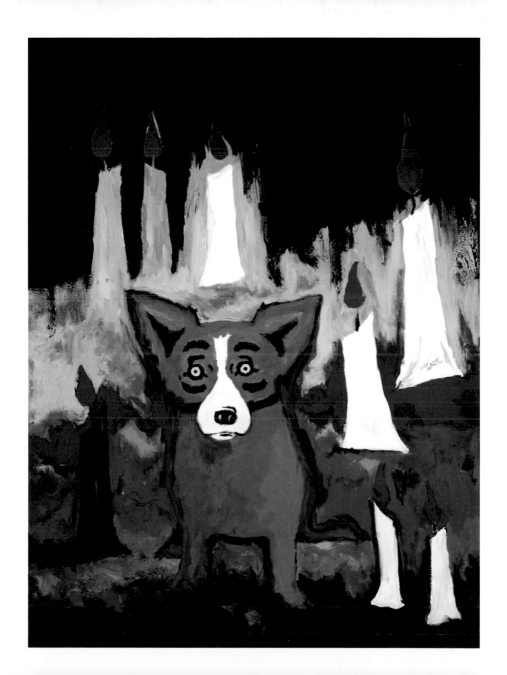

Watch Dog

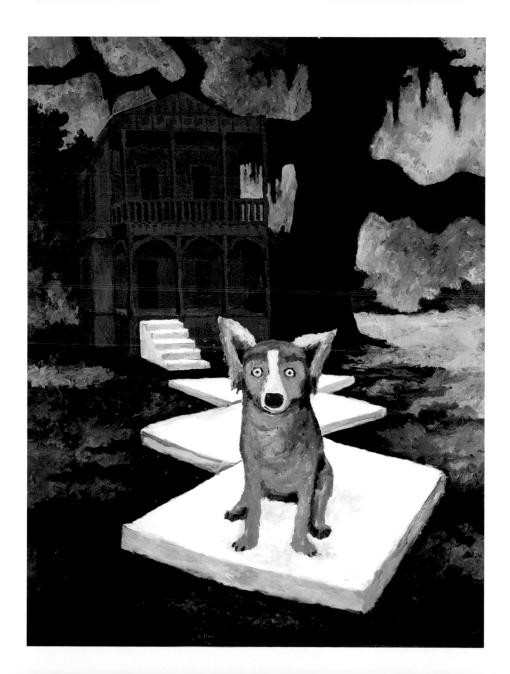

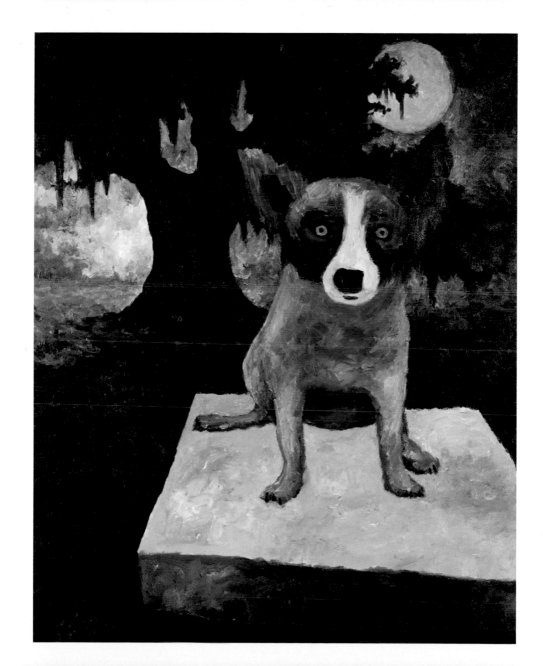

3

Pure
and
Simple

It's Your Turn to Make a Move

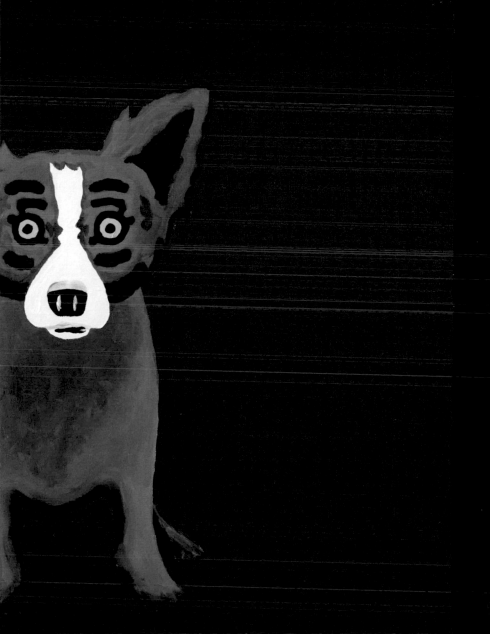

A Palette of ThouGht

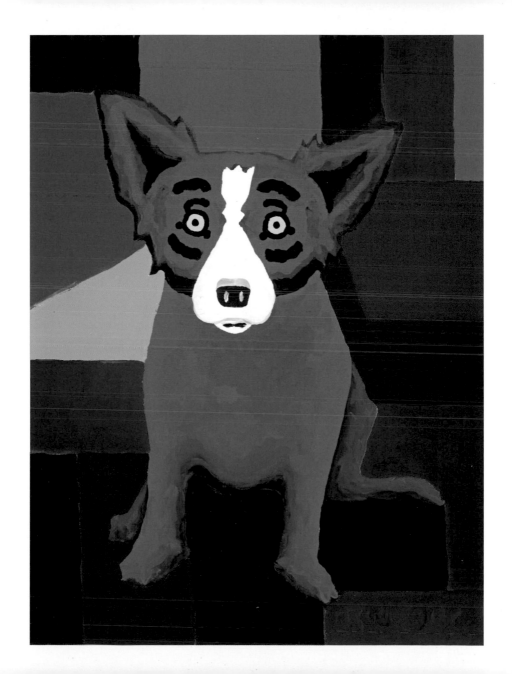

Blue

Little Blue

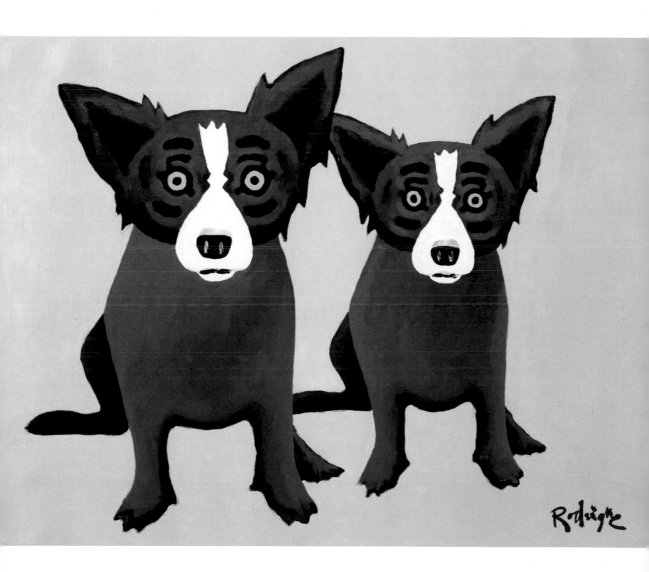

Las Vegas ELECTRIC LiGht Show

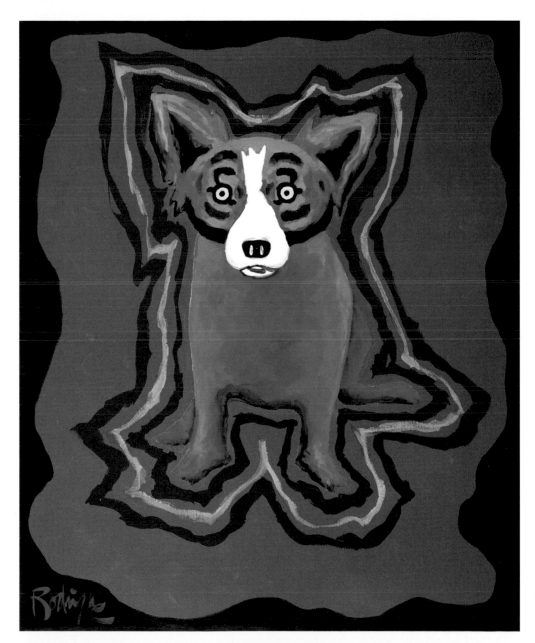

85

Born

with

a

GreEn

Thumb

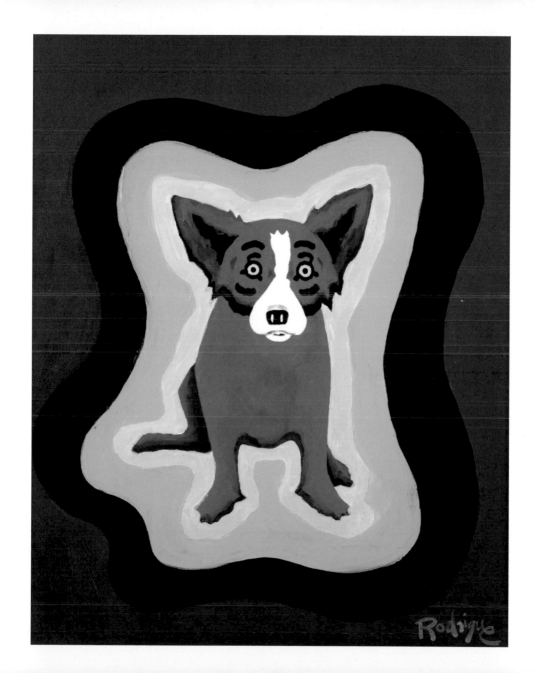

Calling Capt. Kirk from the RED Planet

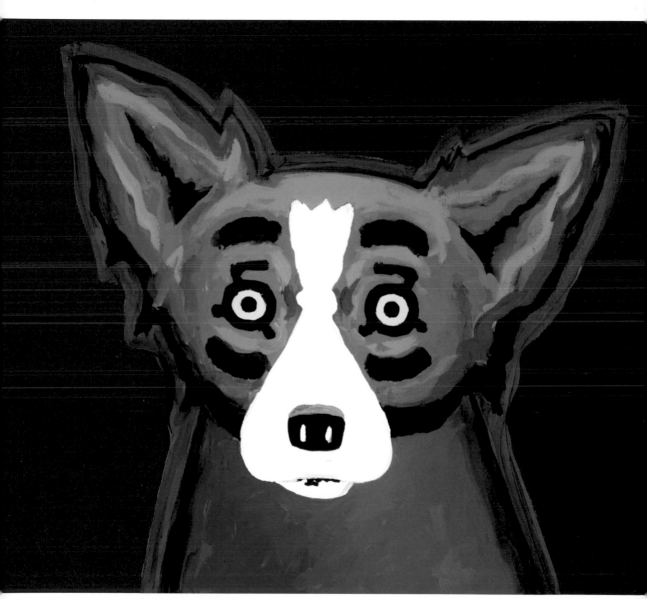

Blue

Pharoah

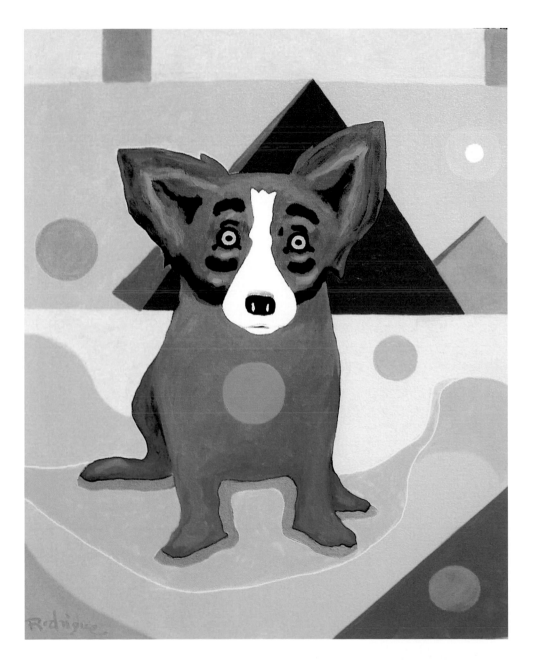

Looking Back at the '70s

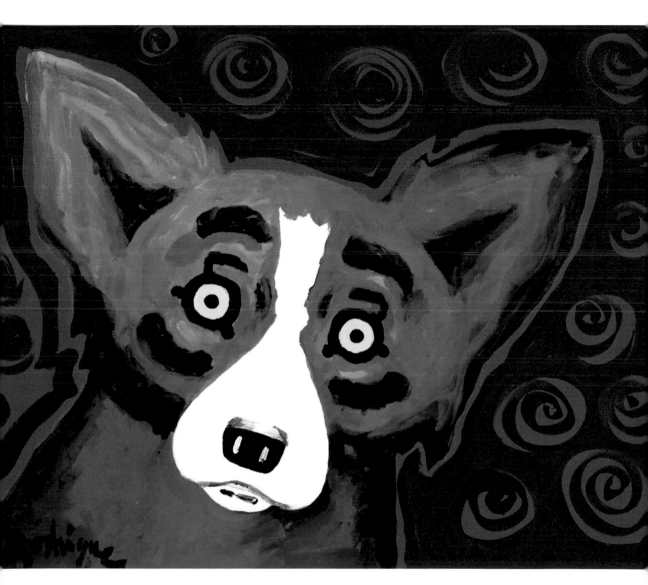

He

Answers

Twice

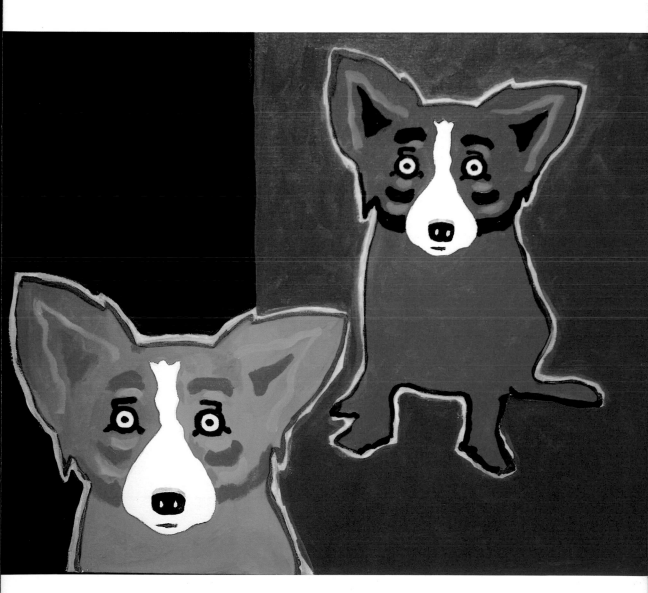

A Face iN tHe Crowd

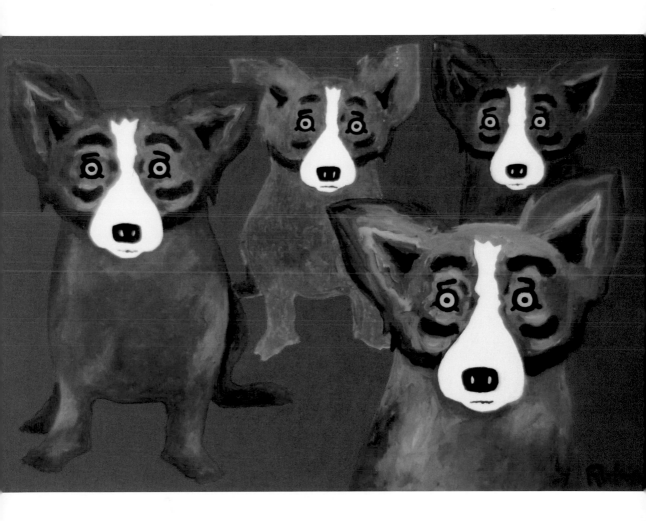

Mickey Mouse
Has
Nothing
on
Me

(Congo Dog)

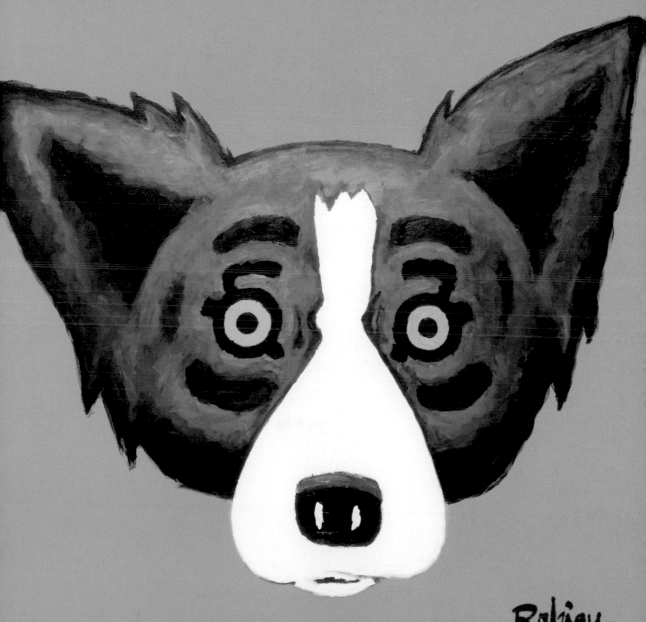

High Places

Places

for Me

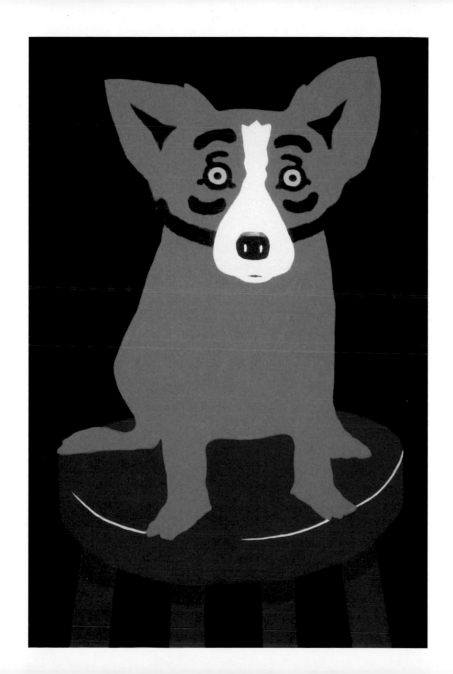

101

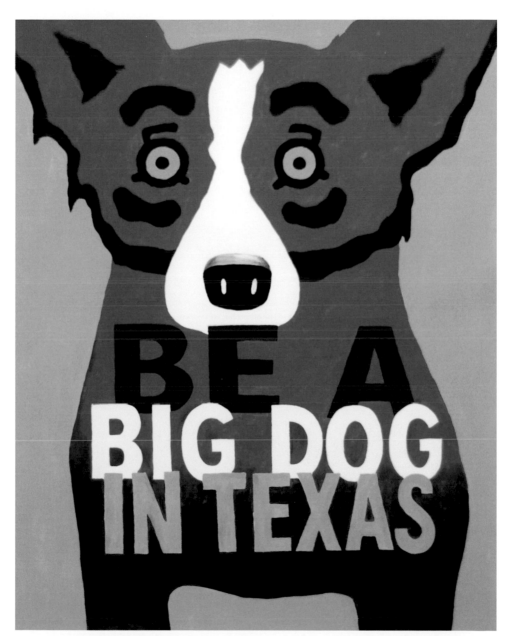

I'M SO Cool

I'M Hot

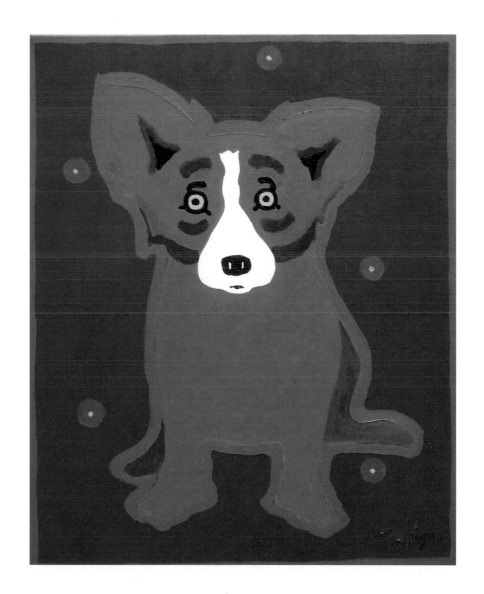

I've

BeCome

a

Different

PerSon

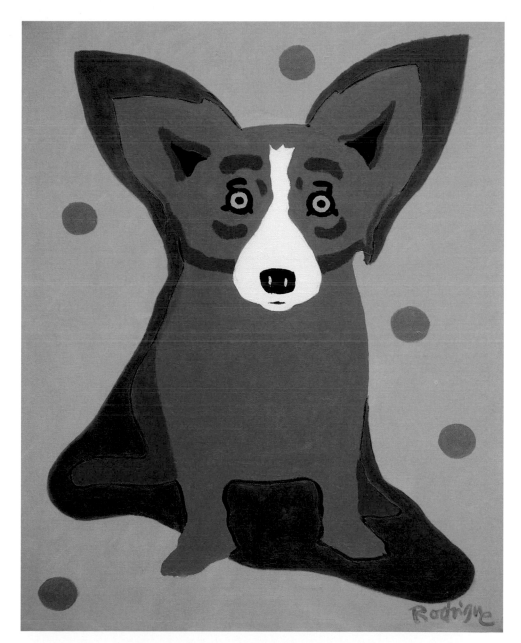

Dif
fer
ent Opinions

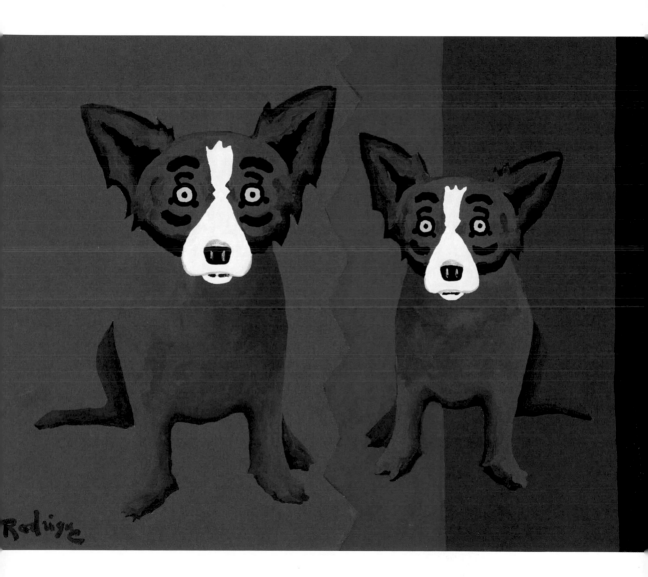

Ancestor

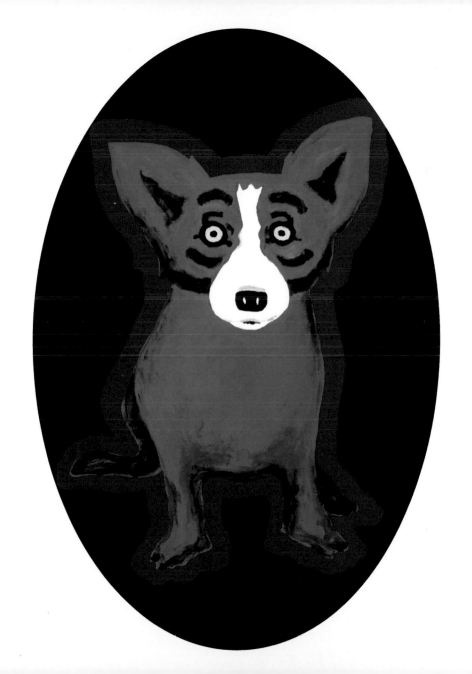

Jacques in a Box

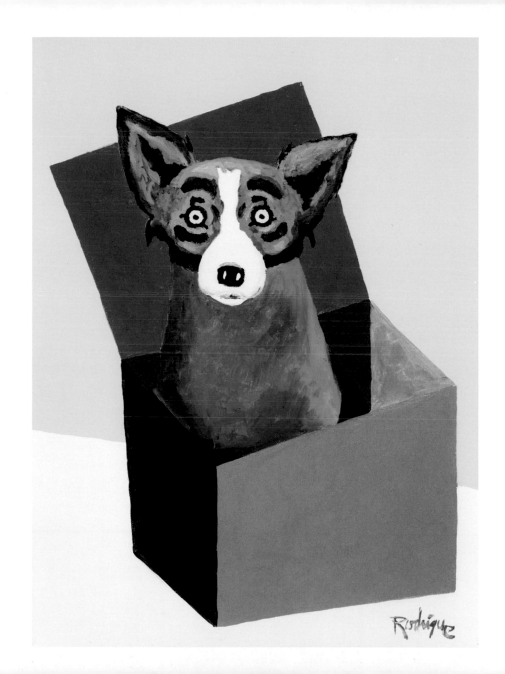

My
Line

of
Credit

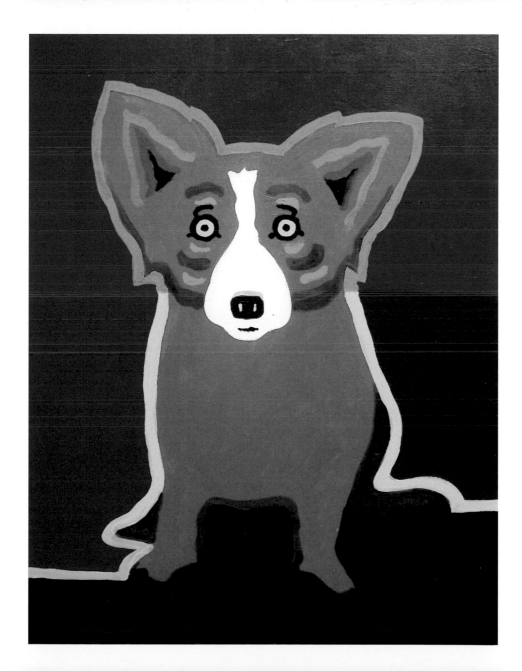

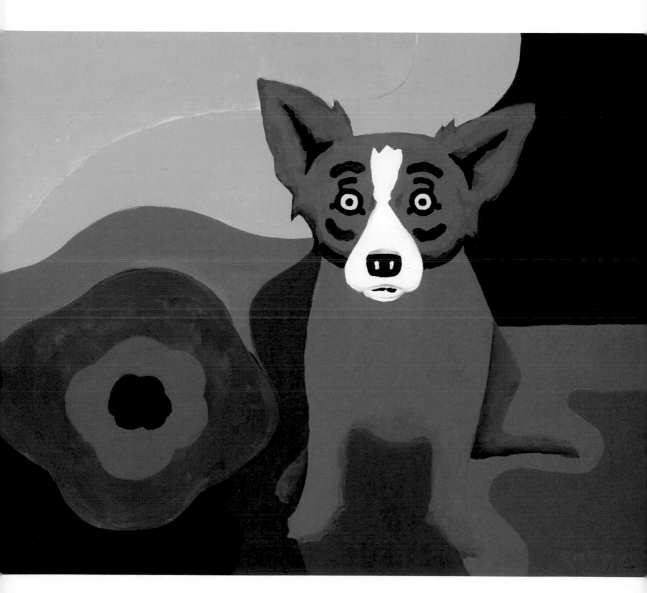

On the Banks of the Mississippi

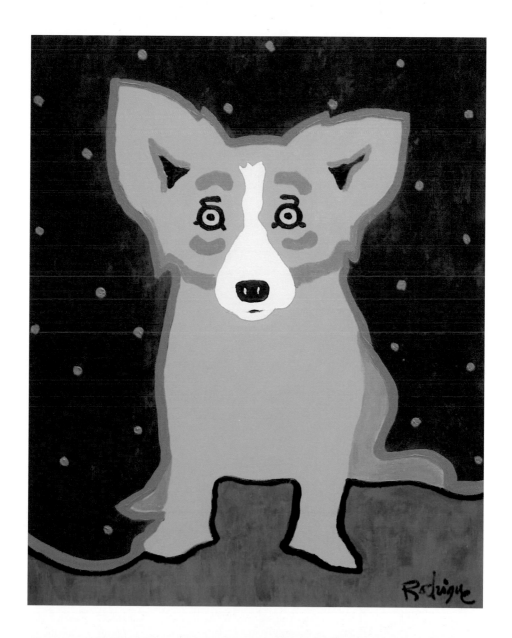

I See you Forever

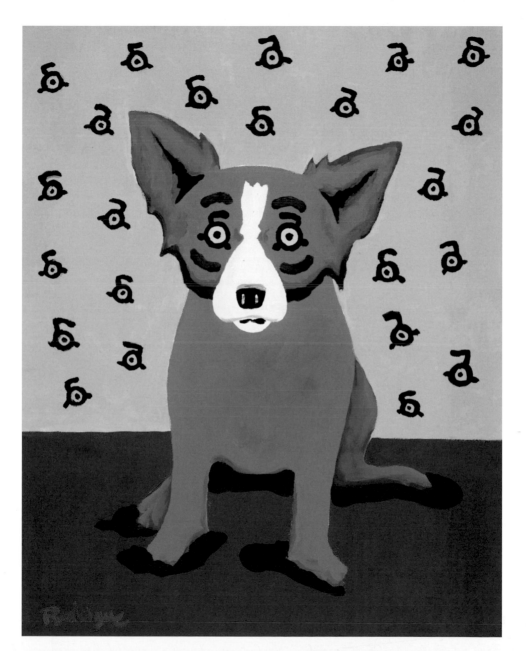

She's Startin' tO Stick oN me

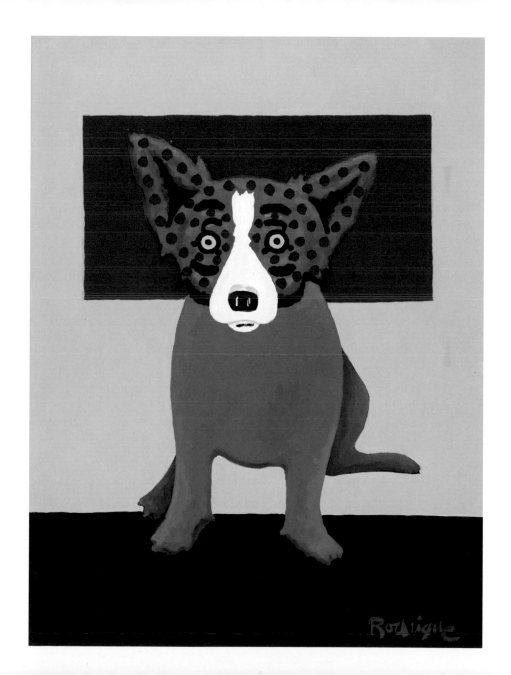

Rodrigue

123

FrOg

She

Called

ME a

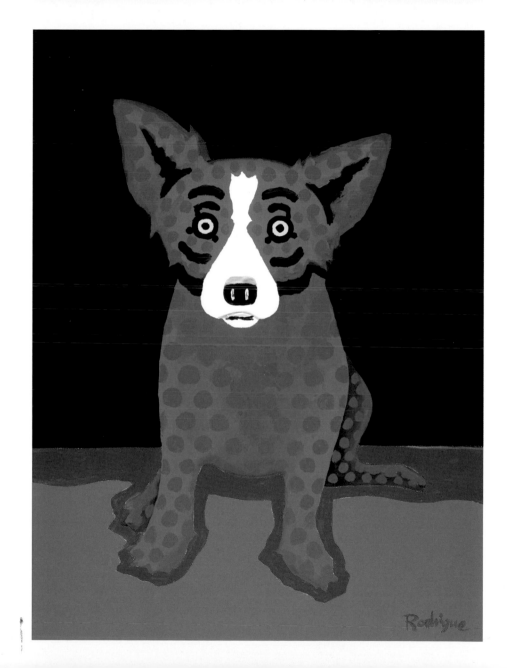

The BLUES

Make Me feel

Like an empty Box

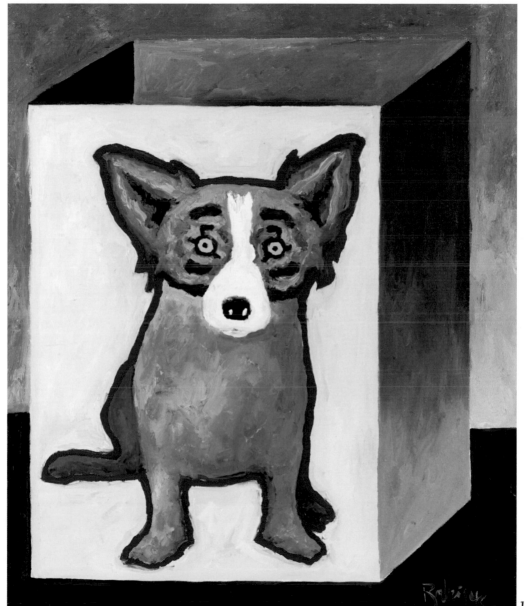

Box for a
Cool Cat

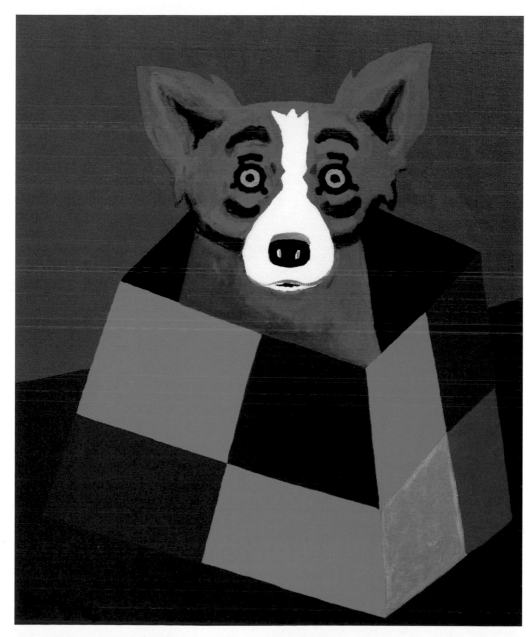

Reaching Out to New Friends

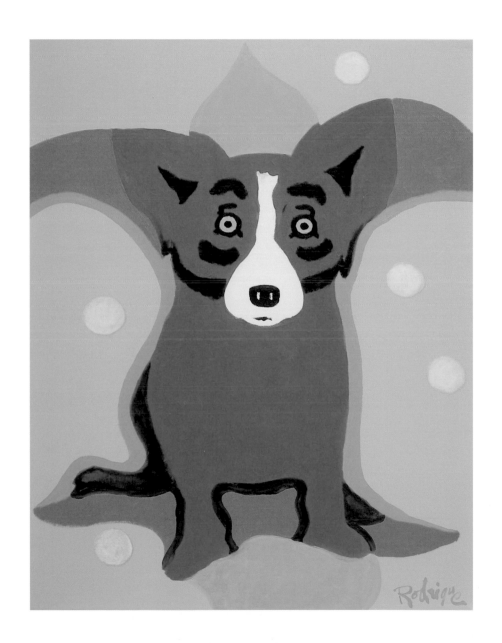

Me

Behind

Far

Not

Are

Memories

My

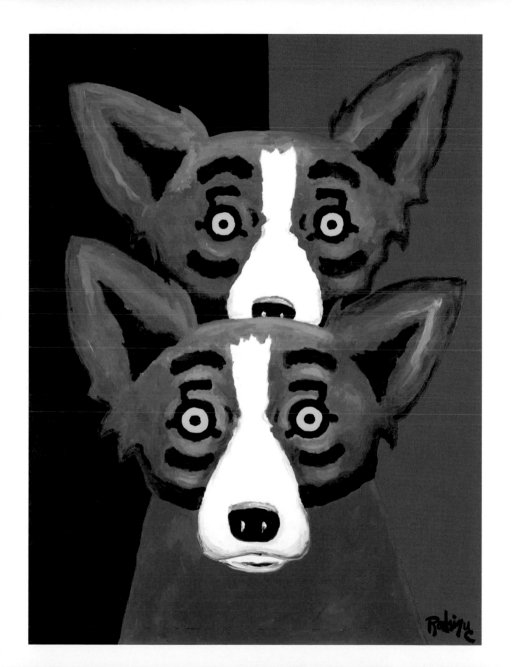

133

THE

DOG

WITHIN

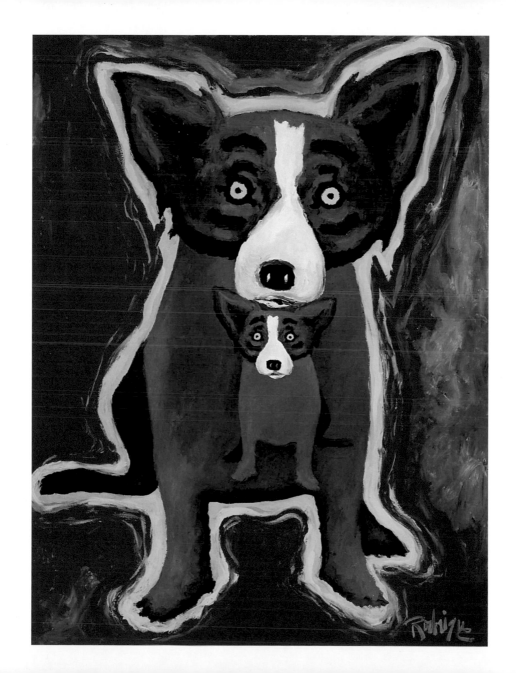

135

IN YOUR FACE

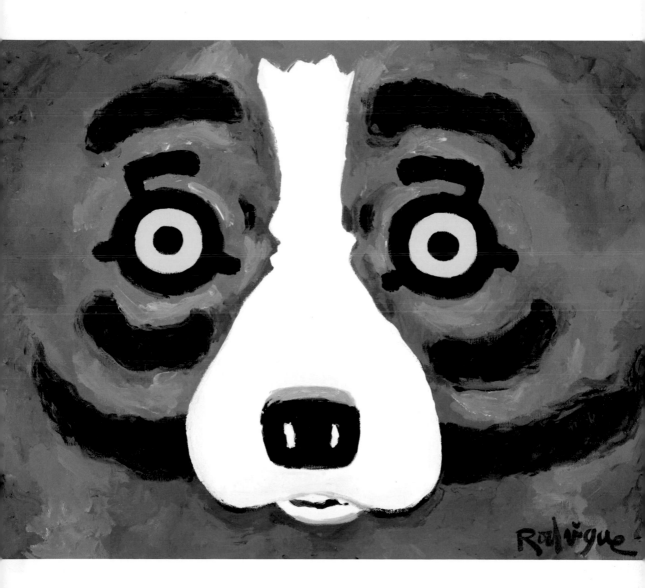

Everywhere
Everywhere
Everywhere
Everywhere
Everywhere
Everywhere
Everywhere
Everywhere
Everywhere
Everywhere
Everywhere
Everywhere
Everywhere
Everywhere
Everywhere

Everywhere

Everywhere
Everywhere

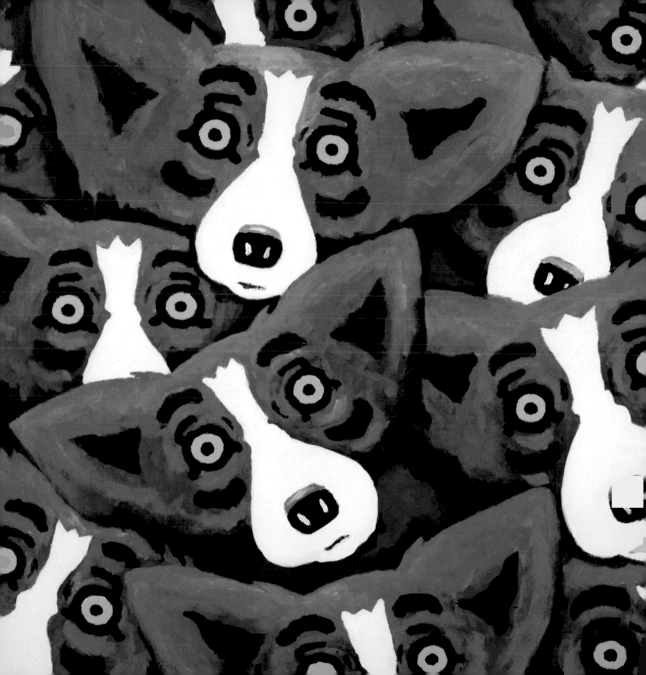

4

Spiraling Out

We Are Spirits Together

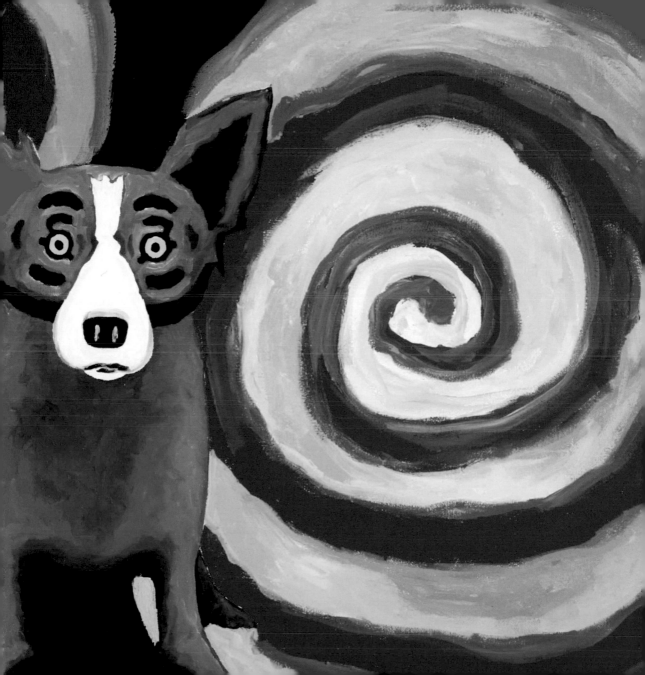

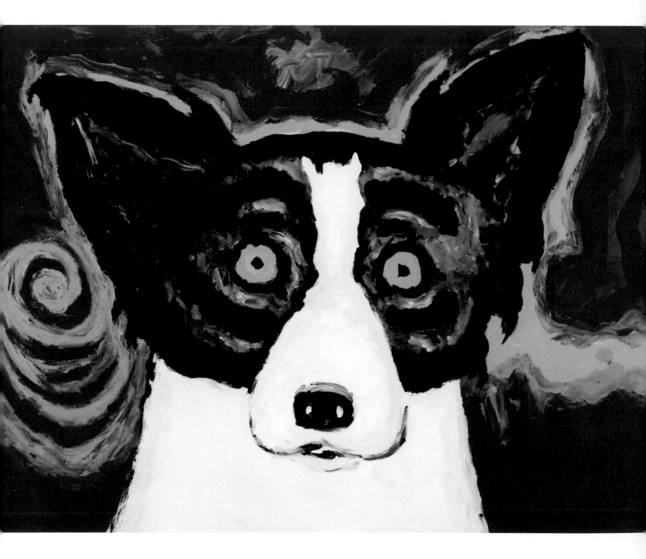

Mr. Watson, Come Here .

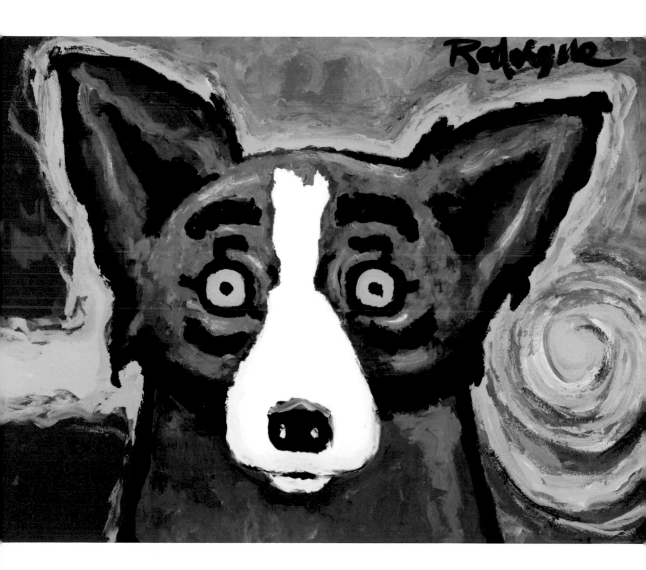

I NEED YOU

Hurricane Romance

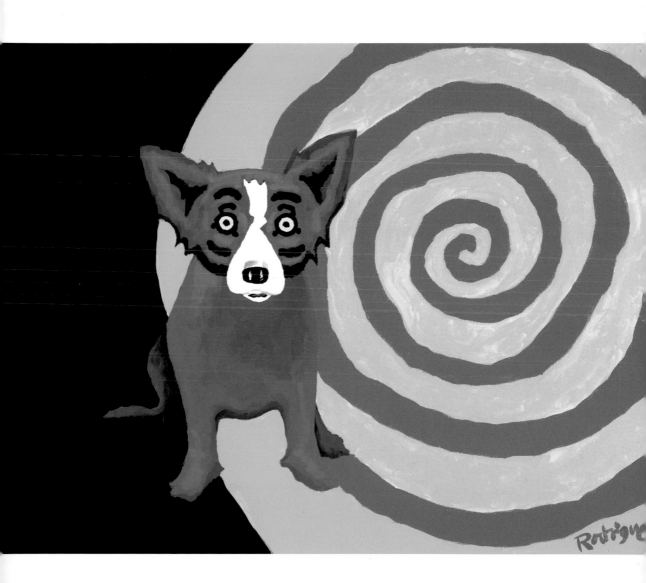

145

Eye of the

Hurricane

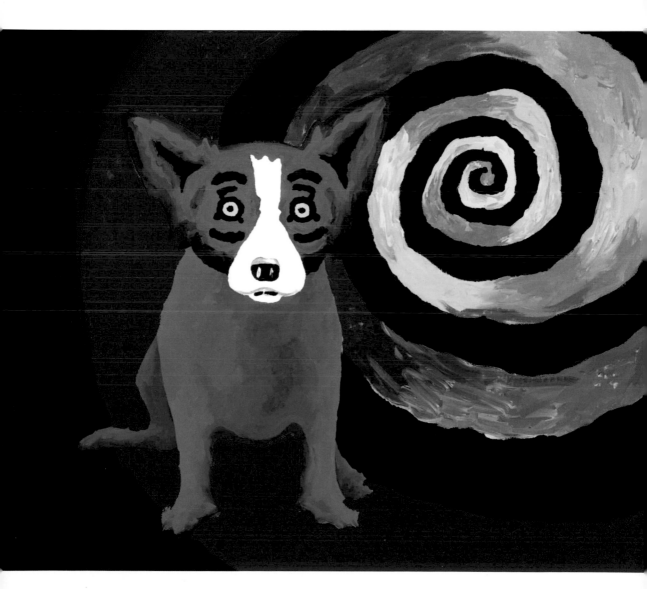

A HURRICANE of a Blue Dog

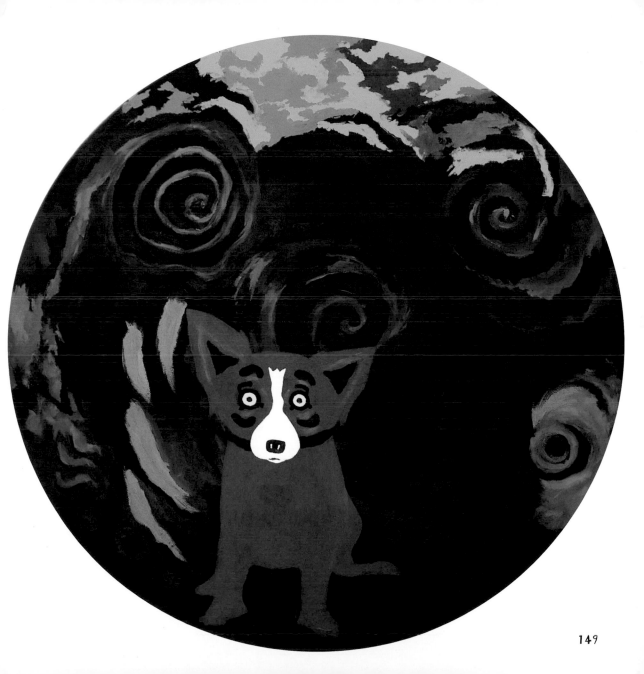

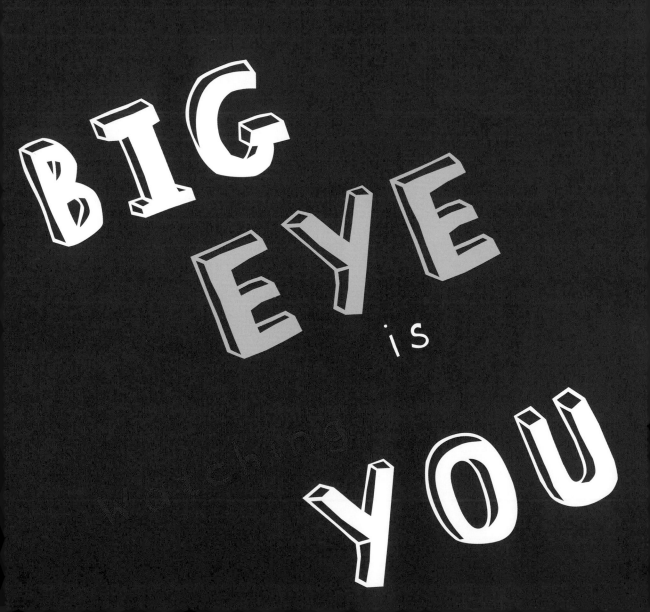

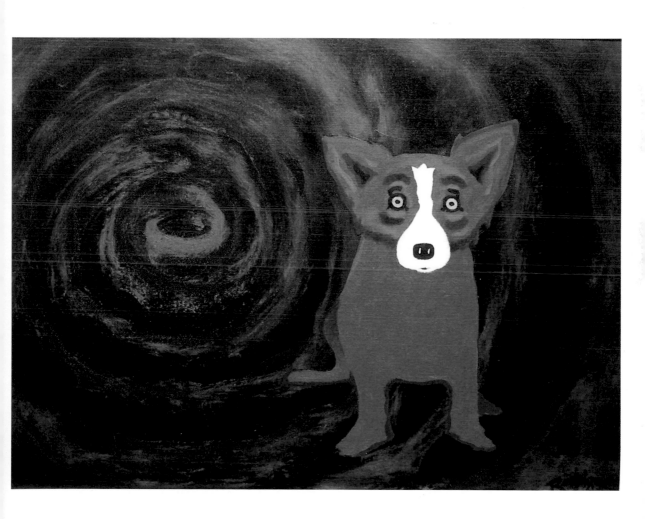

151

The Summer of '06

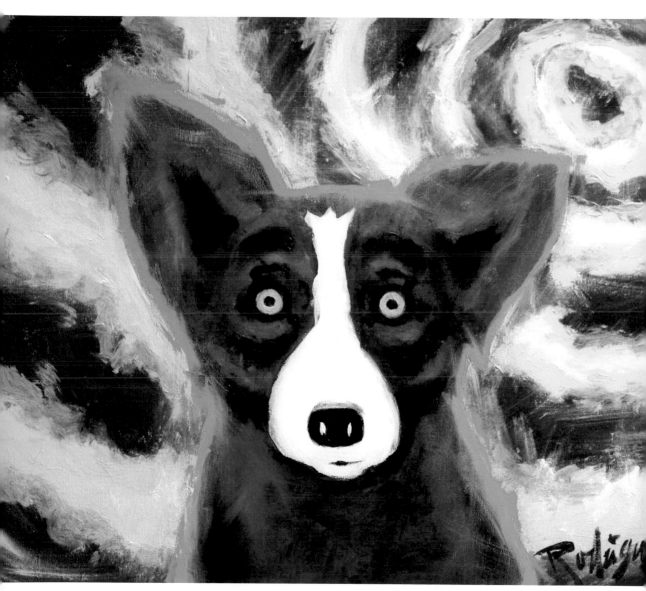

Crossroads of my Life

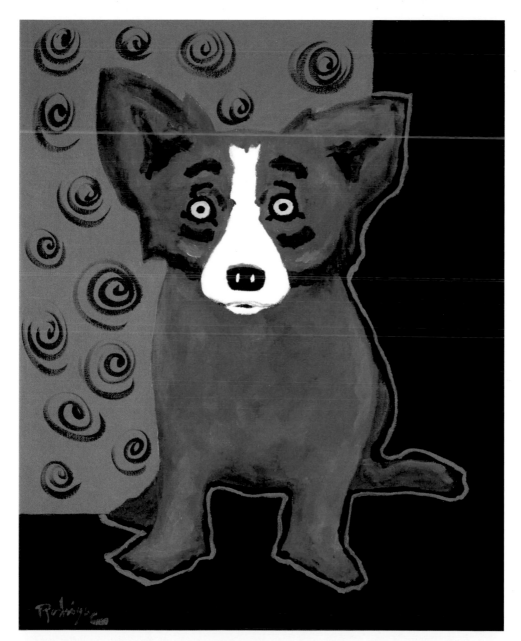

JACUZZI
WHOOZI

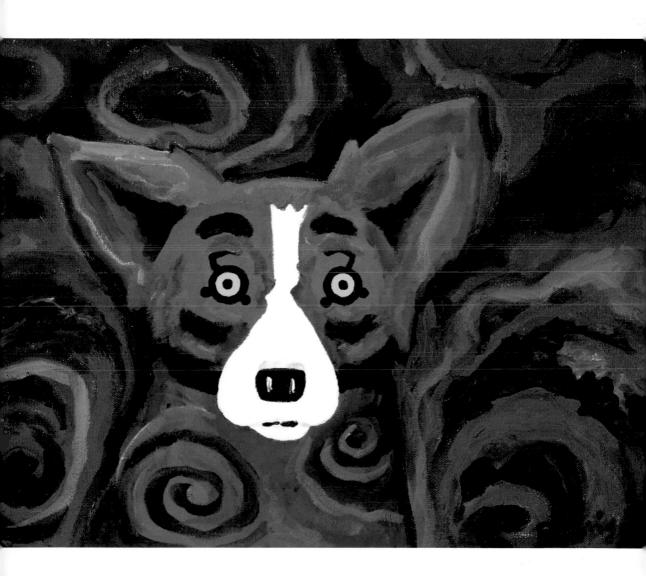

It

was

a

BaD

Night

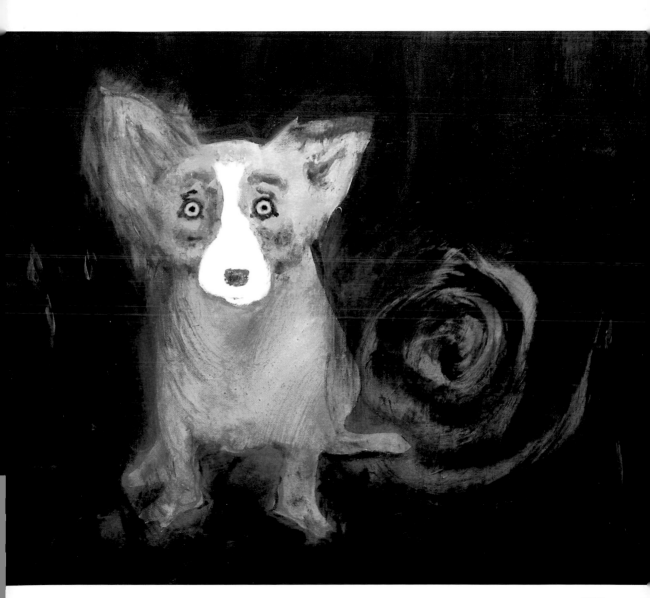

I've Got to Straighten Out My Life

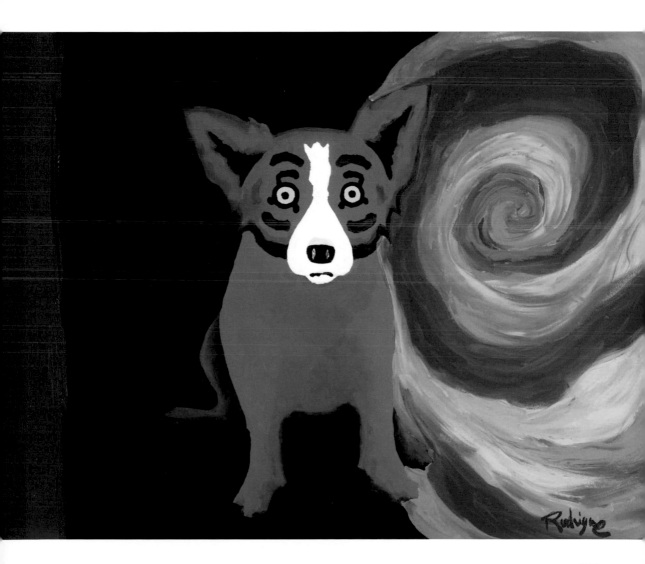

LOVE
Brings
Out
the
Sunshine

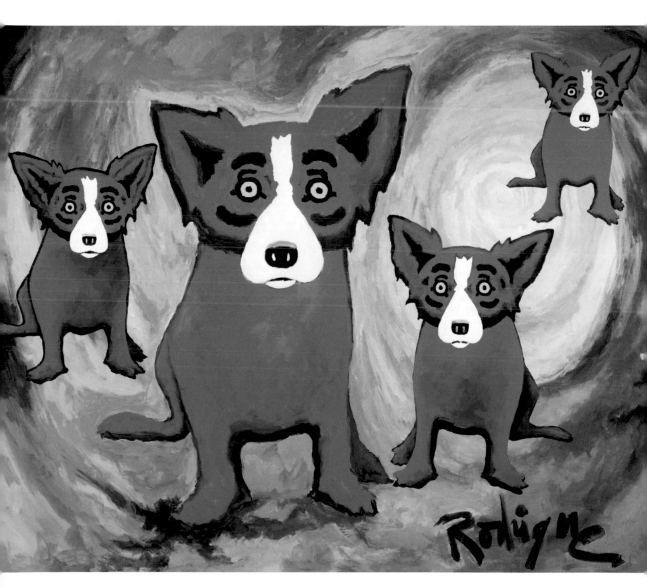

163

You Are My Sunshine, My Only Sunshine, You Are My Sunshine

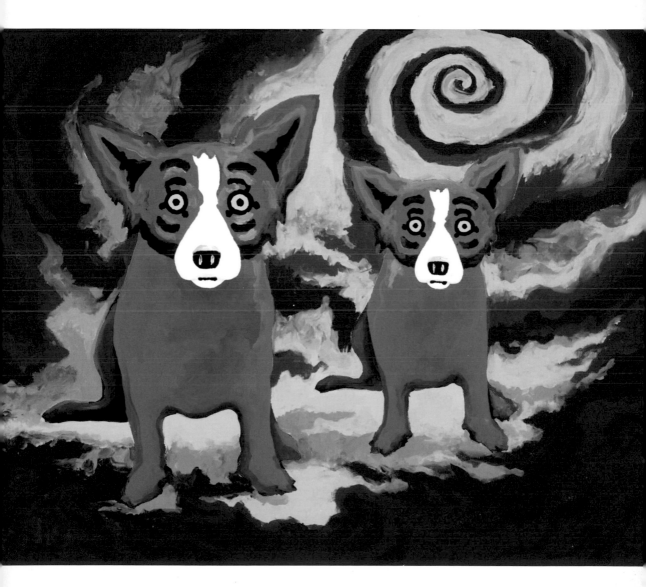

I

LONG

for

Your Kiss

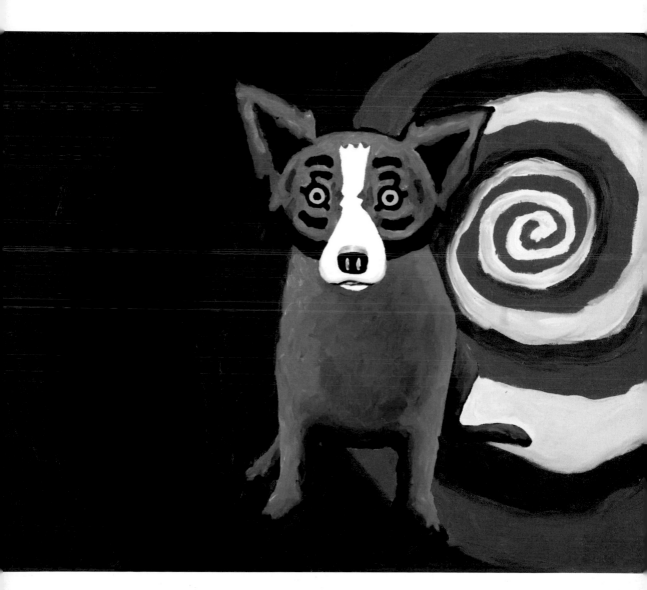

Light
My
Fire
Tonight

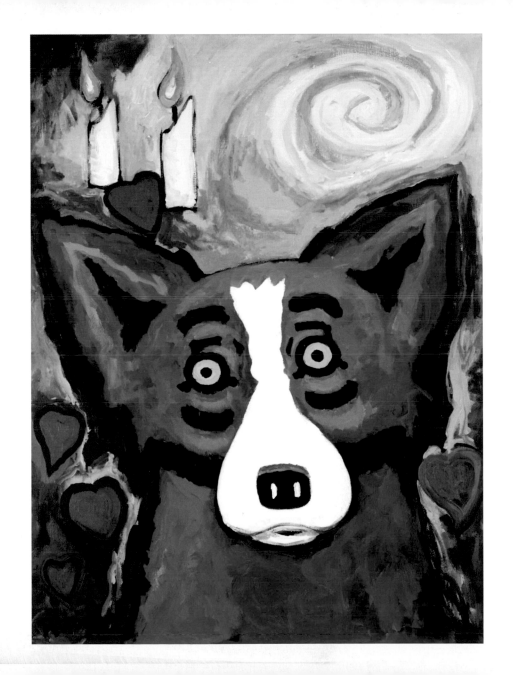

Circle of CANDLES

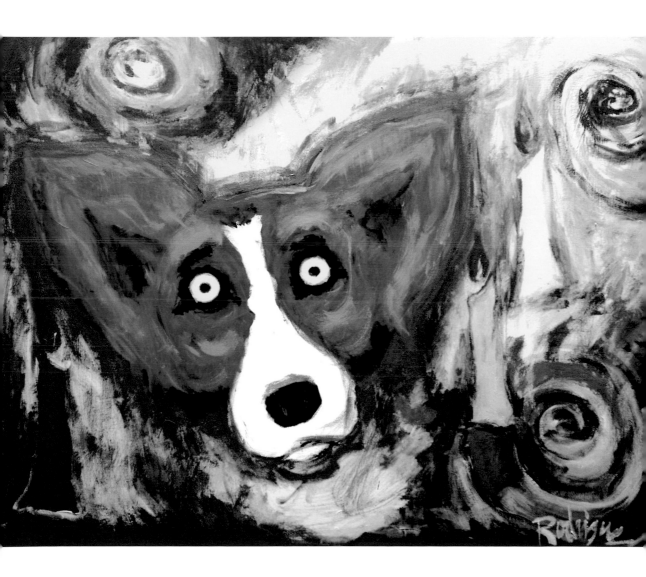

171

Candles in tHe Wind

Rodrigue

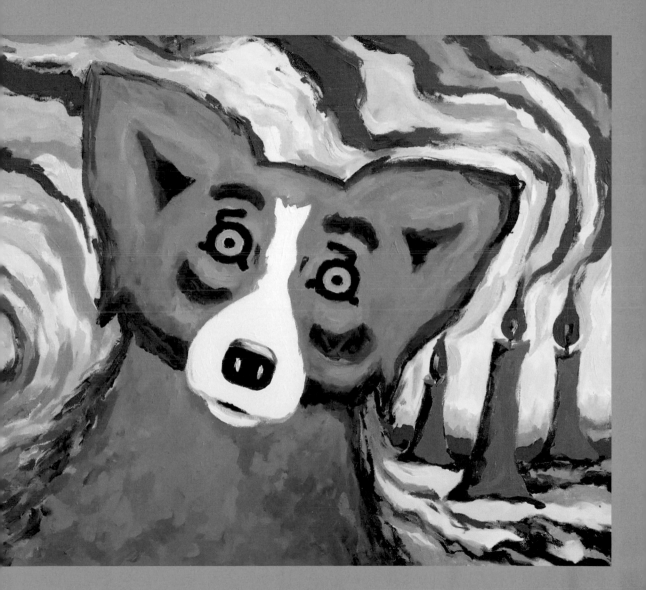

5

The
Art
of
ExpreSsion

Underneath a Warm Blanket of Love

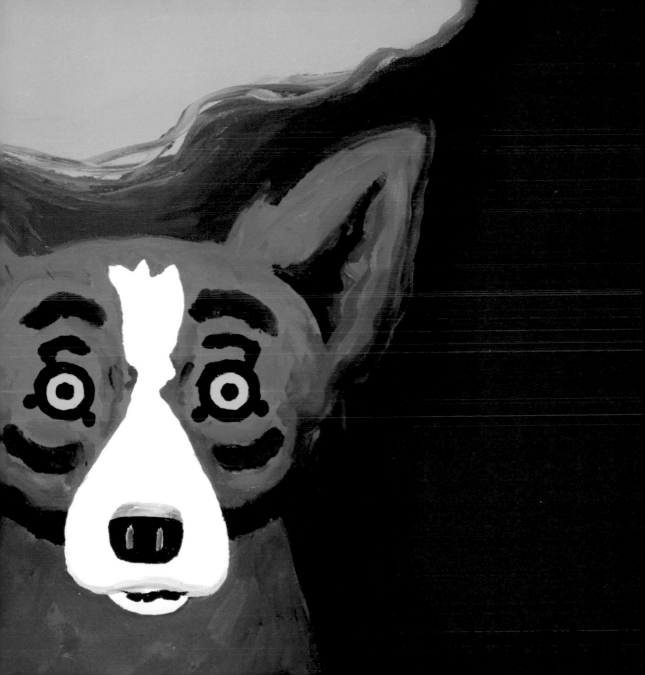

I Am an Artist

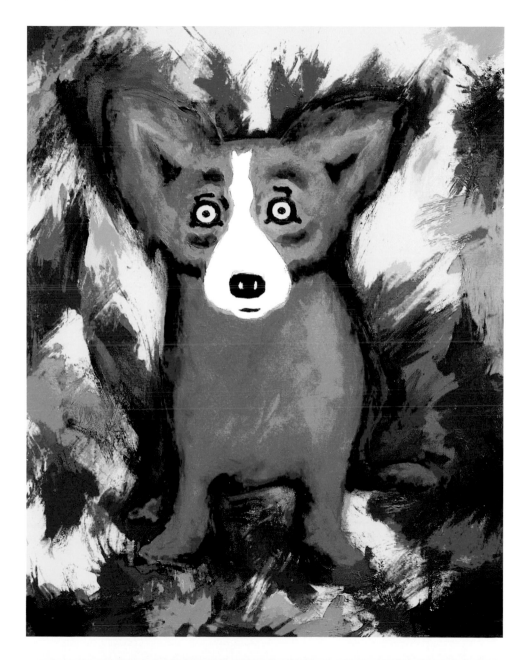

I

DrEam

of

Being

BLUE

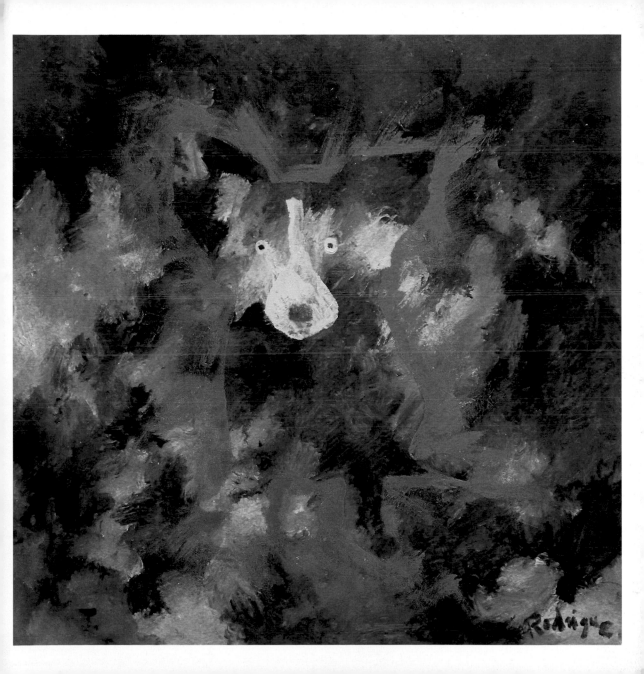

Night

o o

Myself

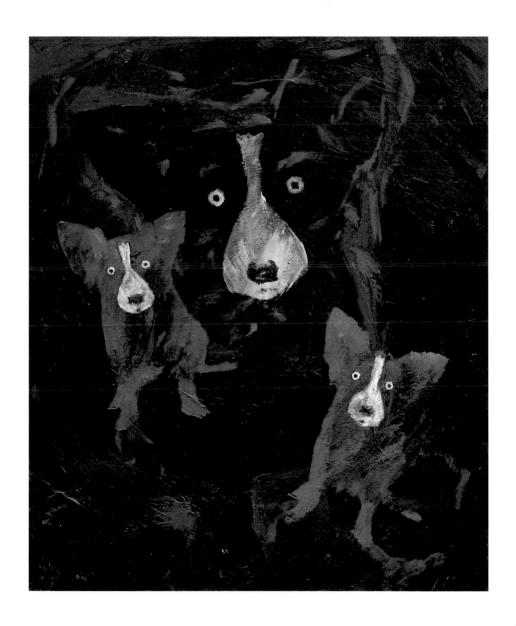

I Hear the Blues,

I See the Blues,

I Sing the Blues

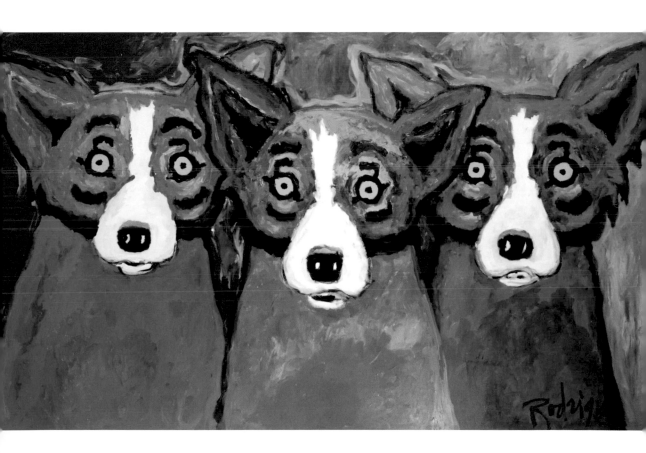

183

I Can't

Get YOU

Off MY

mind

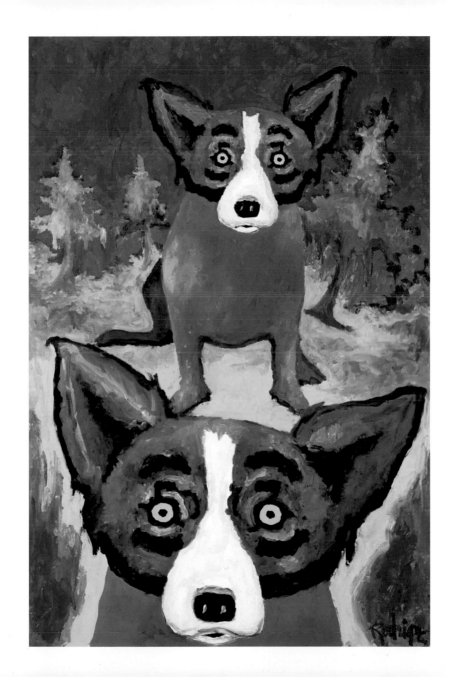

185

You're Part of my

Rainbow

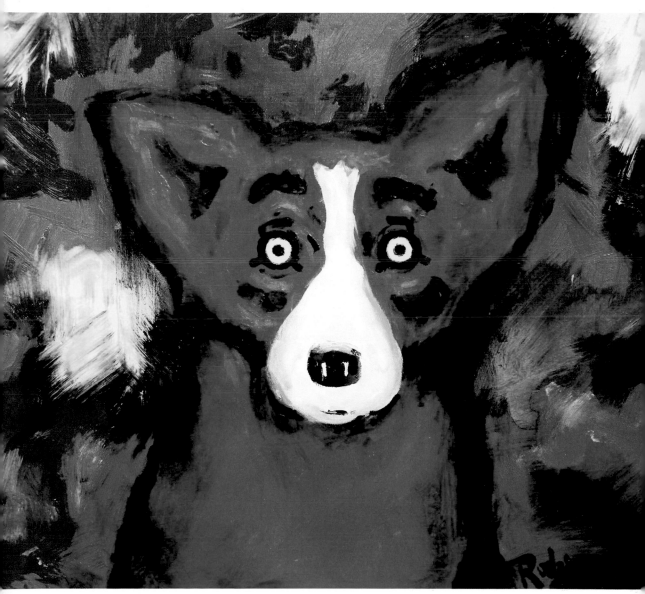

HeaRts

in

LoVE

You're the Only One Under the Sun

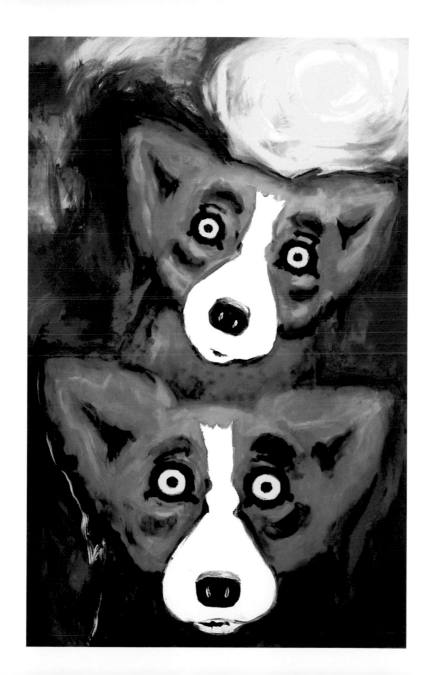

Half

of

Me

Loves

You

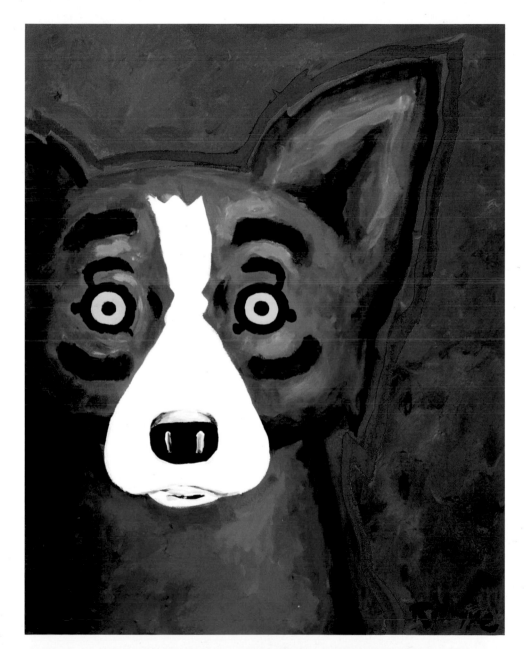

I've Been Known to

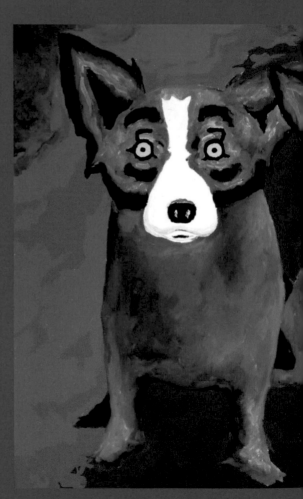

Change My Position

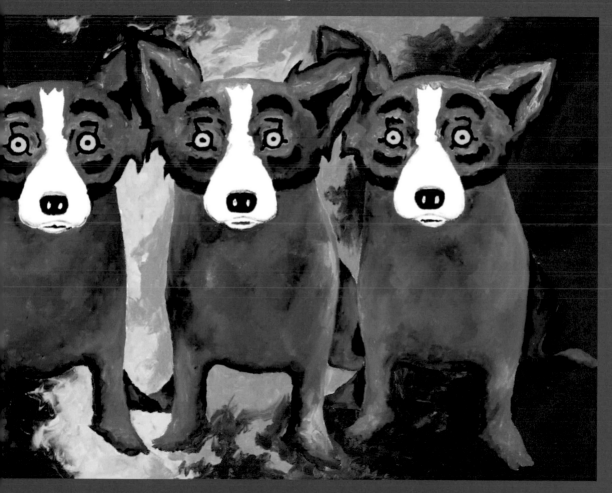

You Got PrOBlems?

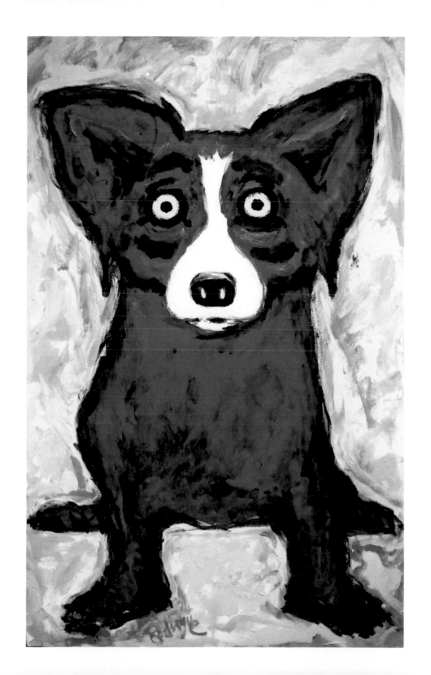

In

the

Greenhouse

Again

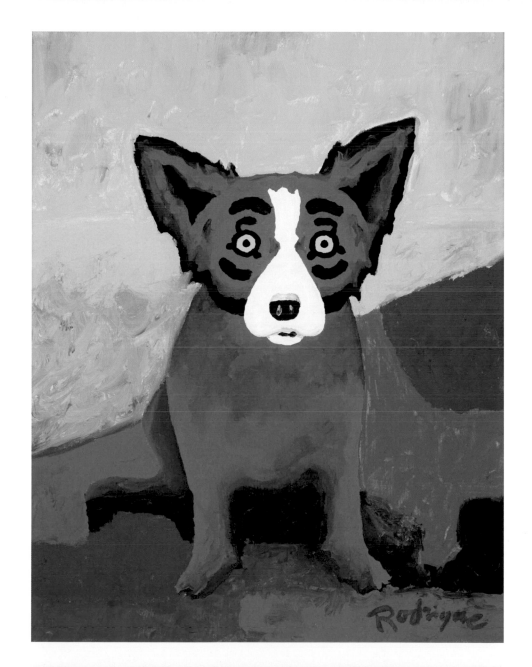

Red HoT SummEr of '06

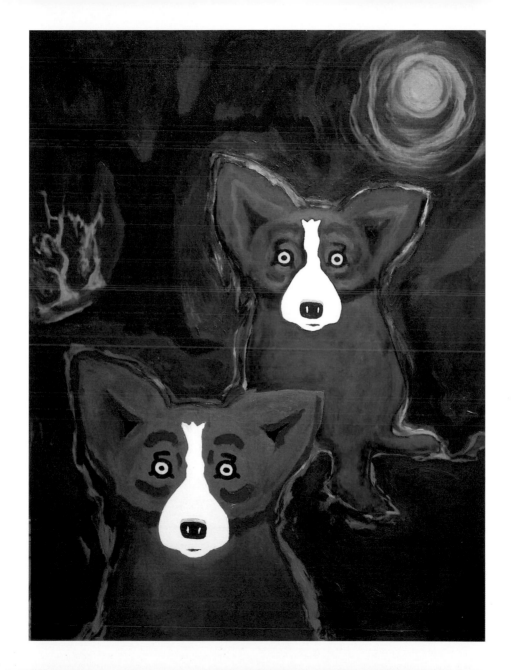

A

Mardi

Gras

Night

BLACK

MAGIC

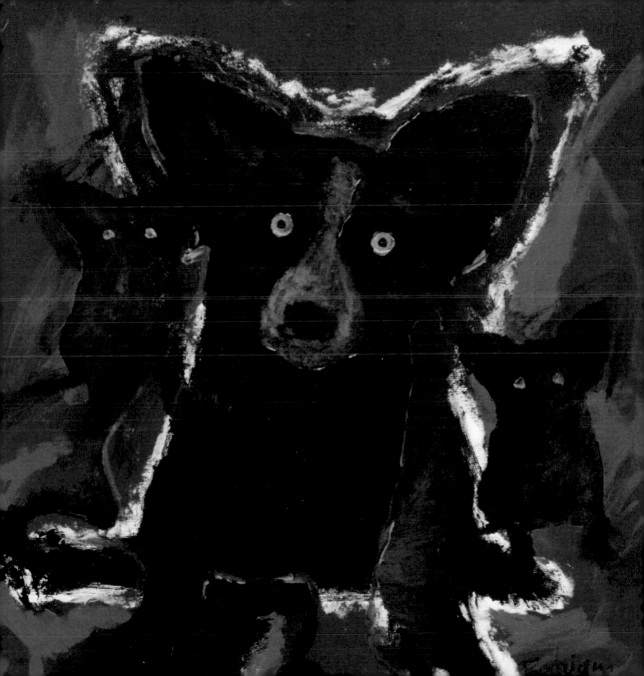

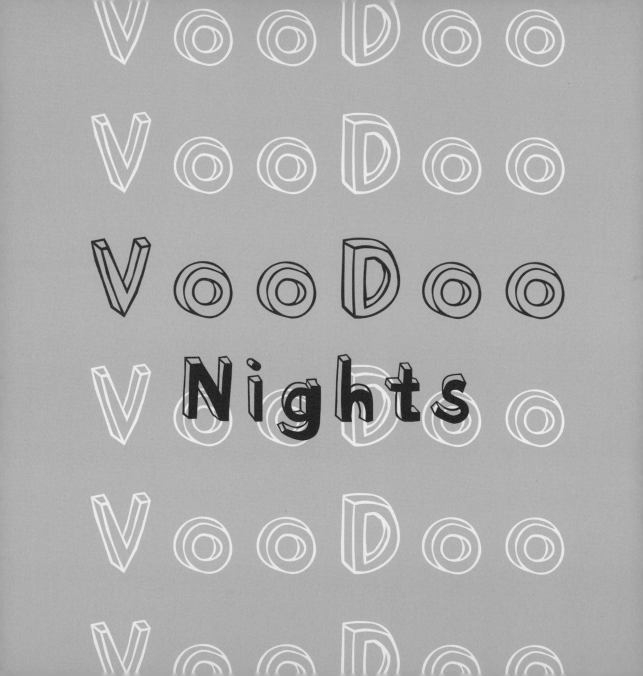

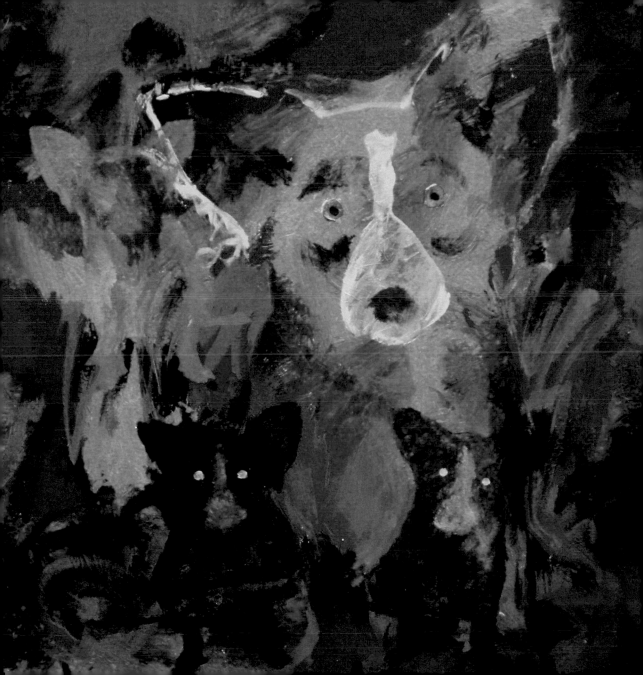

Midnight

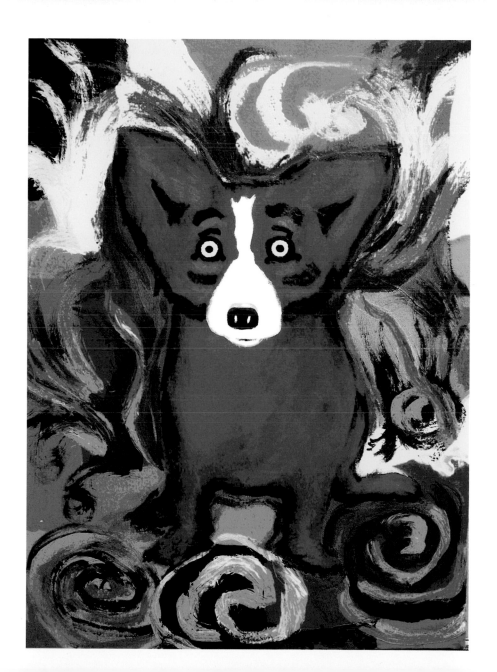

209

Do the Town Tonight

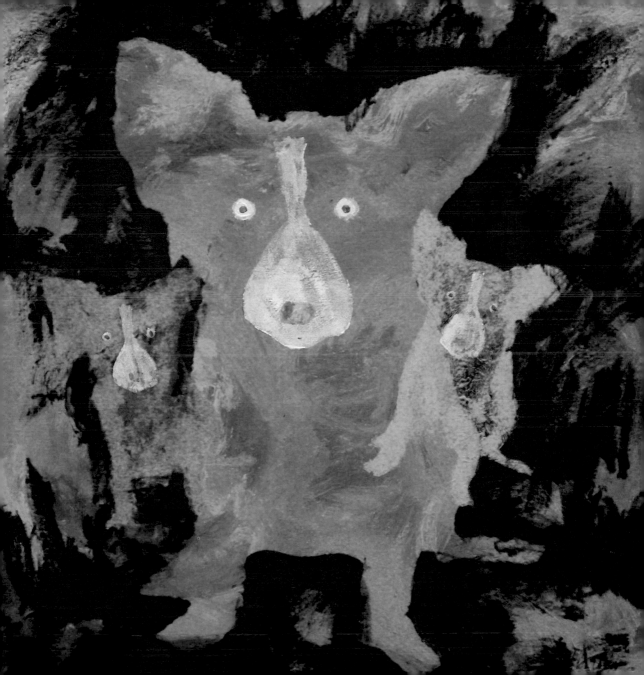

Blue

Dog

on

the

River

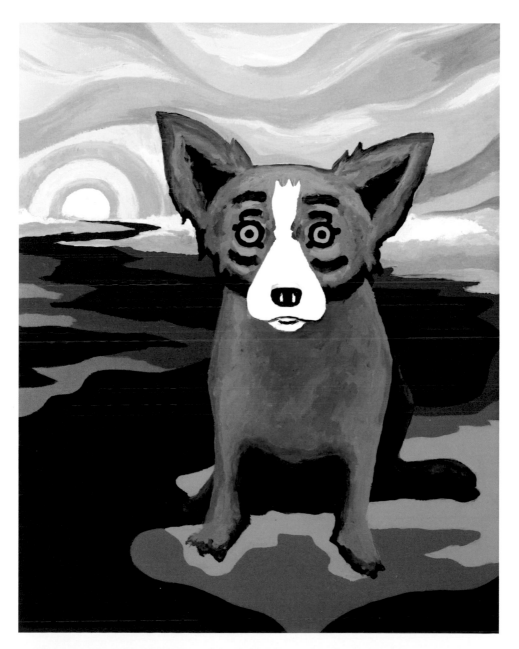

213

It's Been

a

Hot Cold

Night

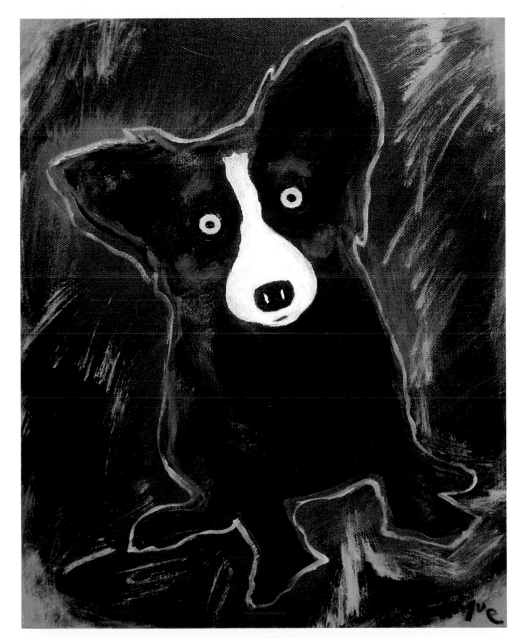

215

Ice

Me

Down

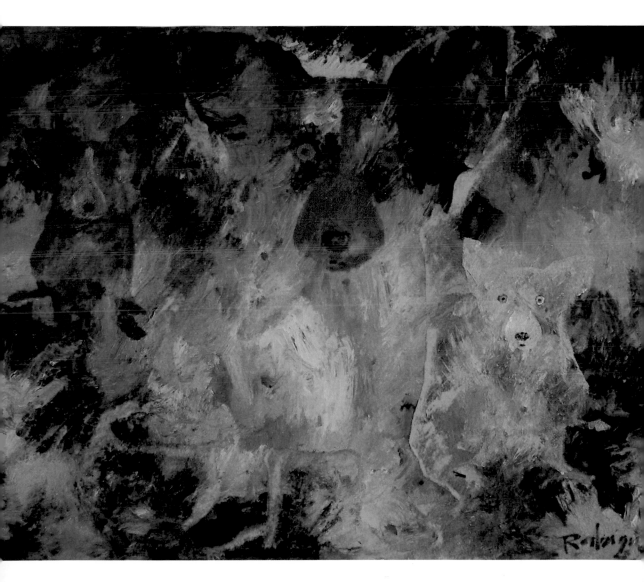

Wash with **HOT** Water

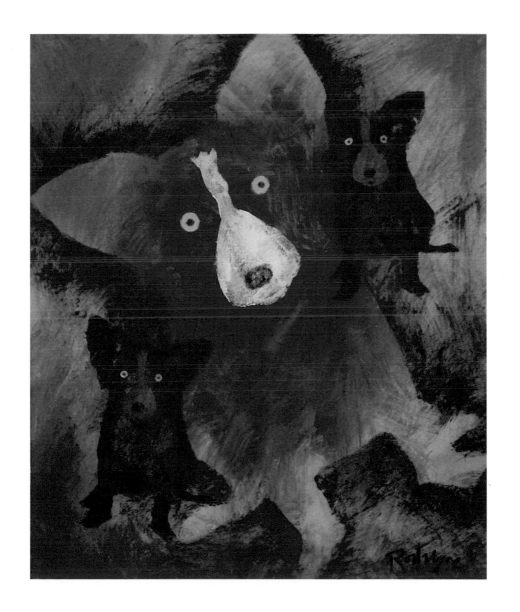

Play It One More Time

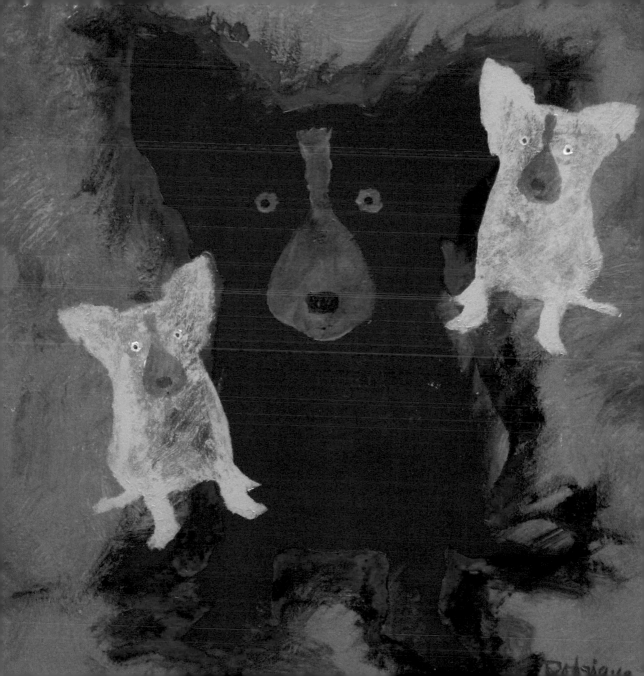

The Red Hot Reunion

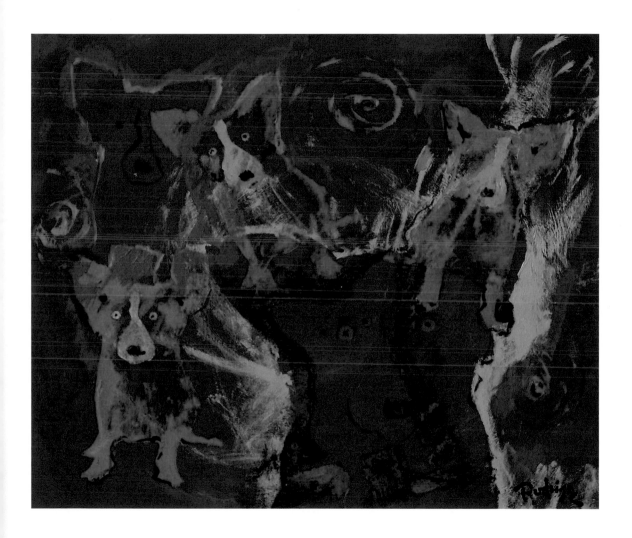

Making Waves

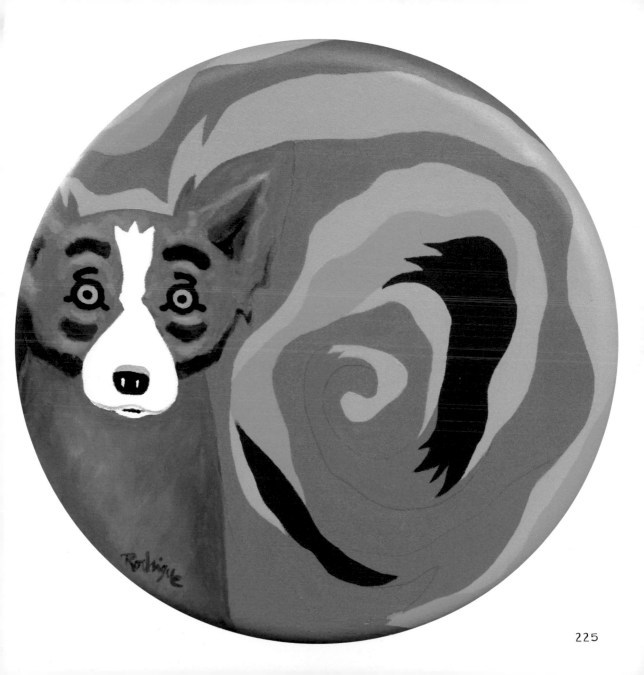

225

Fall Colors for All

When the Le v e Fal l
a
e
a

s

a Leaves Leaves v

UNCLE BILL'S CHILDREN

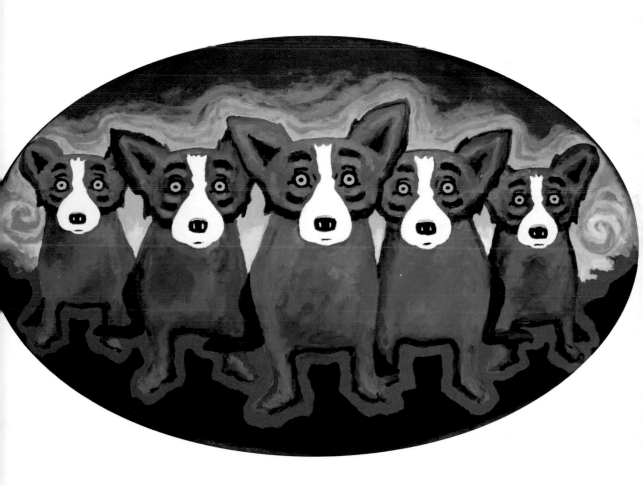

Five of a Kind

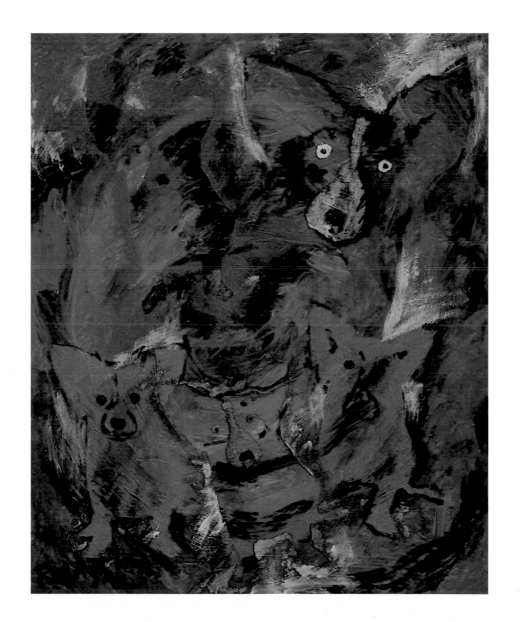

233

You

Would

Think

We

Are

the

Same

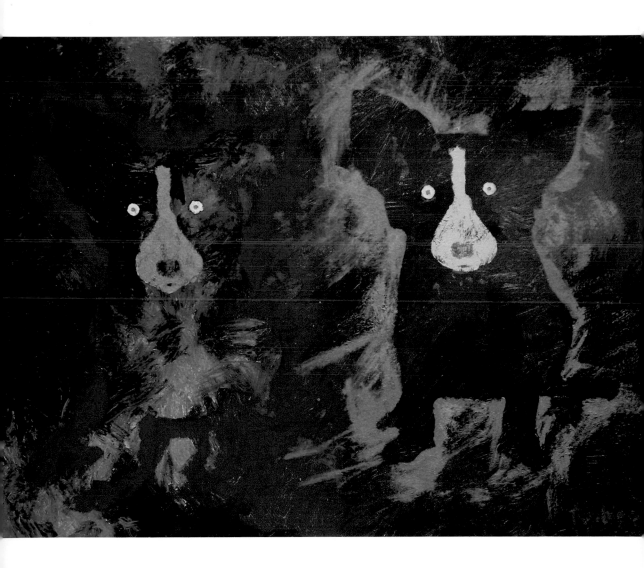

Three

Little

Pigs

We're Not

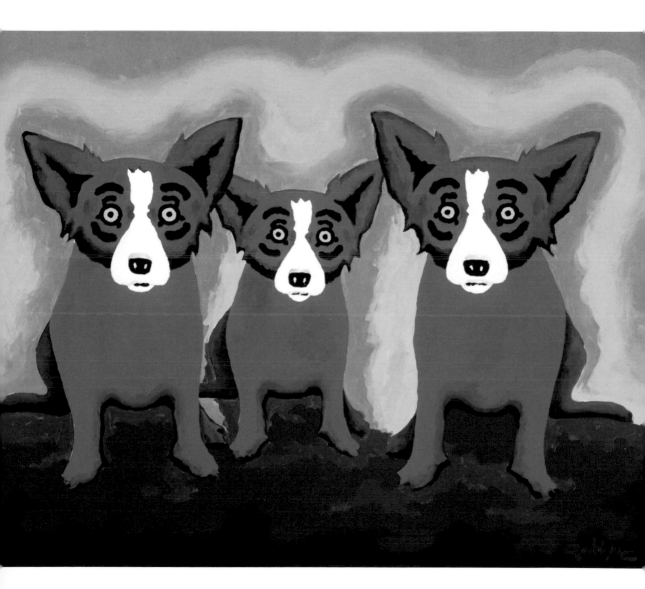

I Look Different

Close-up

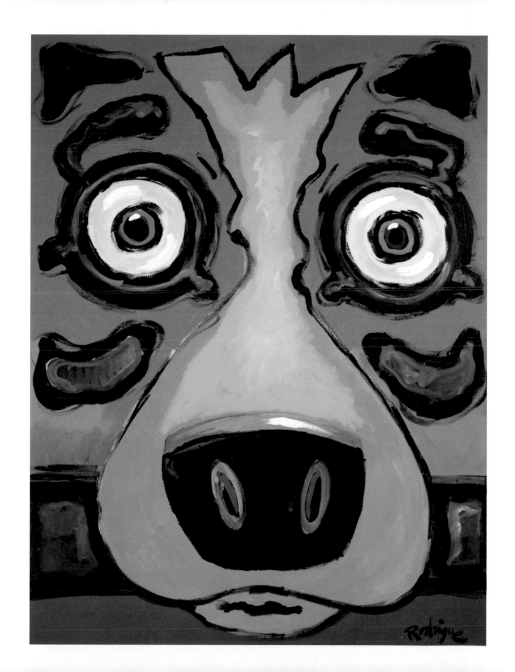

239

Totem
Dogs

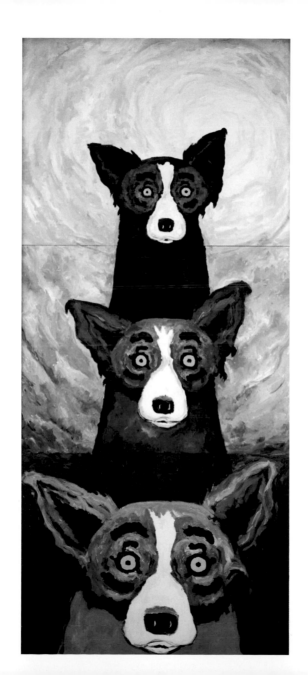

241

STACKED

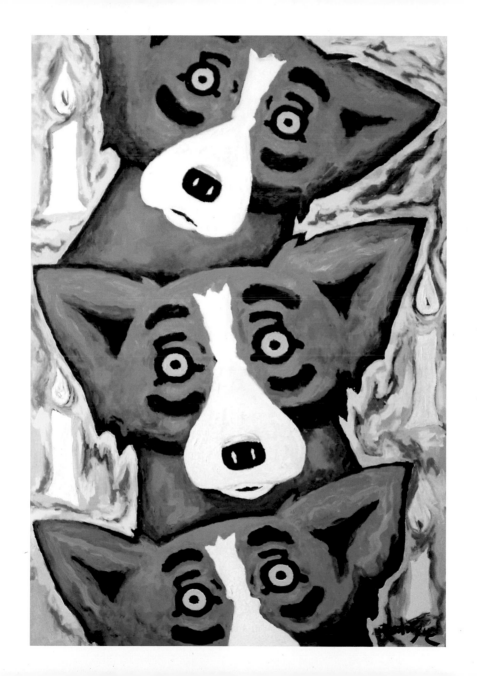

243

Warm Dreams for a Cool Night

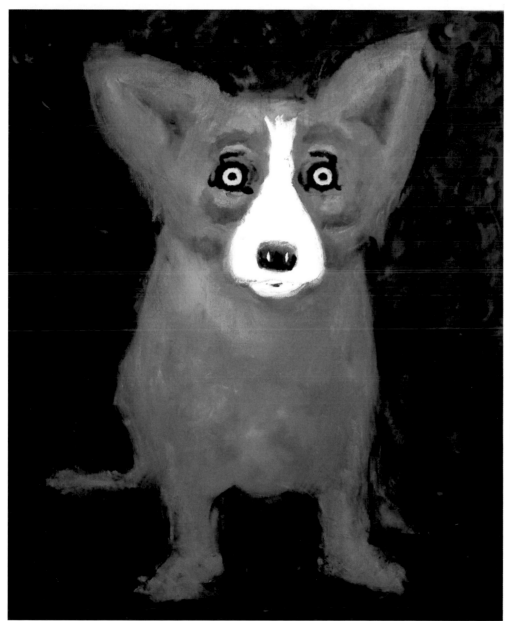

245

Spring Is Coming

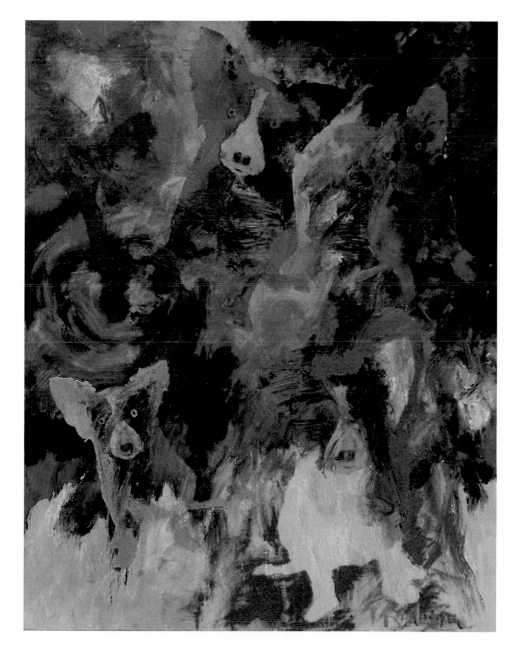

247

We Are Lost

Together

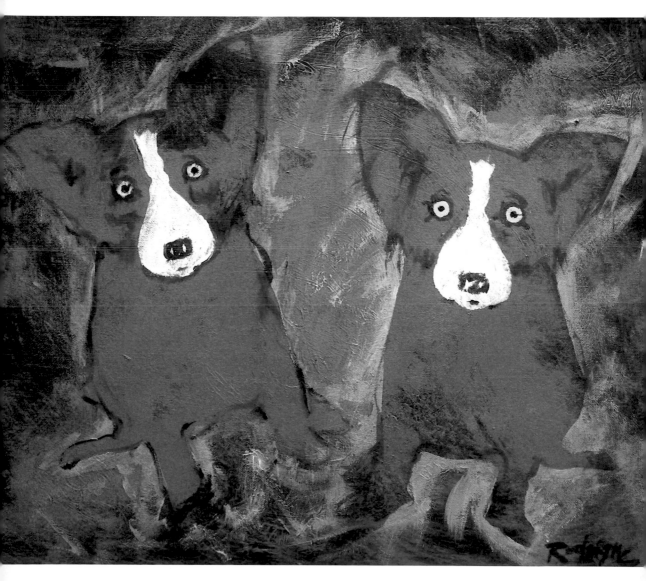

249

Waiting
to Be
Caught
by
LOVE

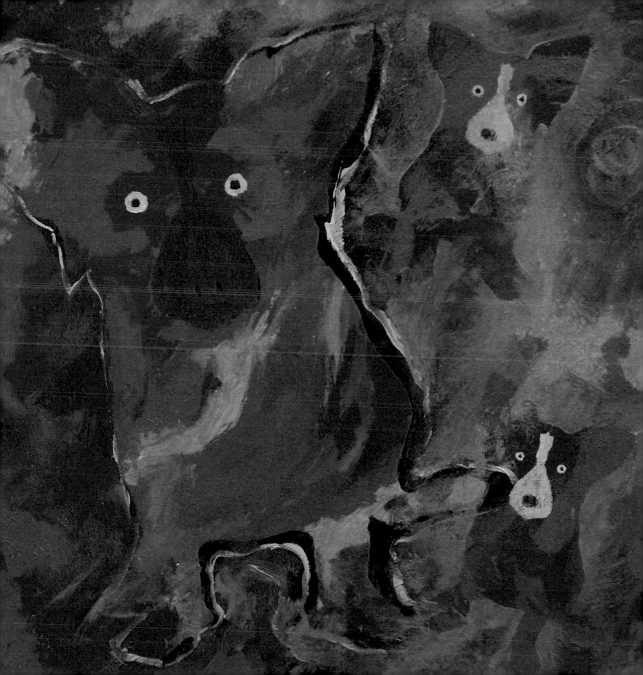

6

The Flowers of Love

Love Me, Watch Me Grow

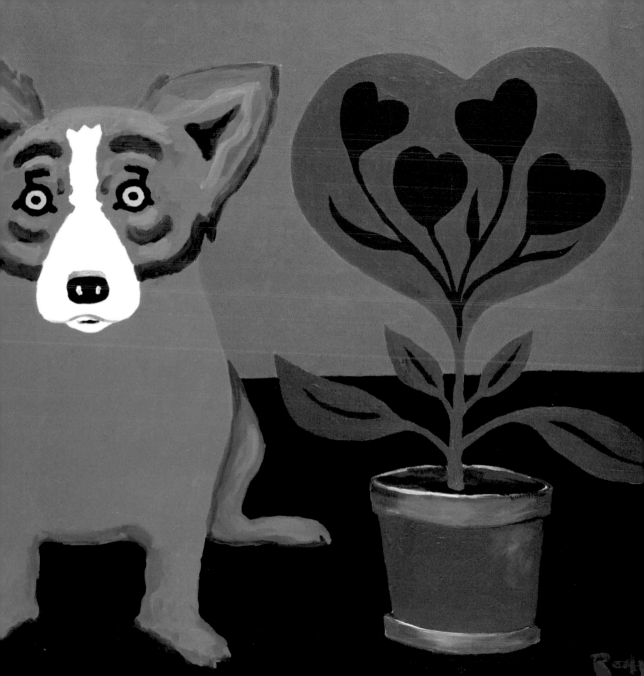

1-800 Flowers

(I Am What I Grow)

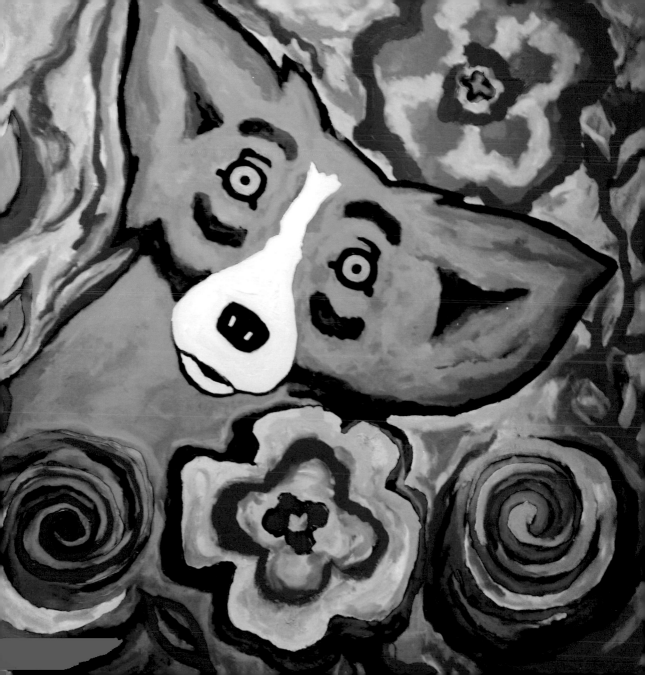

All By Myself with My Happiness

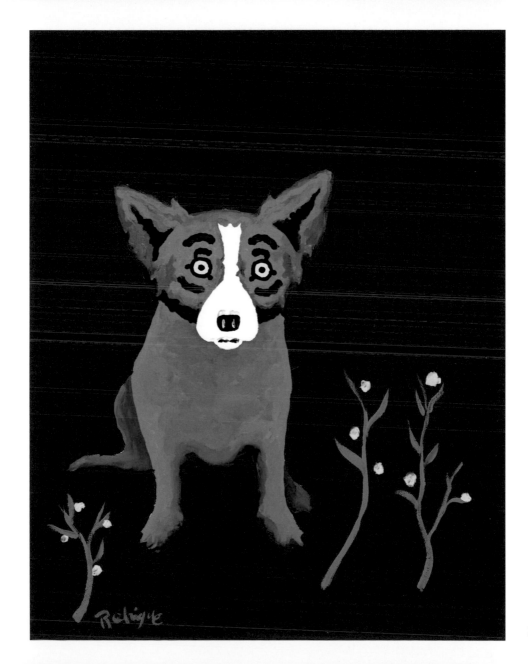

Faith,

Hope

Charity

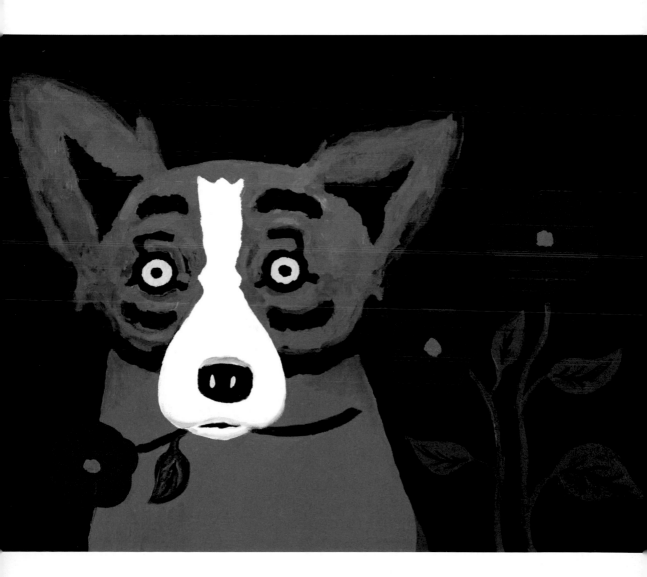

259

I GROW FLOWERS FOR A LIVING

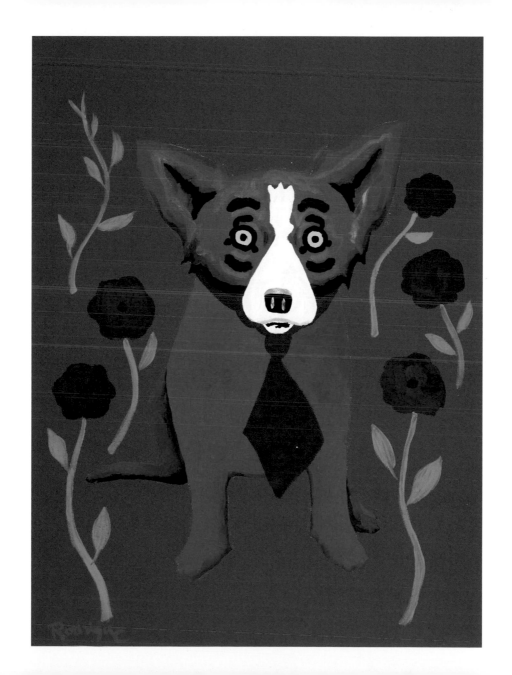

I Planted

THE

Seeds of Beauty

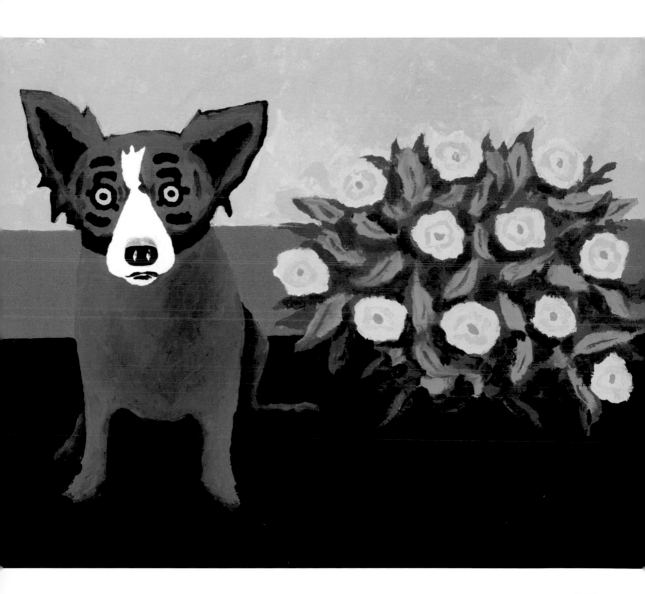

263

From a Seed Flowers Grow

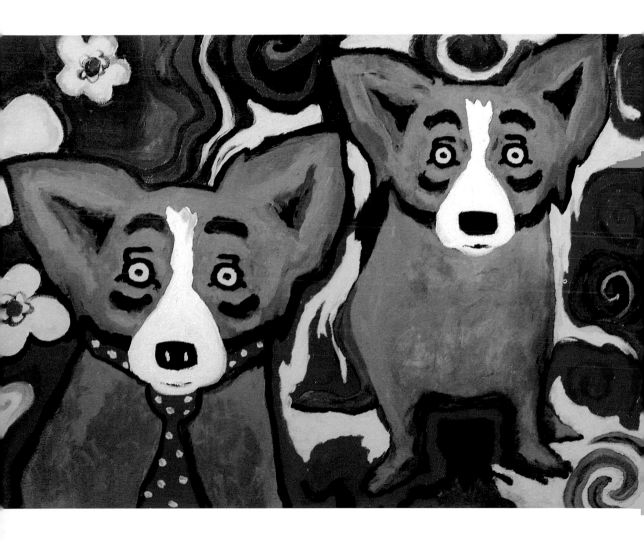

He's Just a

MEAN

Flower Machine

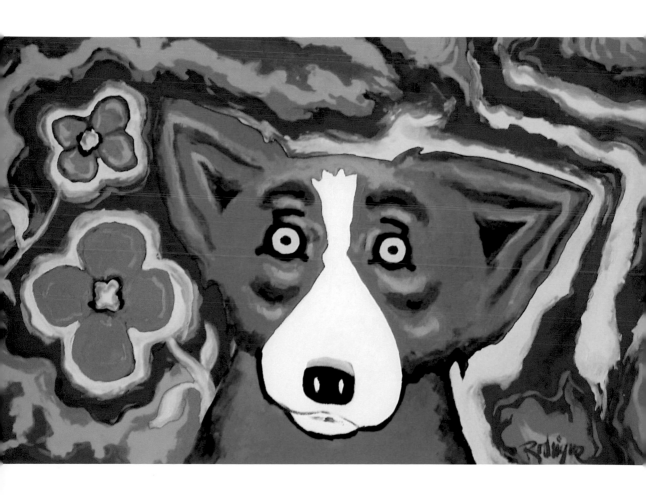

267

Grow

 SomEthin'

Mister

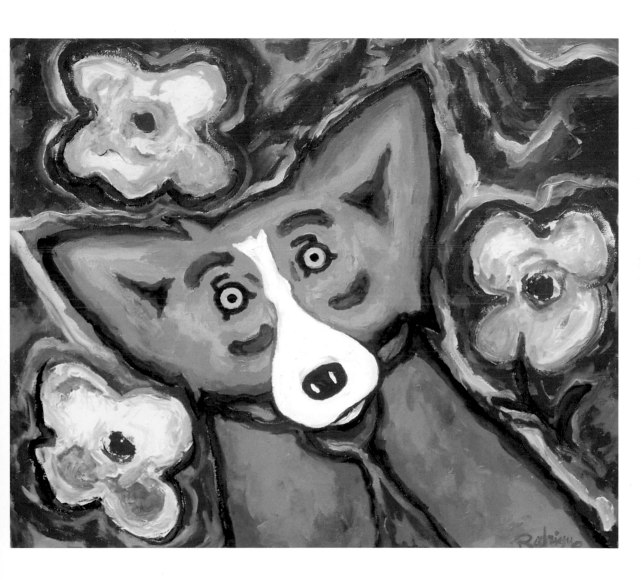

269

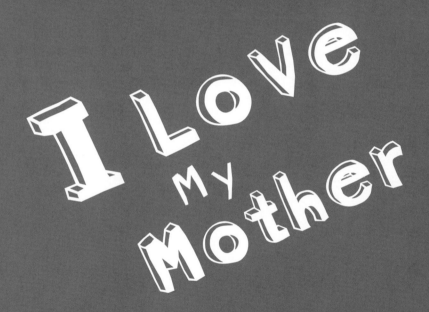

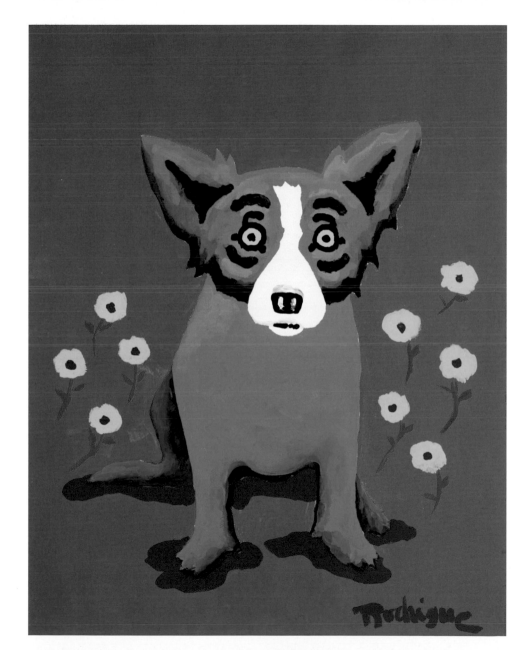

Sunshine Over My SHOULDER

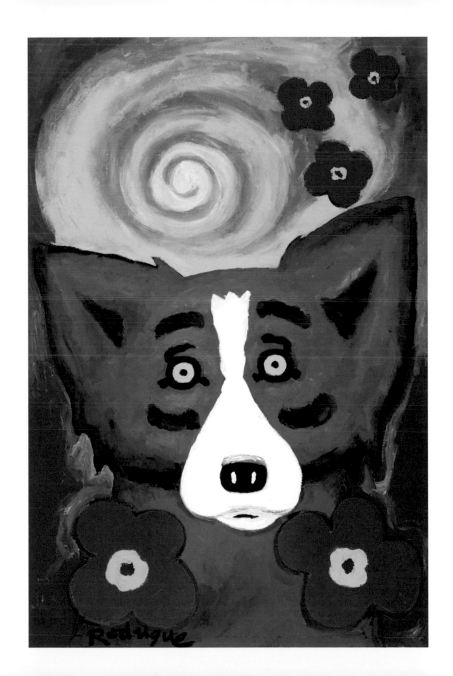

273

Springtime in Louisiana

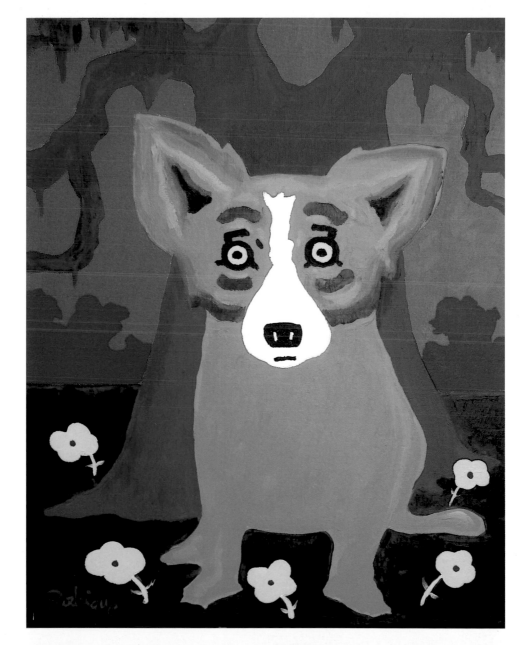

She's

Got

Me

Waiting

with

the

Wallflowers

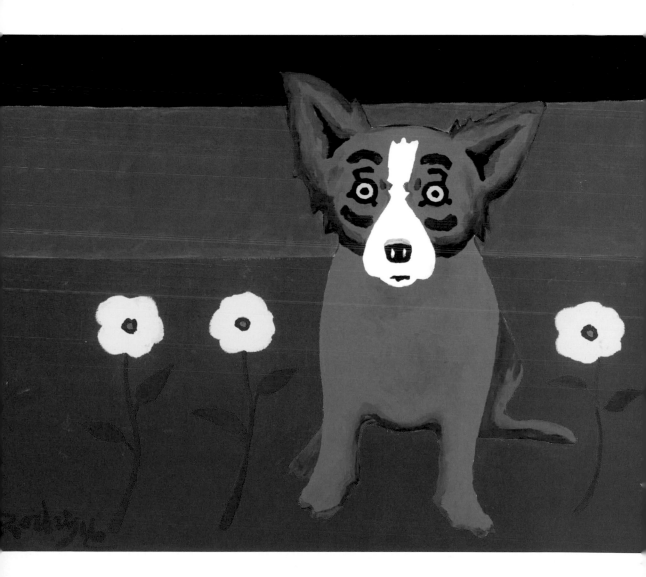

She Took My Heart for a Loop When She Threw Me for a Away

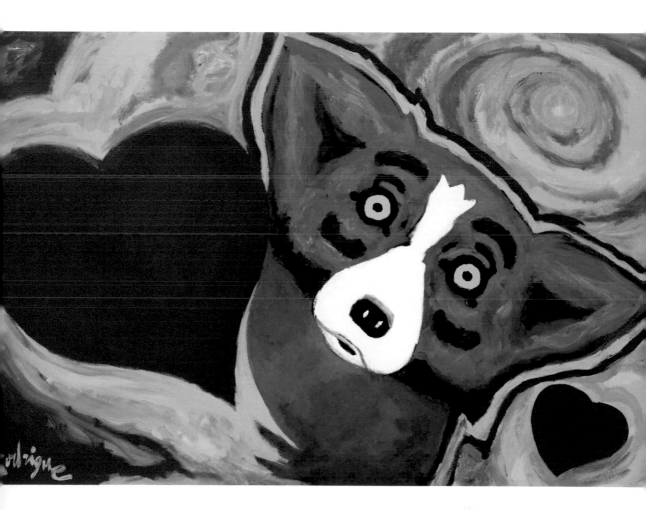

I Sent My Blues Back to Her

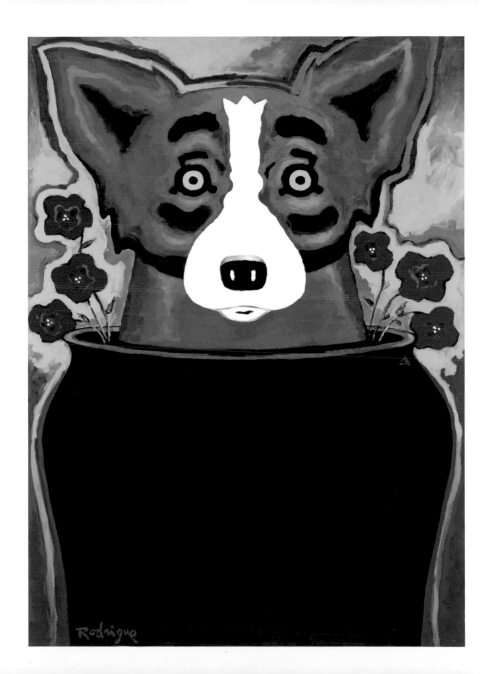

Hawaiian

Blues

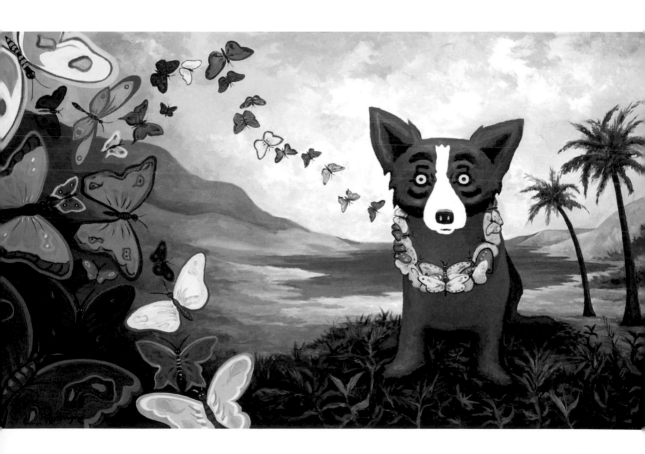

Rut

My

of

Out

Getting

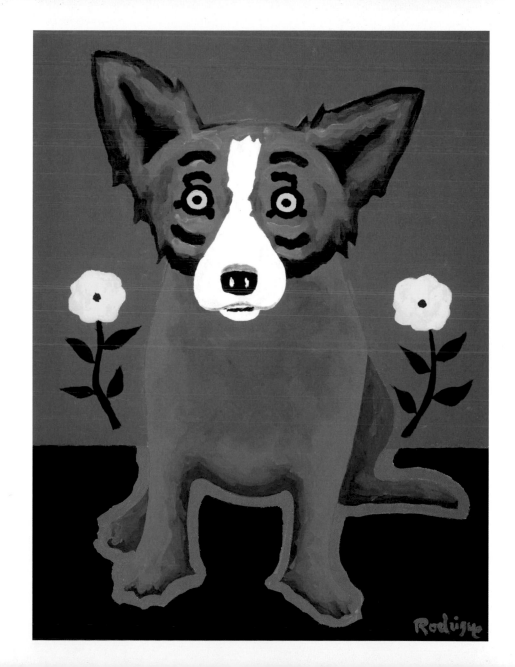

285

Me

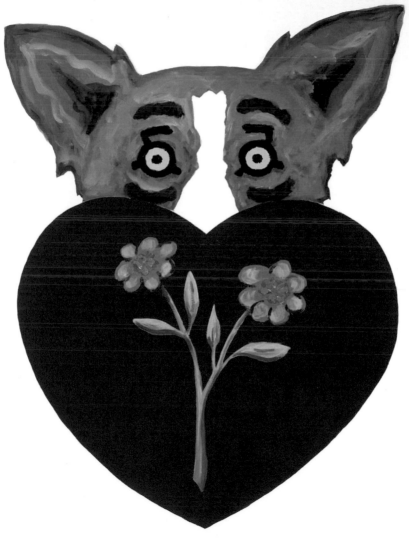

Rodrigue

287

My world is Full of Love

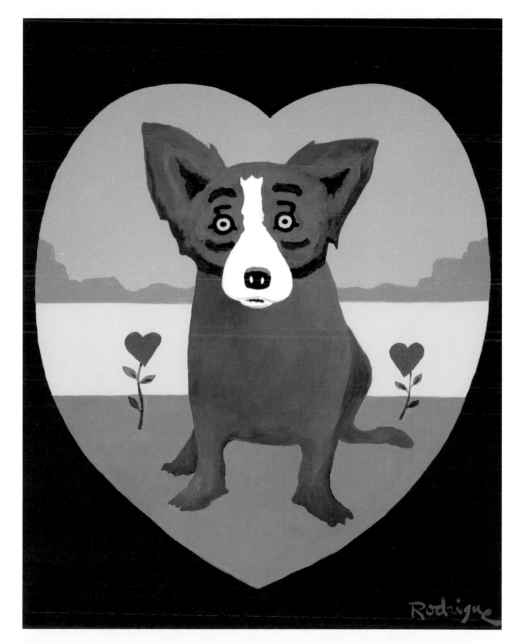

289

Our Love Blooms Forever

Forever Forever Forever
Forever Forever Forever
Forever Forever Forever
Forever Forever Forever
Forever Forever Forever
Forever Forever Forever
Forever Forever Forever
Forever Forever Forever

(The Day Love Bloomed)

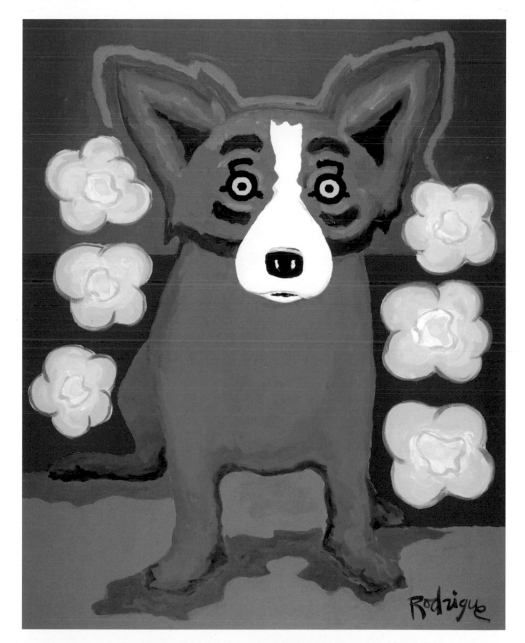

MY LOVE TREE

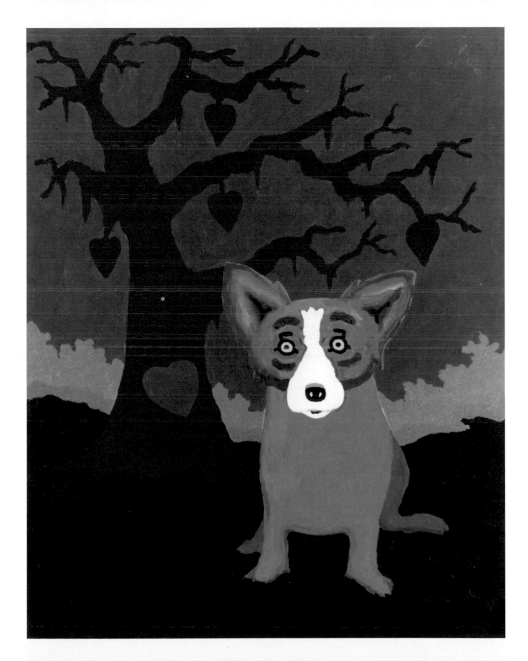

Red

Hot

Kisses

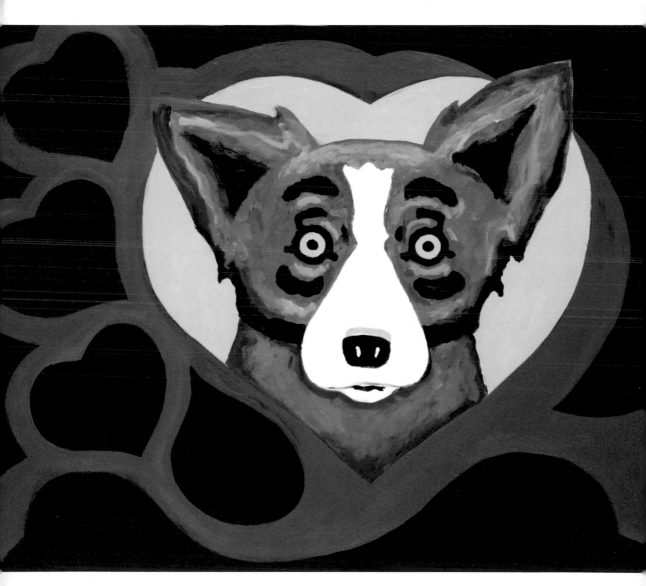

Hot Poppies

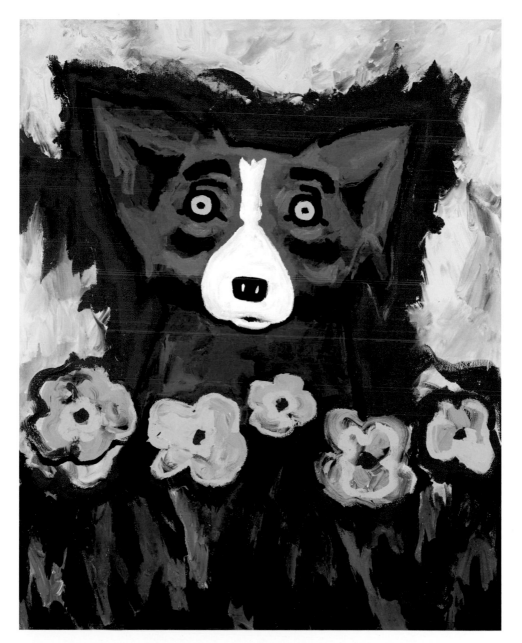

297

Let's

Walk

in the

Flower
Garden

I Cannot Tell a Lie

(Don't Pee on My Cherry Tree)

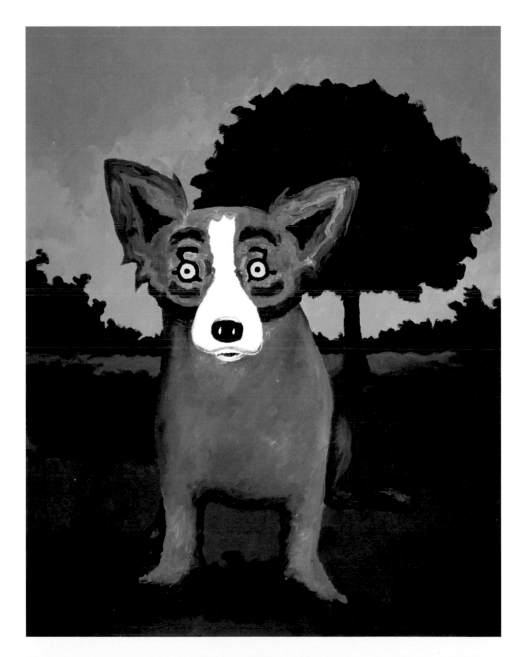

In My
Heart

You'll Live Forever

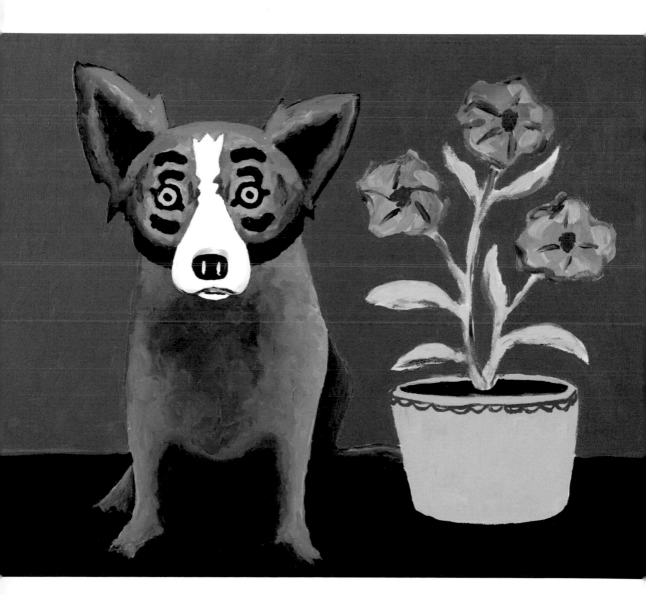

Two Hearts in Love

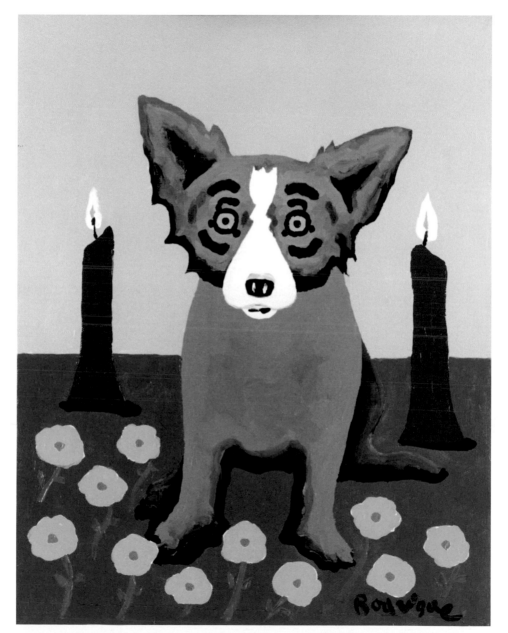

Rodrigue

7
A
Woman
Loves the
Blues

She Drove Me Crazy

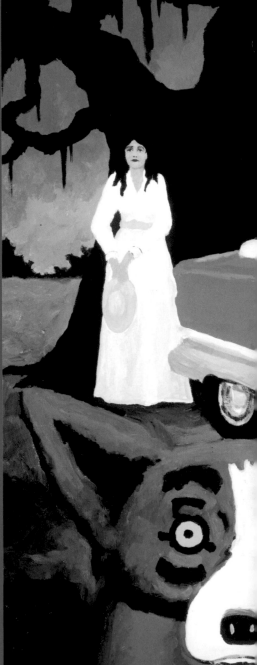

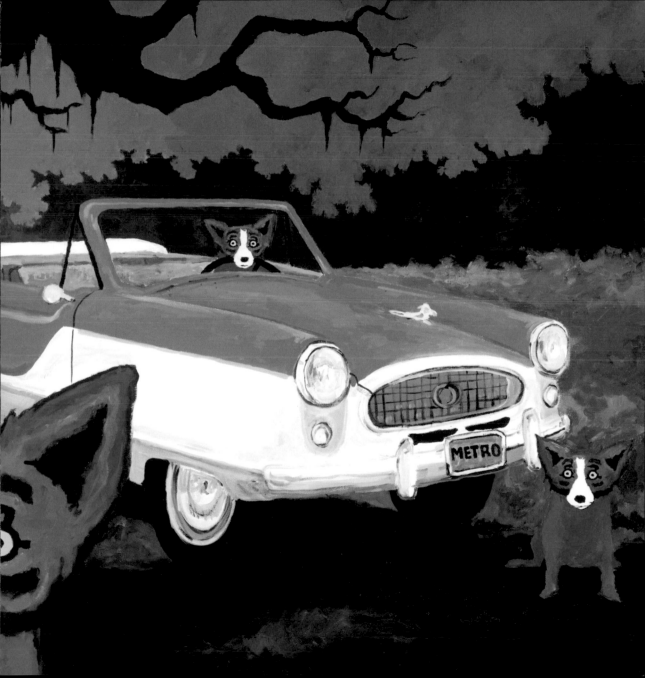

Wrong

Century

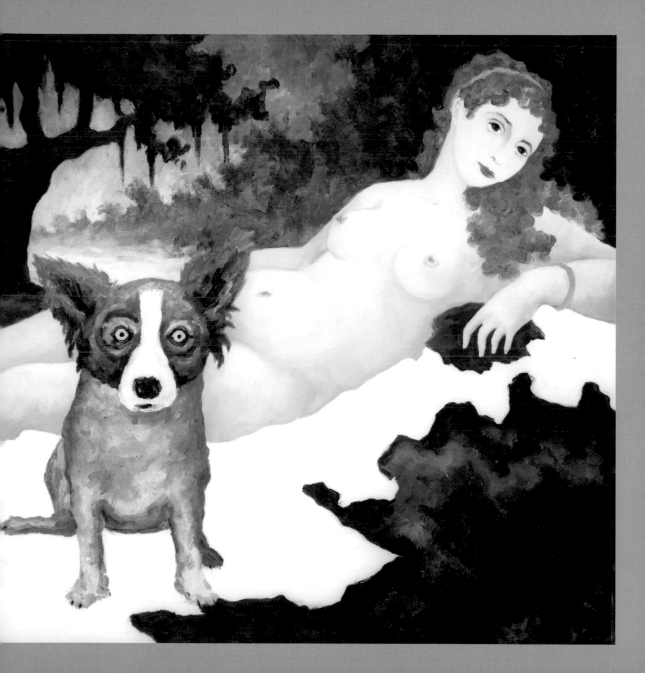

Handle My

HEART

with Care

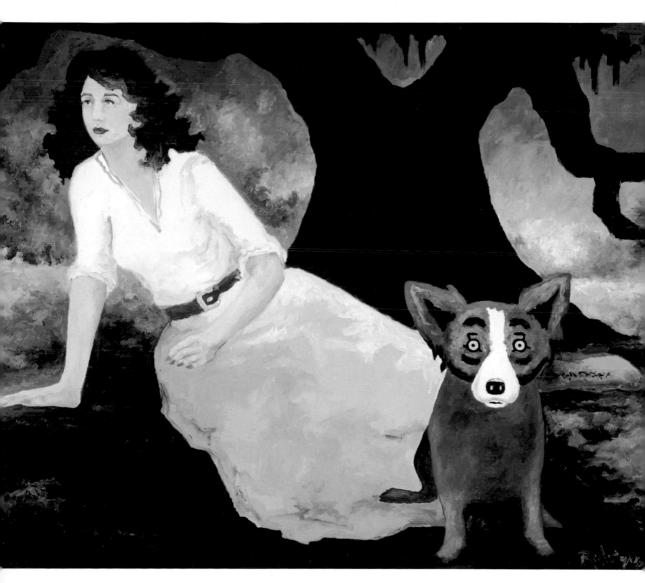

311

Calif ornia

Dreamin'

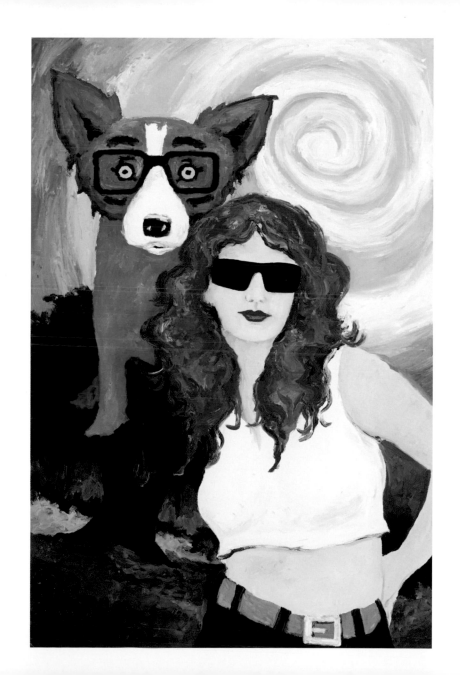

Blue Eyes Blue Heart

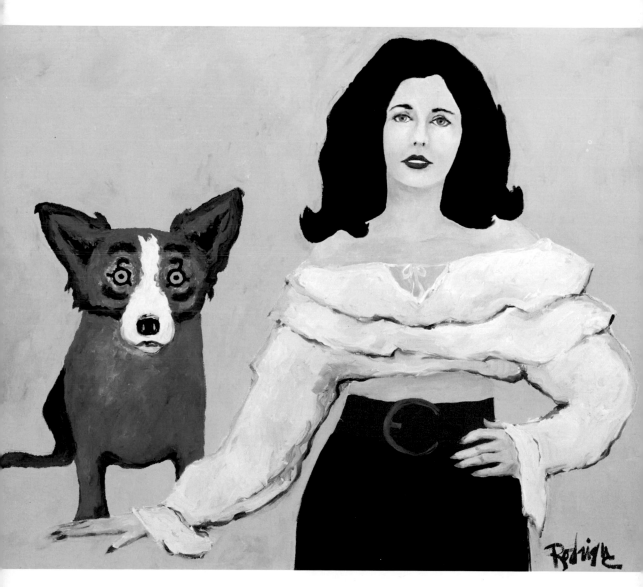

Speaking to the WIND

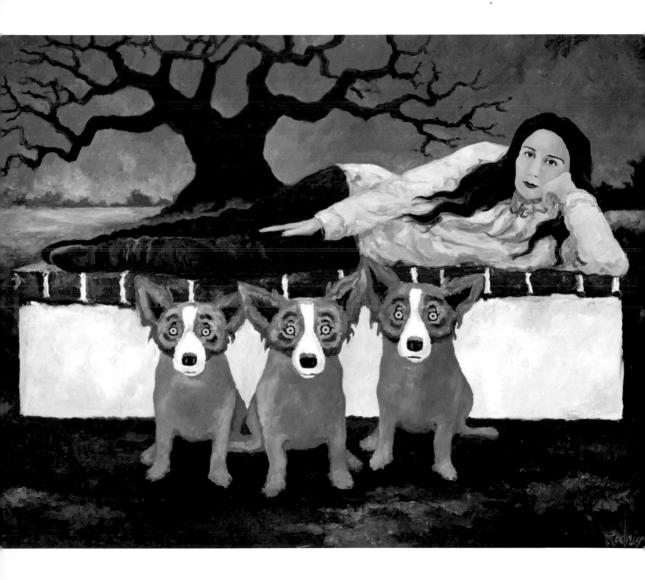

She Brought
Color
to My Life

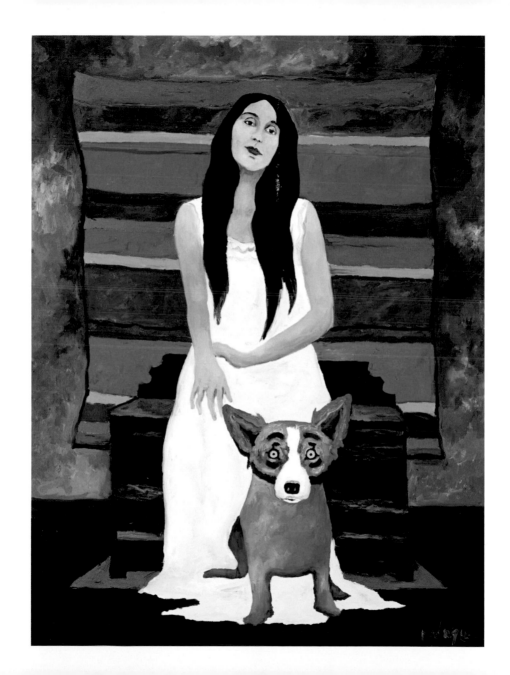

319

Virtual Reality

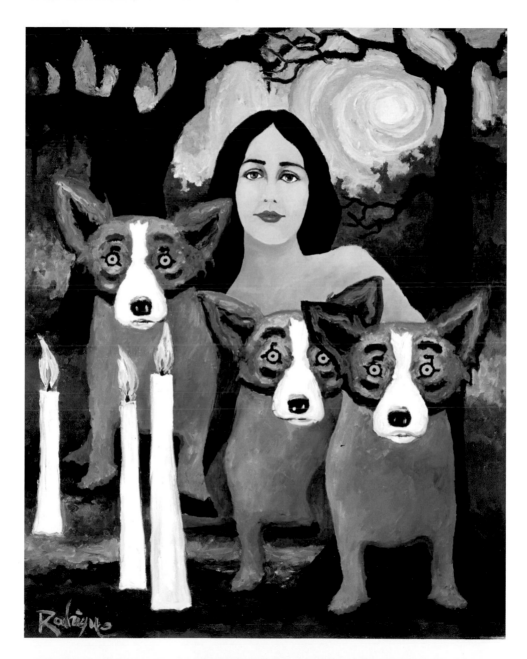

Right Place,

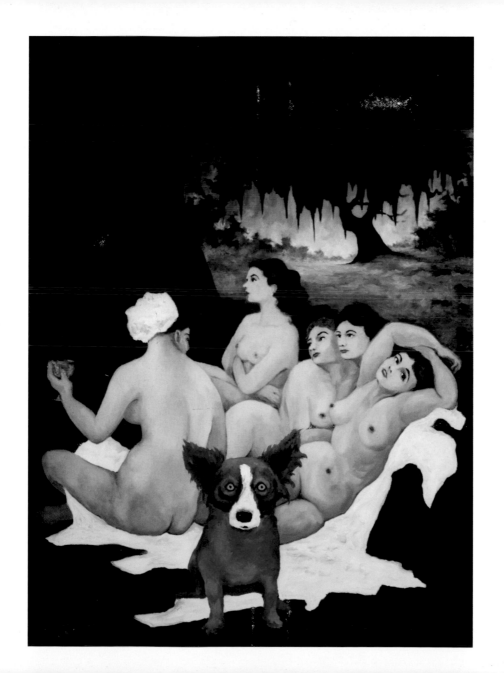

Another

Dangerous
Woman

Crept

into

My Life

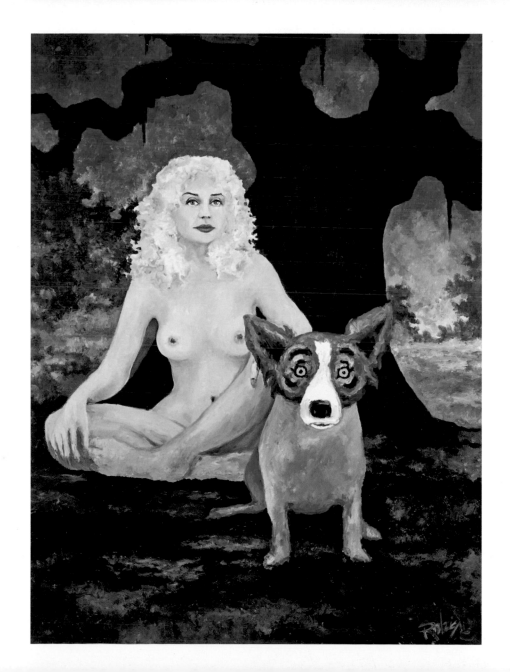

325

She

Never

Saw

Me

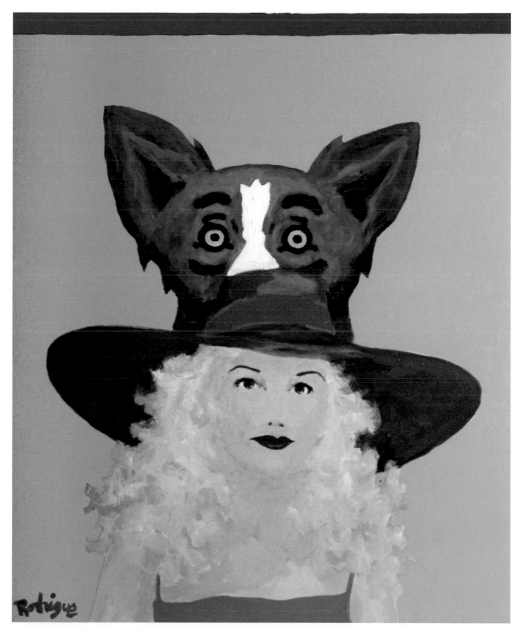

Jolie Blonde

on My Mind

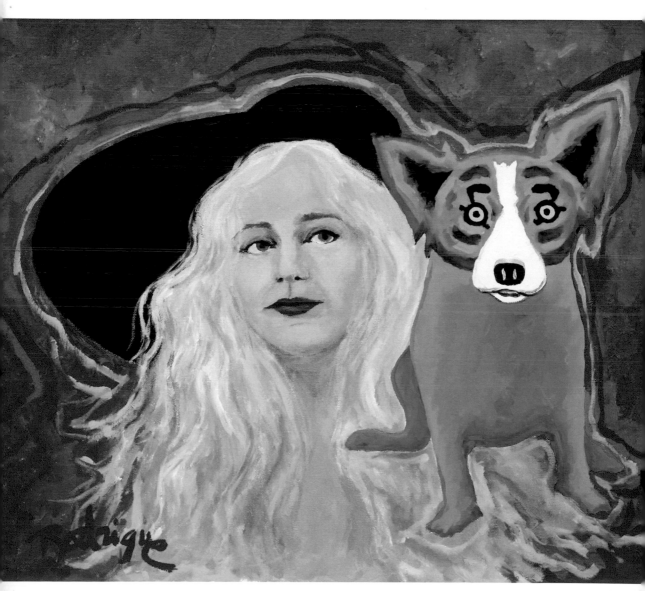

Here We Go Again, She's Got on Her Mind

Again

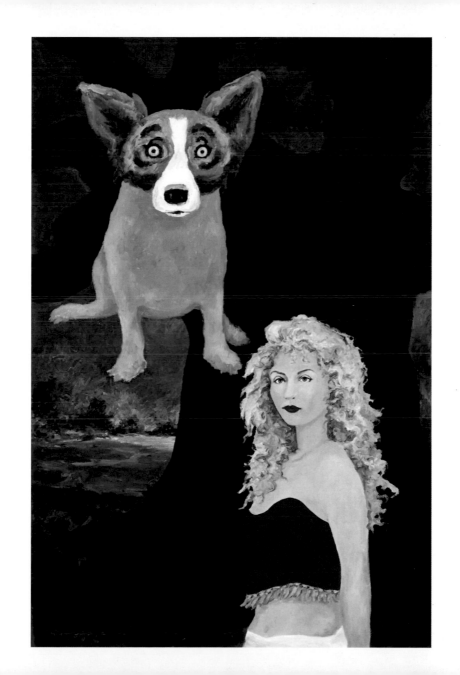

Jolie
in the
Middle

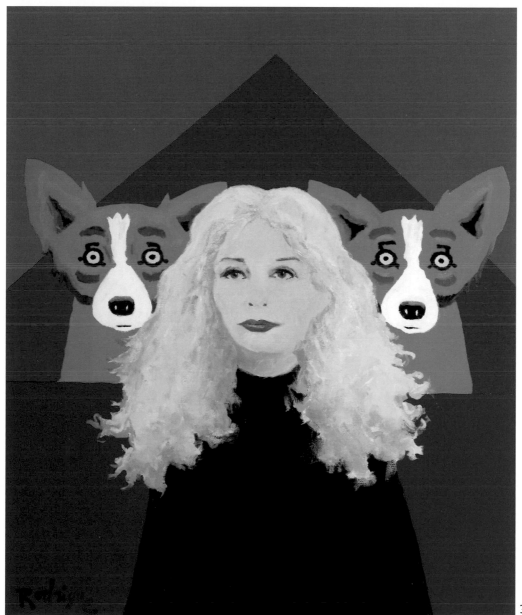

333

Multiplicity

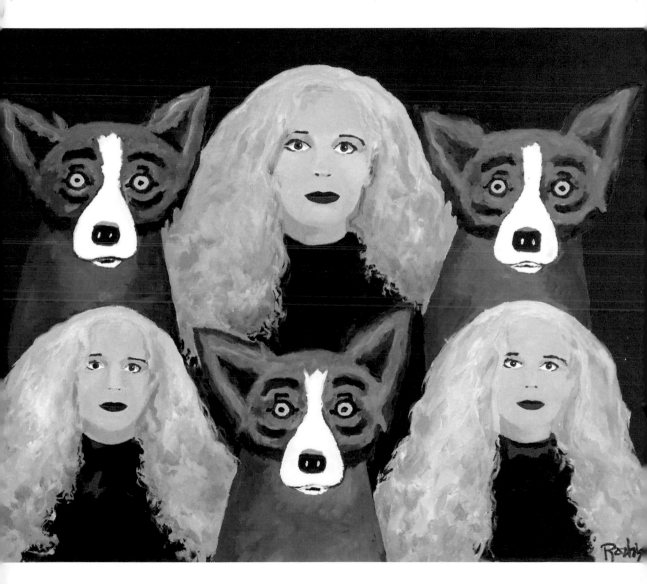

Your Daughter's a Cowgirl

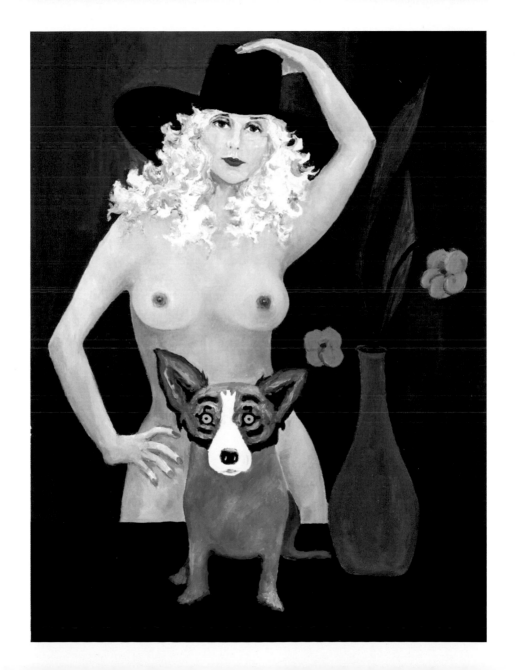

337

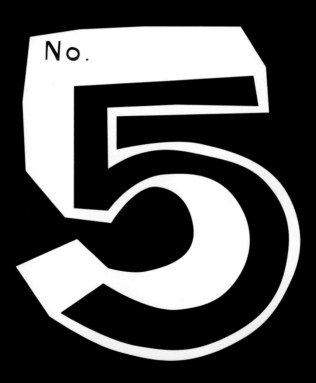

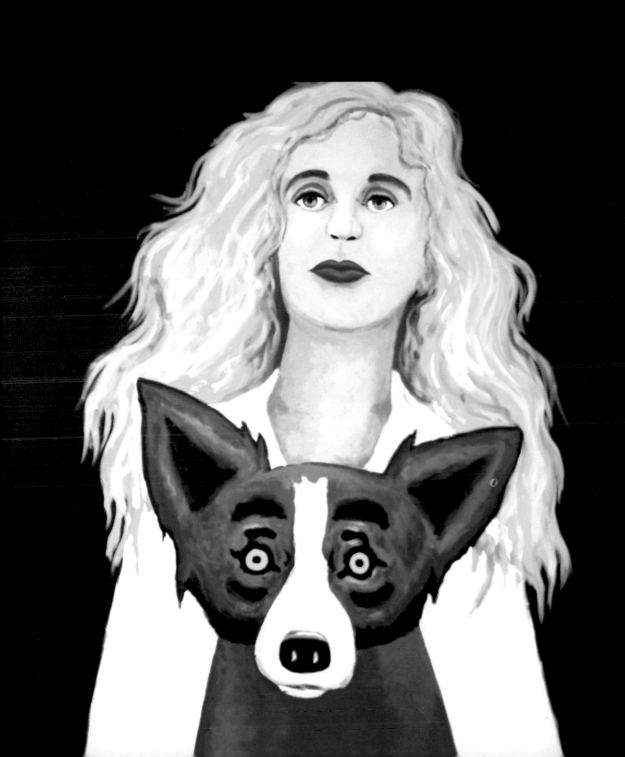

Peroxide Blues

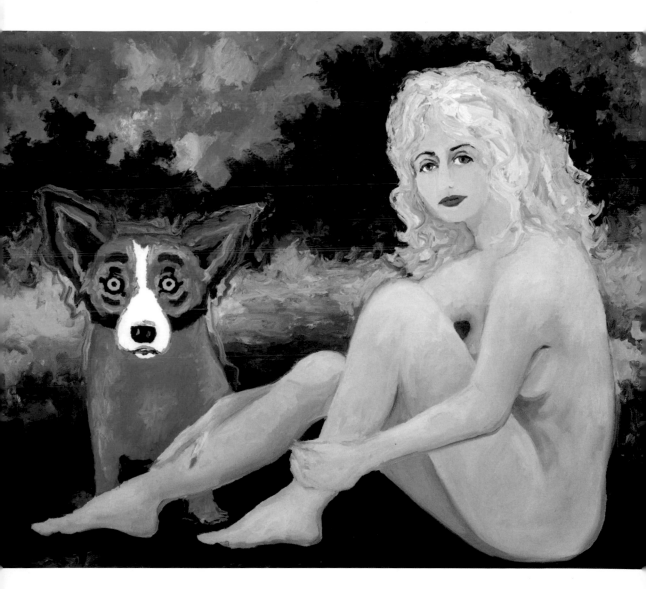

341

Wendy and Me

(The Invitation)

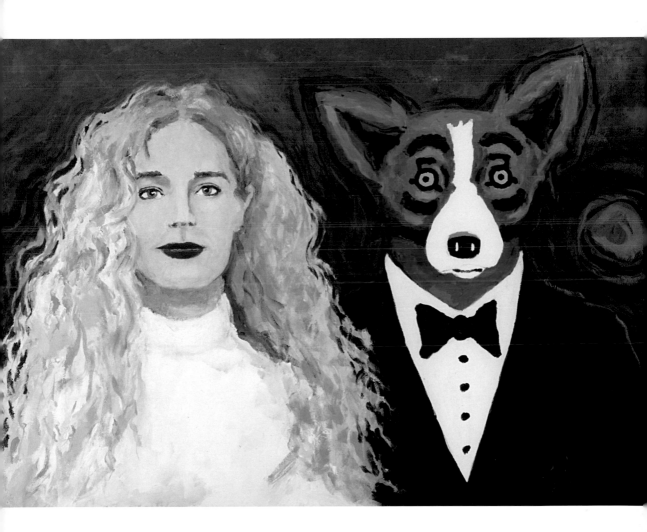

343

The Finish Line

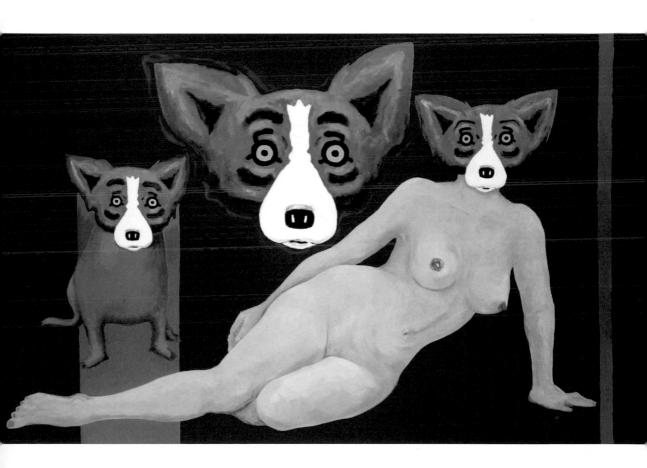

345

8

A

Dog of a

Different

Color

Lipstick on My Collar

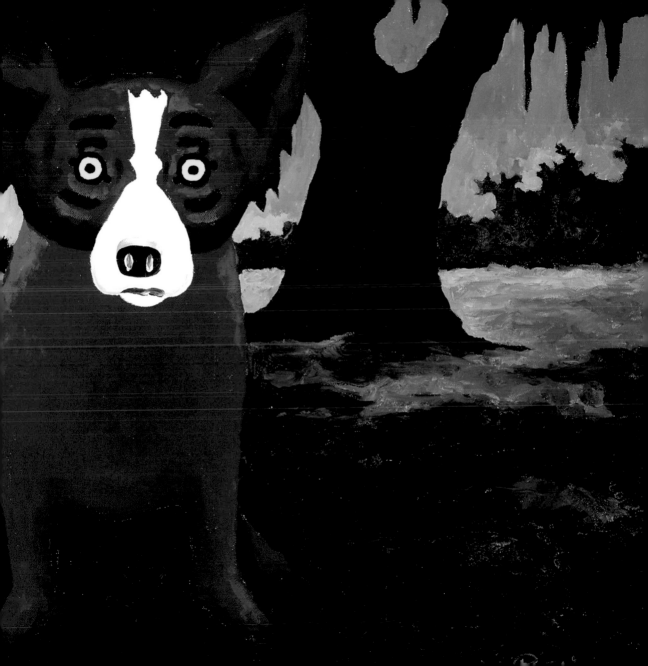

You Never Know Who

or What

Is Coming

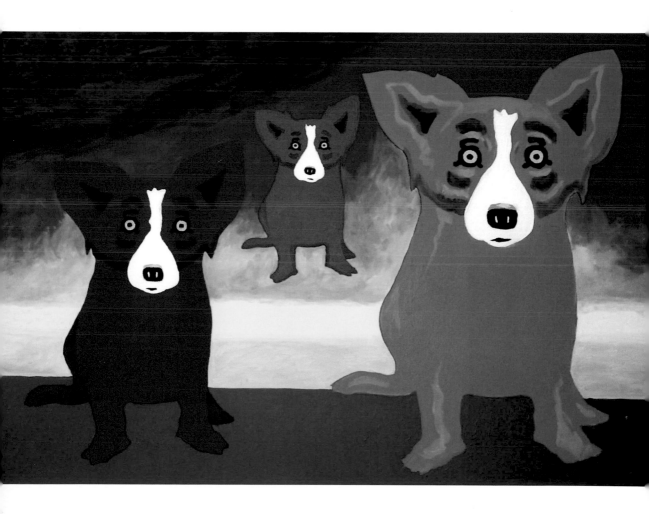

349

The **Blues** Can Hide

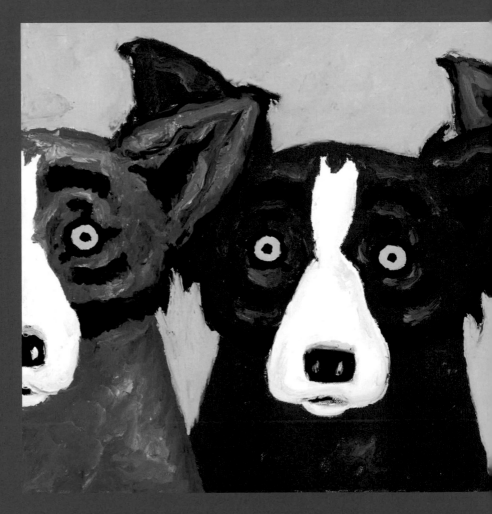

a Bad Apple

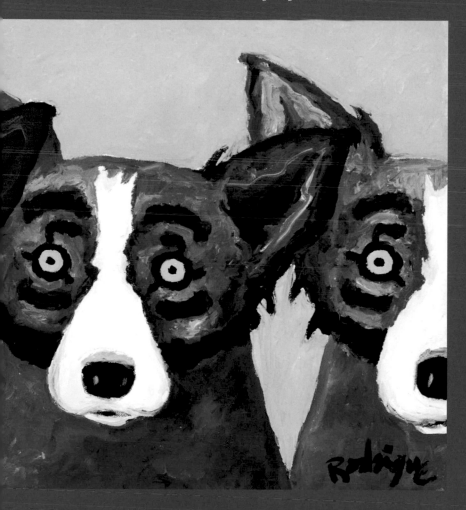

Identical Twins

Identical Twins

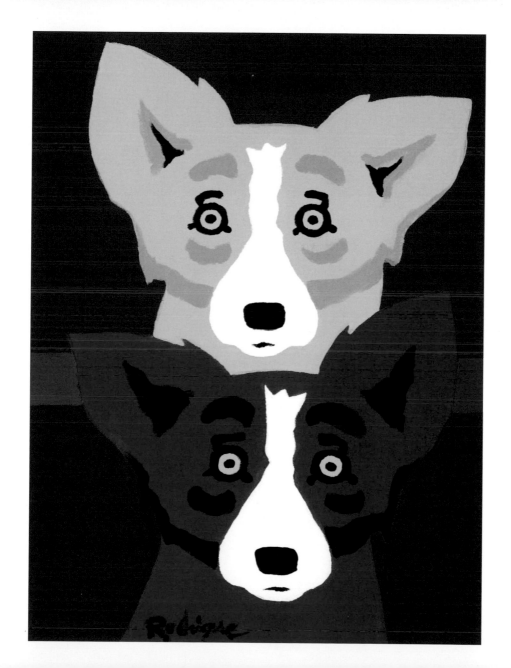

My

GOLD

Pet

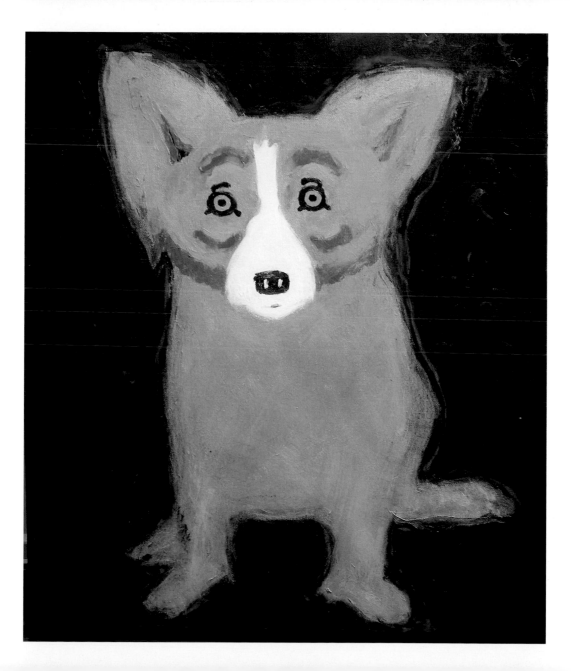

Gold shoes

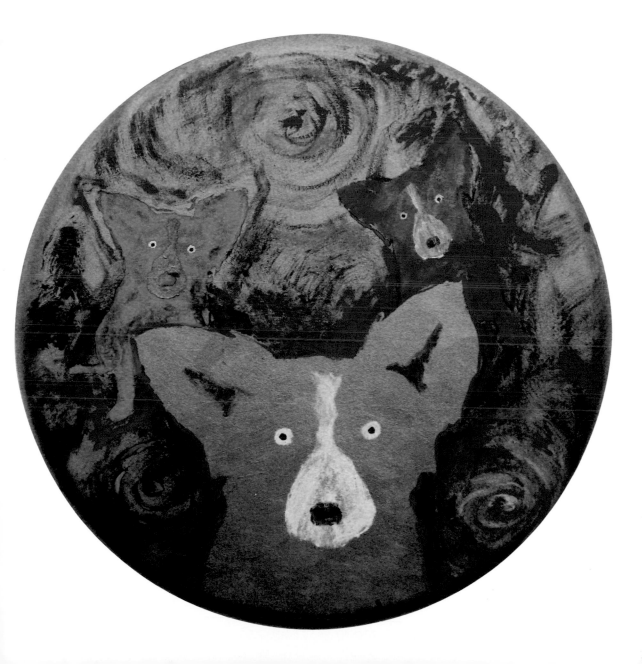

The Andrew
Sisters

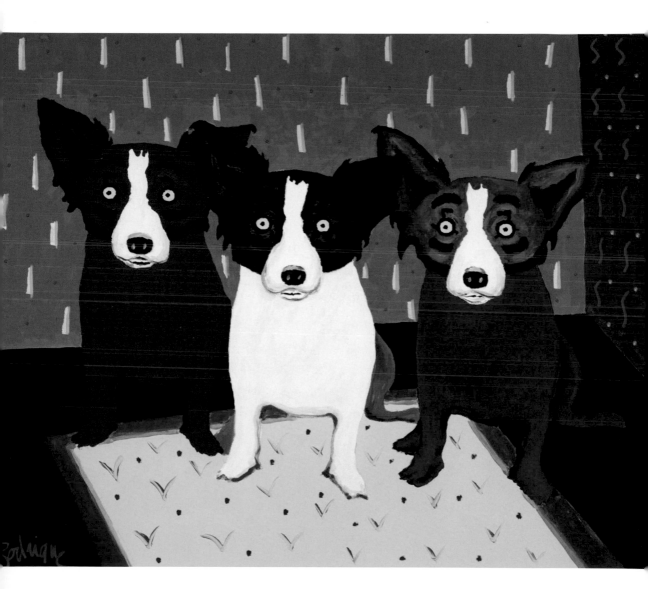

359

The Everly Brothers

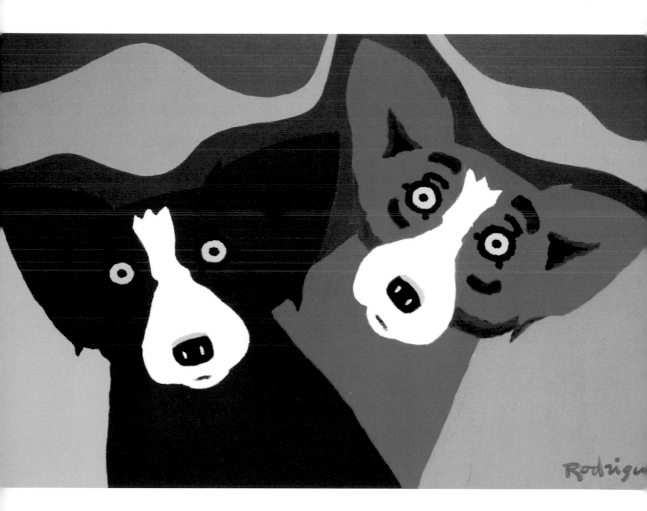

Three

DOG

Night

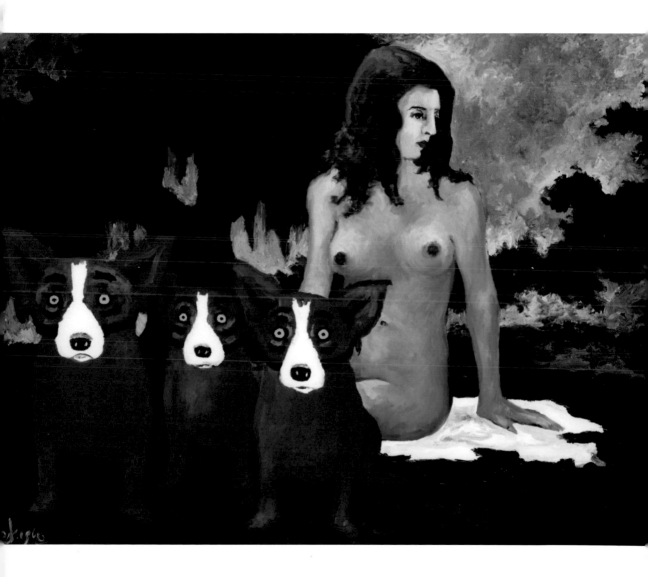

363

Sun Kiss and the Orange Peels

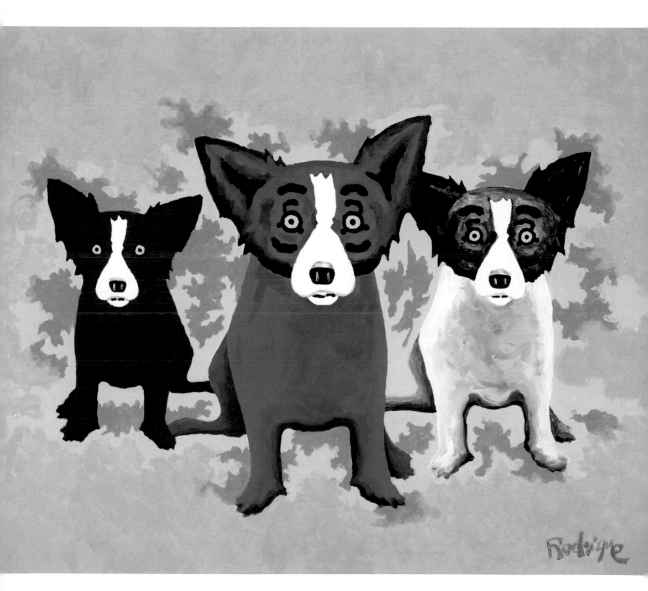

Gold

Blues

Me

Away

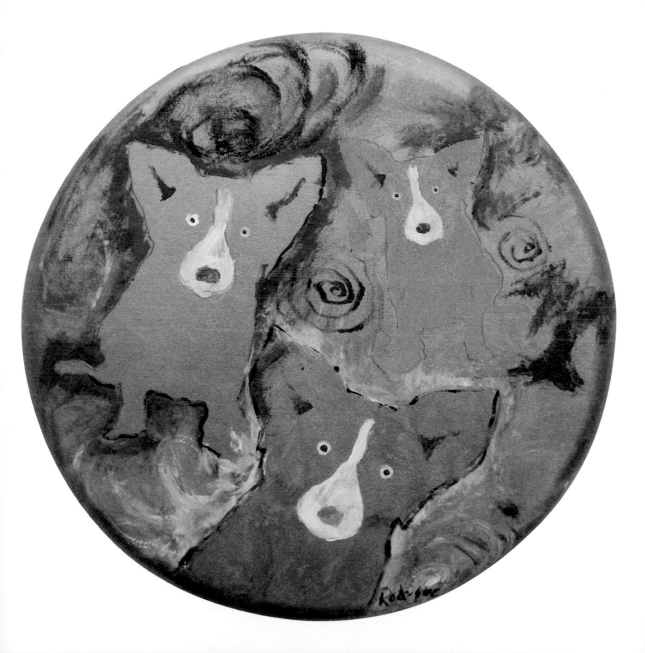

Stars

Out

Hang

Together

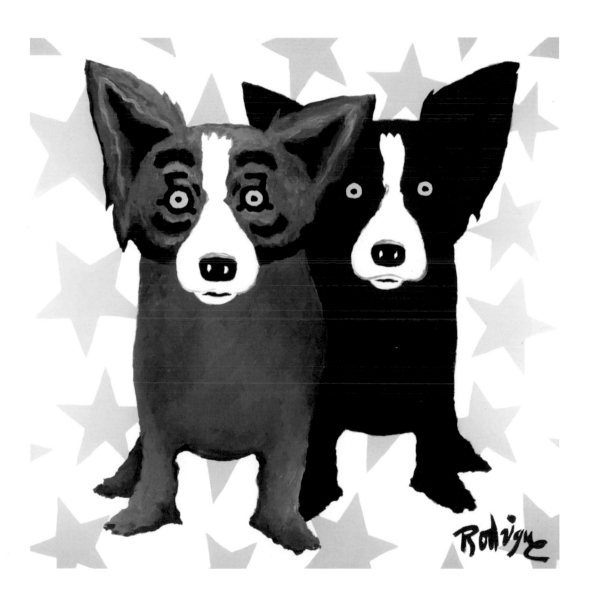

369

Boiling My Blues Away

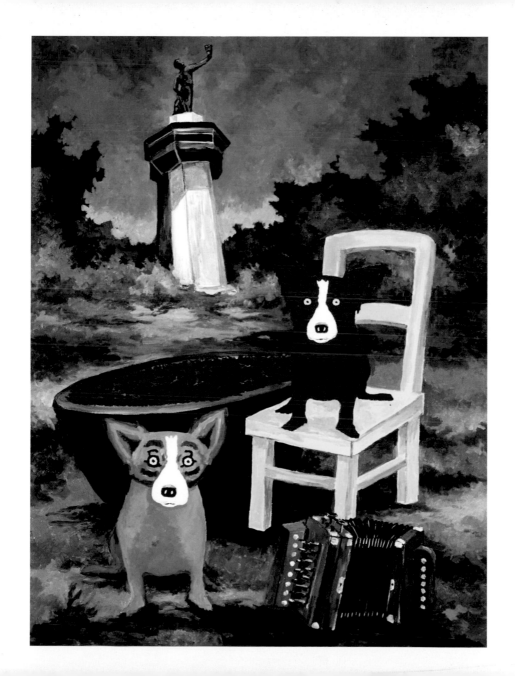

371

The Birthday Party

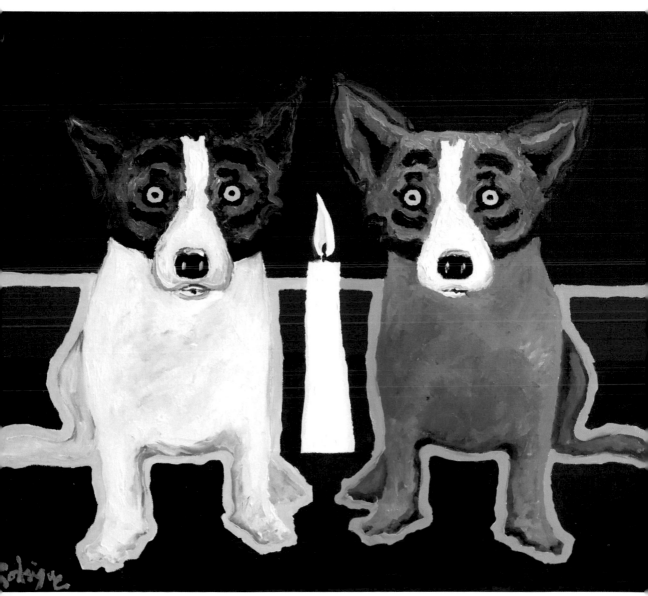

373

Islands in the Stream

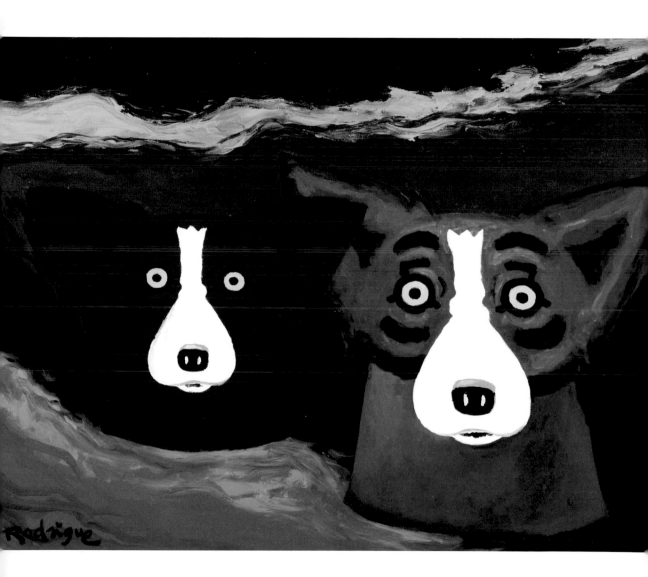

375

WHEEL OF FORTUNE WHEEL OF FORTUNE WHEEL OF FORTUNE WHEEL OF FORTUNE

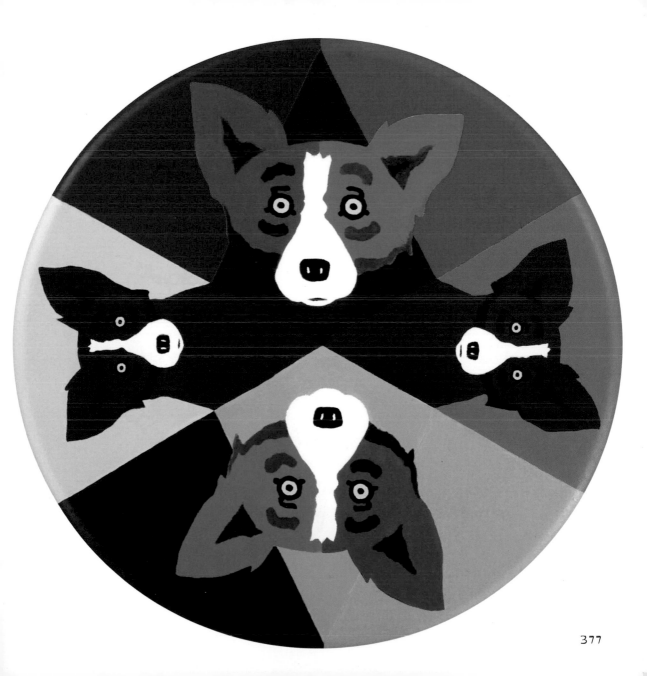

Don't

Show Me

Your

Colors

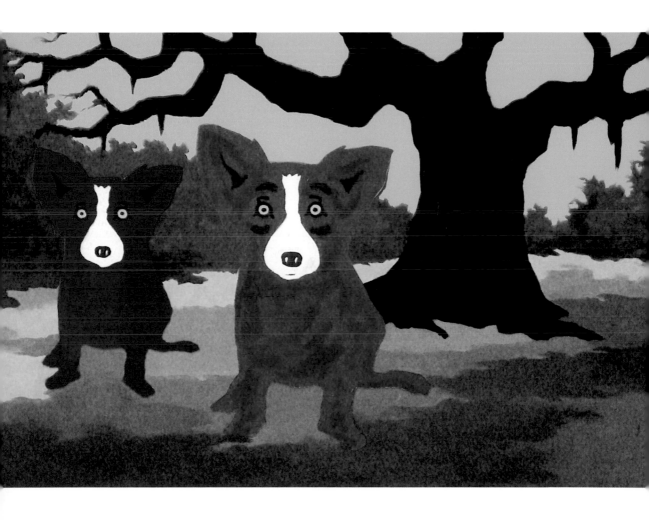

379

Stoplight

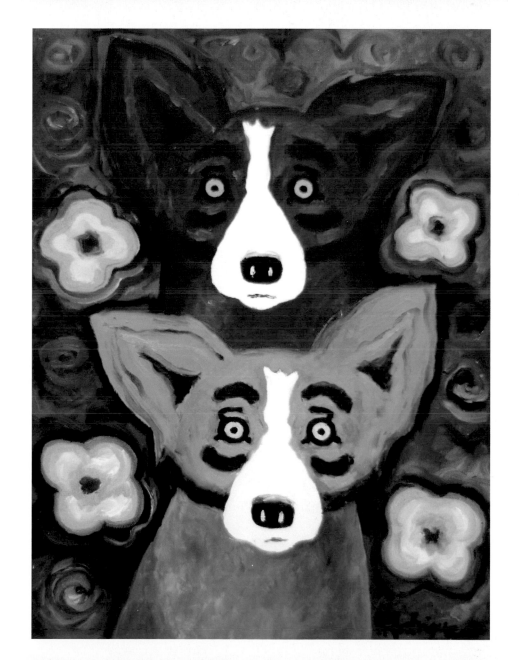

381

She

Stole

My

Burning Heart

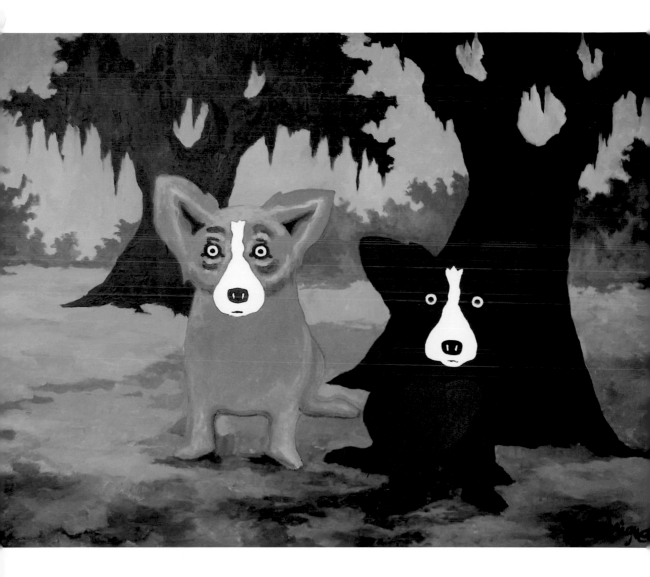

383

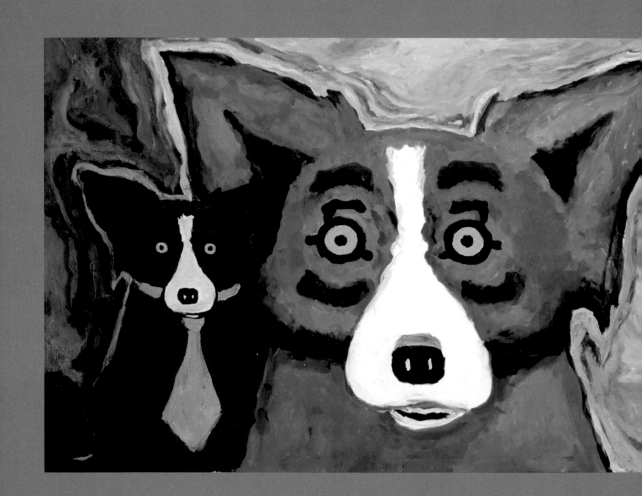

Angel on My Shoulder

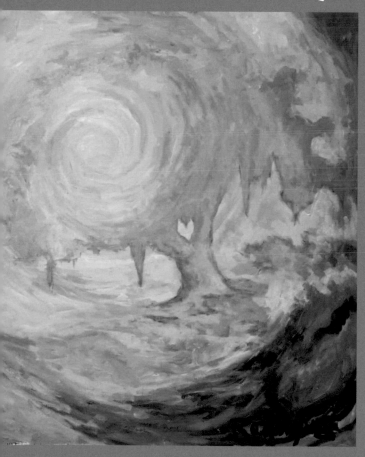

Evermore

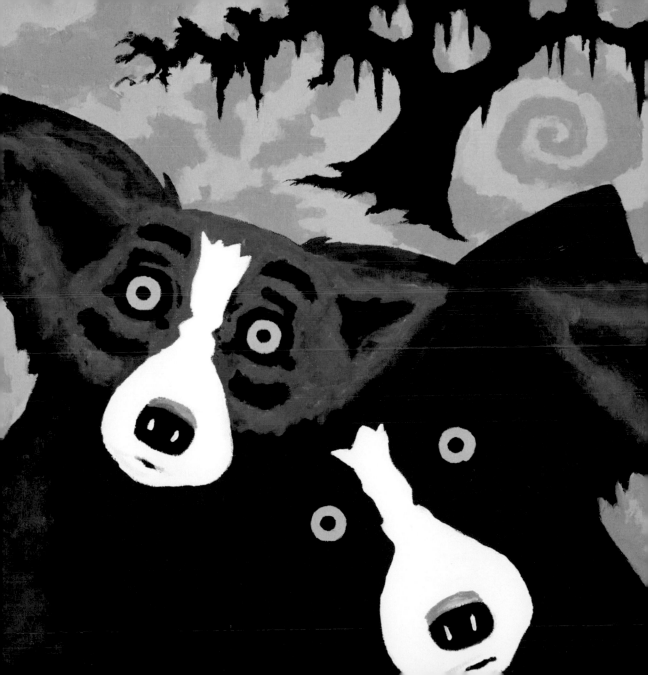

9
Masquerade

I Just Don't Wanna Be Me

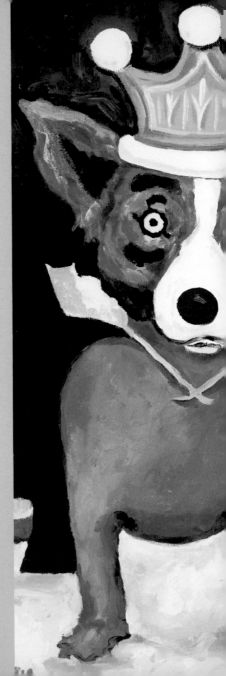

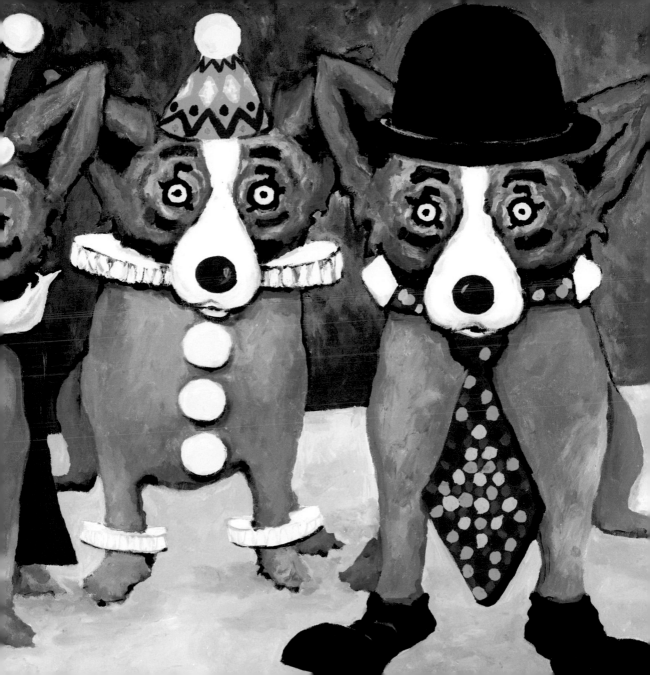

I Grew Up a

C o w b
o

y

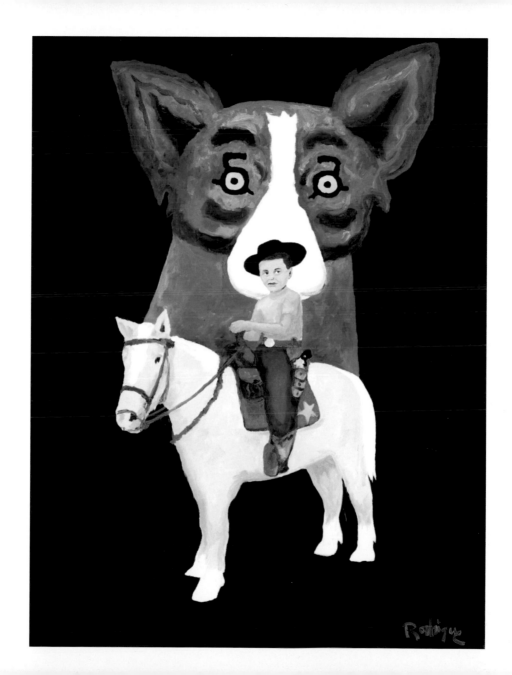

They All

Ask

for

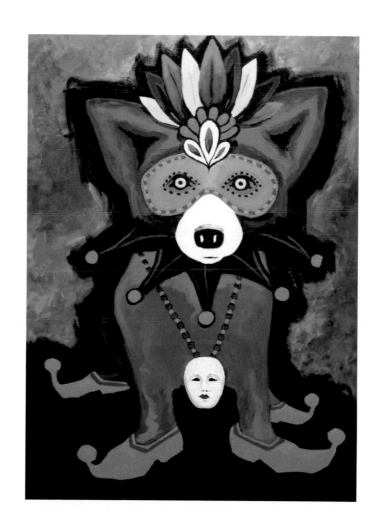

BIG TOP DOG

(My Baby Made a Clown Out of Me)

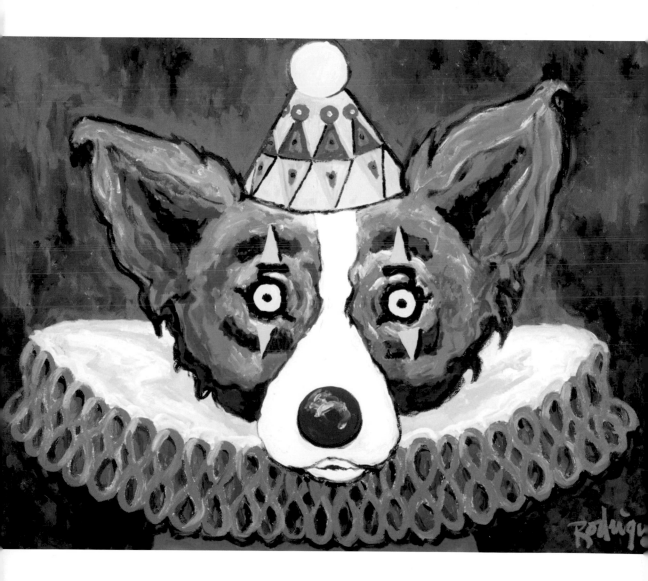

395

High

I Was a King in Places

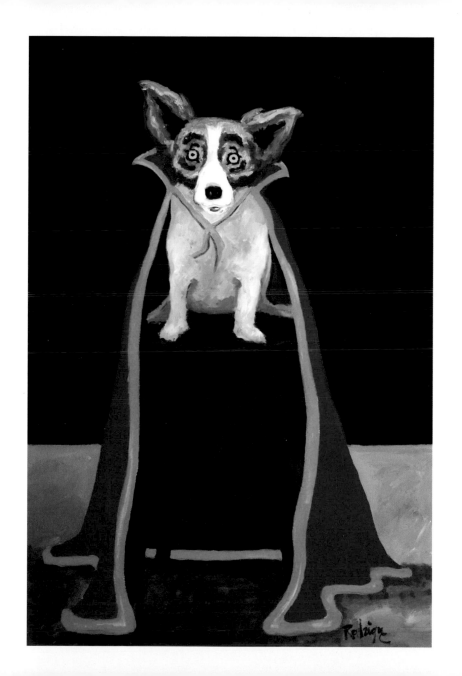

Jester

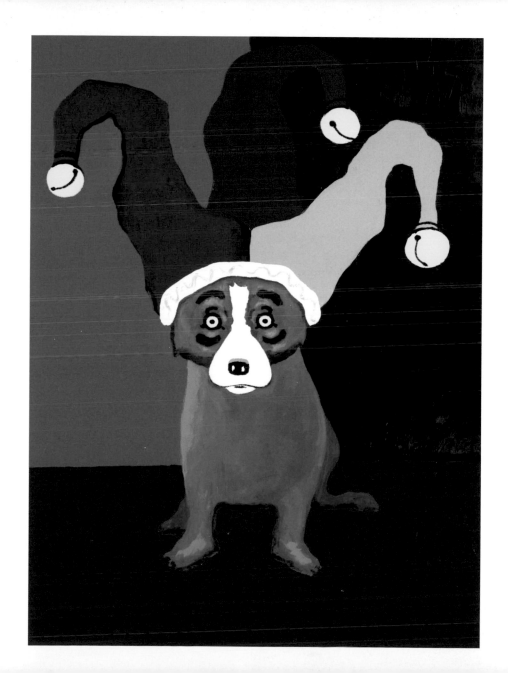

399

My

Hero,

Count

Dogula

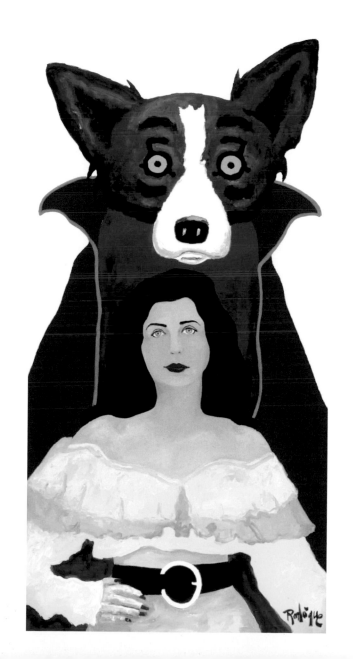

401

Justice

Power

and

Faith

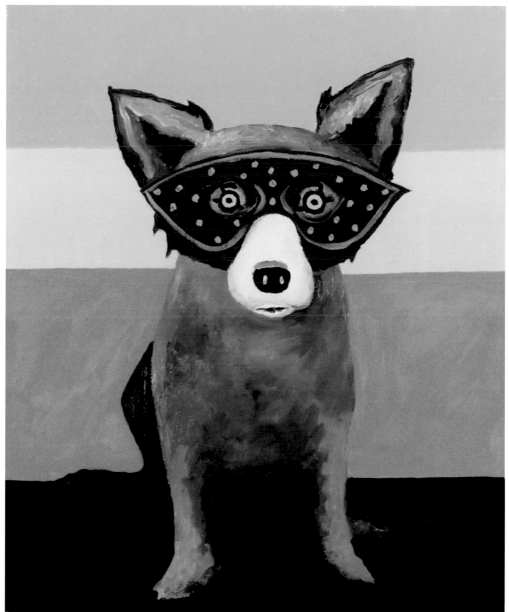

403

Phantom

Dog

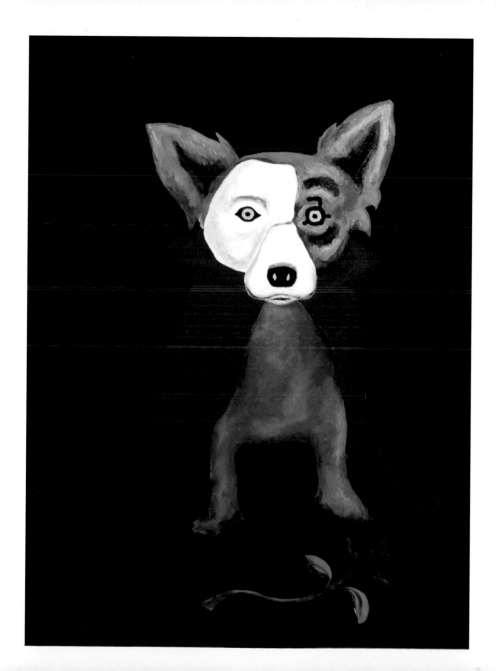

405

Mardi Gras

Dog

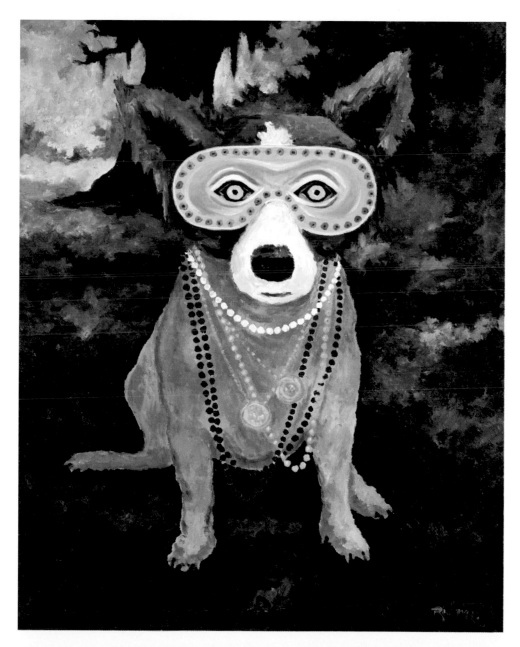

407

Now You
See It,
Now You Don't

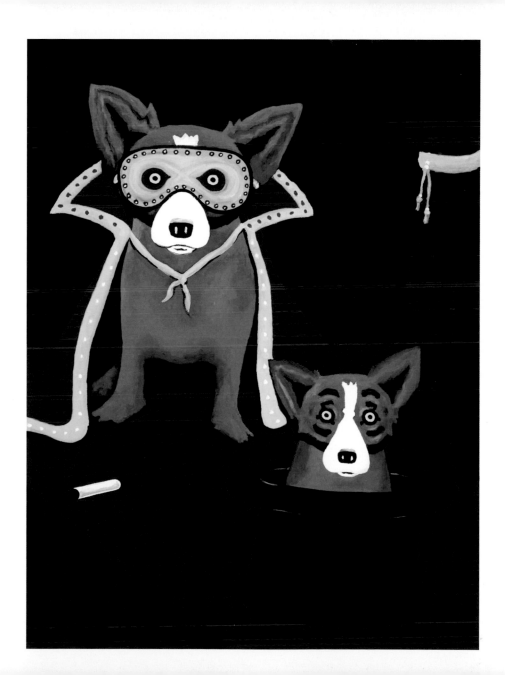

409

10
At Home
with the
Blues

When My Baby Left Me,
All She Left Me Was My Blue Suede Shoes

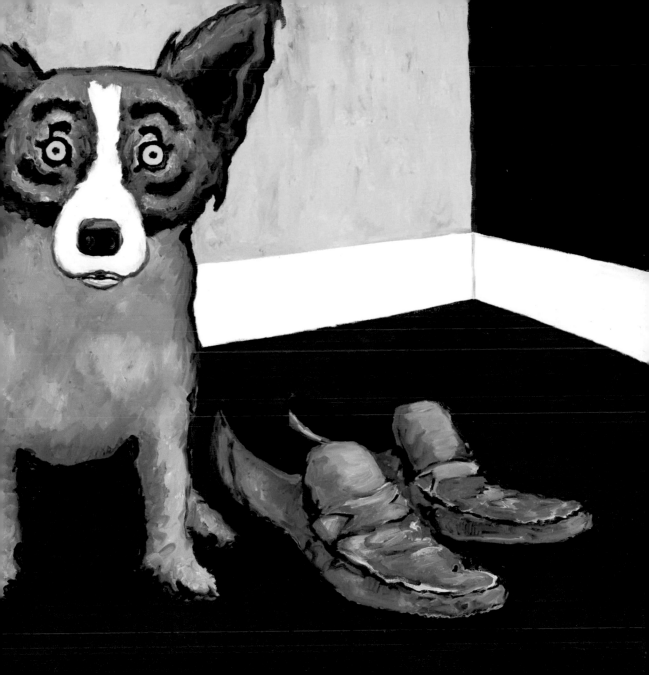

I Proved My Love
for You with
Credit Cards,

But You Were Only
Window-shopping

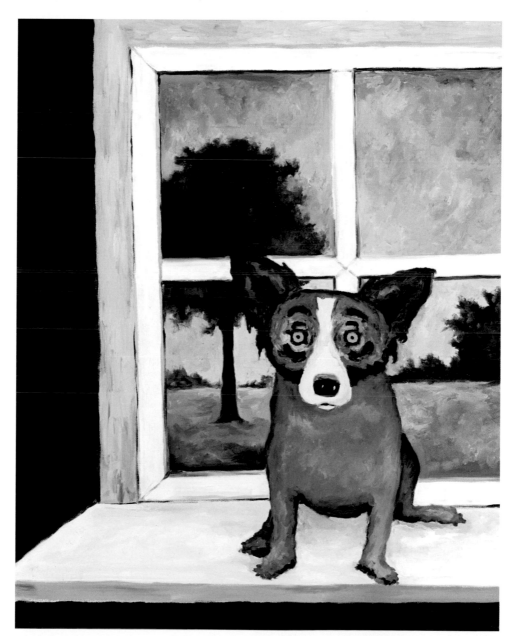

Hiding

from the

Blues

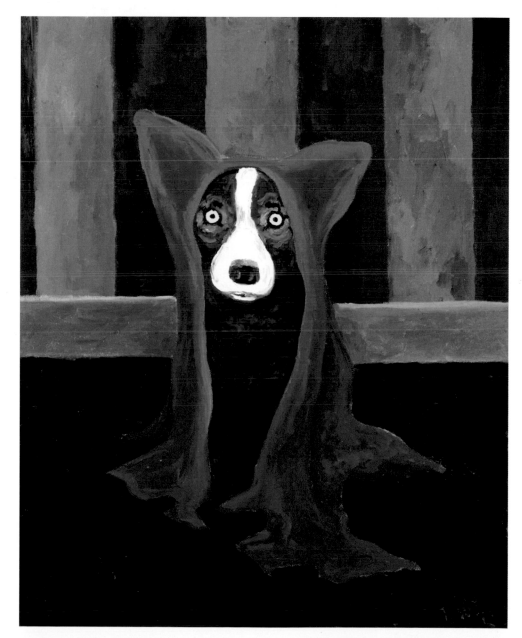

415

I'm Just Another Memory on Your Nightstand

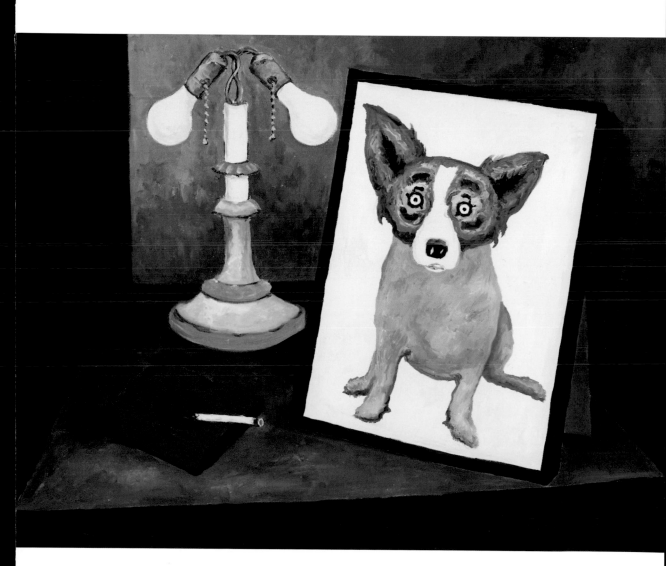

A

Smarter

Breed

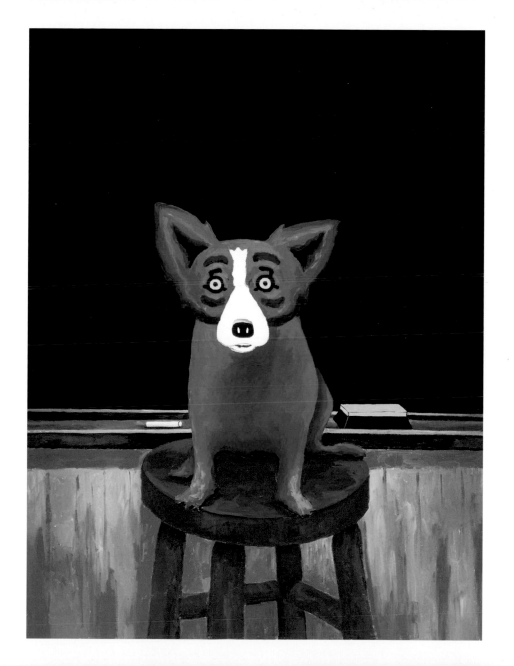

419

I Once
Debated
Nixon

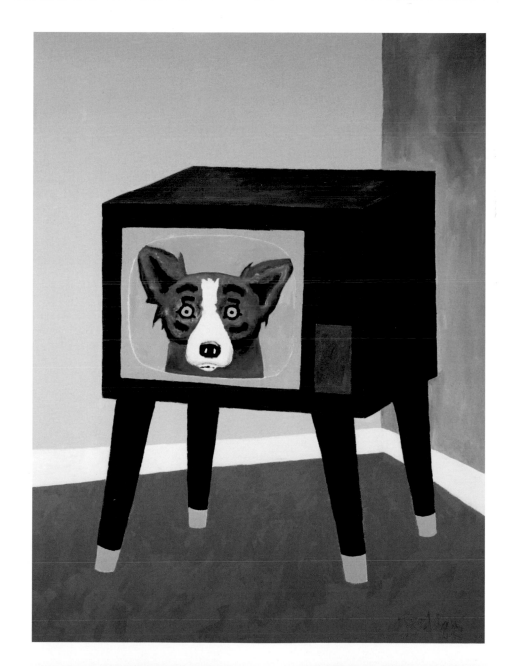

421

TWO
SHOES

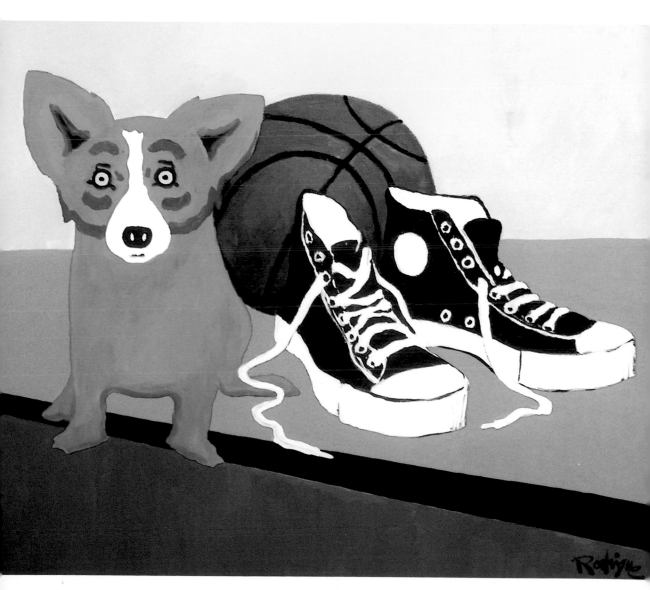

423

My
Yellow
Chair

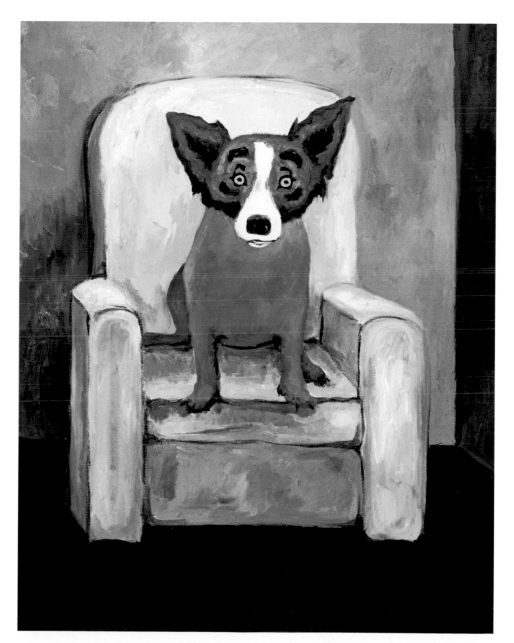

PC
Blues

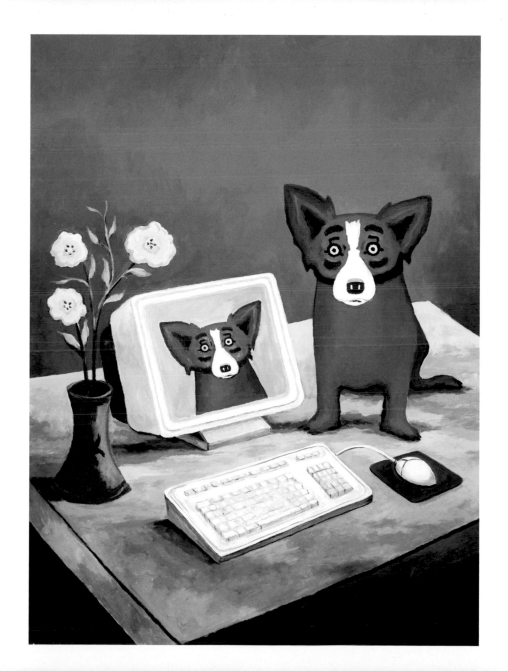

427

11

On the Road

Breaux Bridge Shoefly

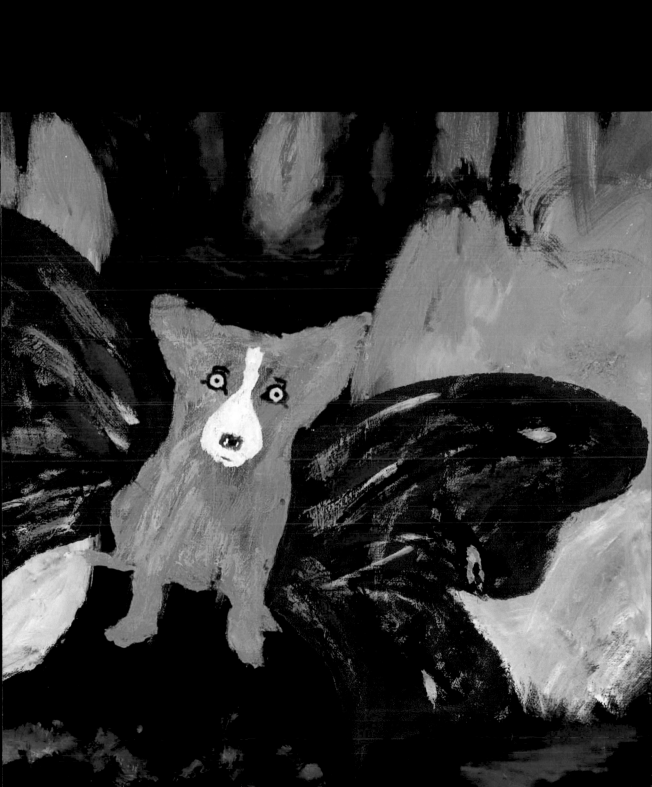

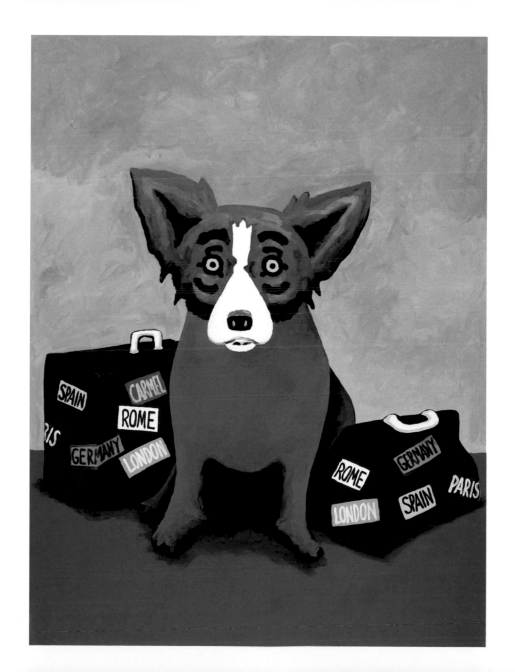

431

On the Road Again

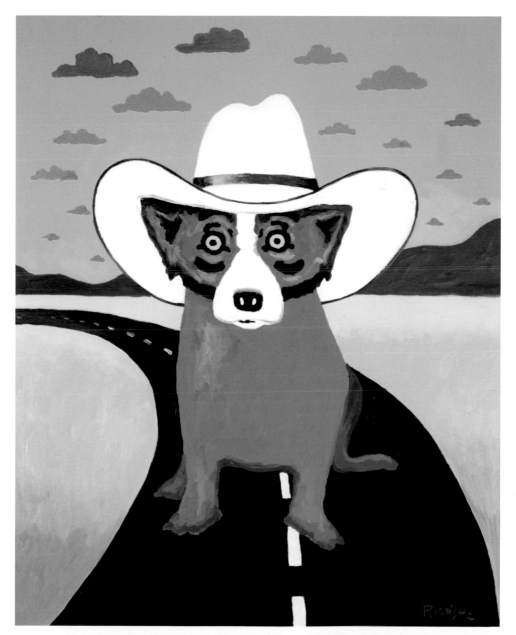

433

The Free Life

(A Faster Breed)

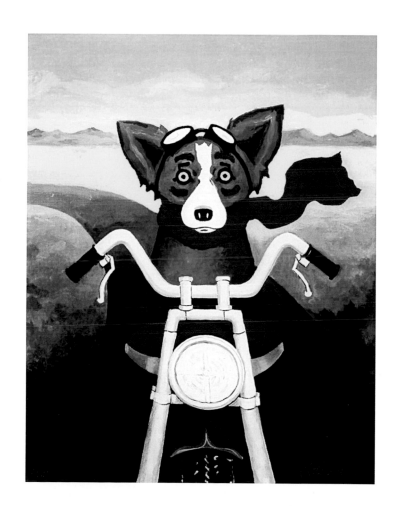

My Favorite Part
of Town

(I'm Just Waiting for My Turn)

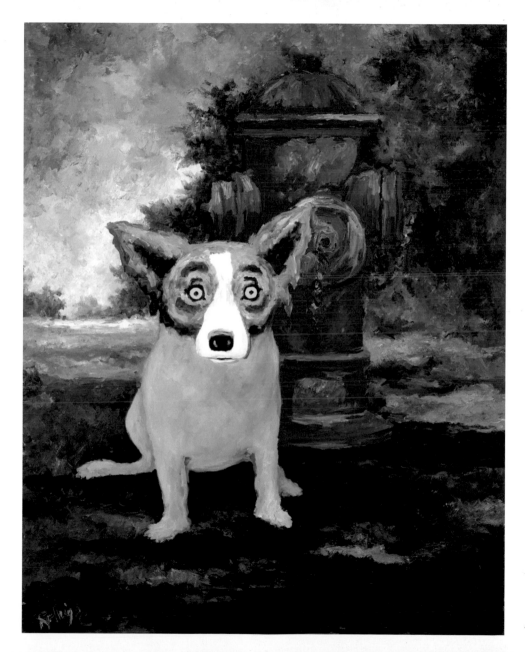

437

The High Country

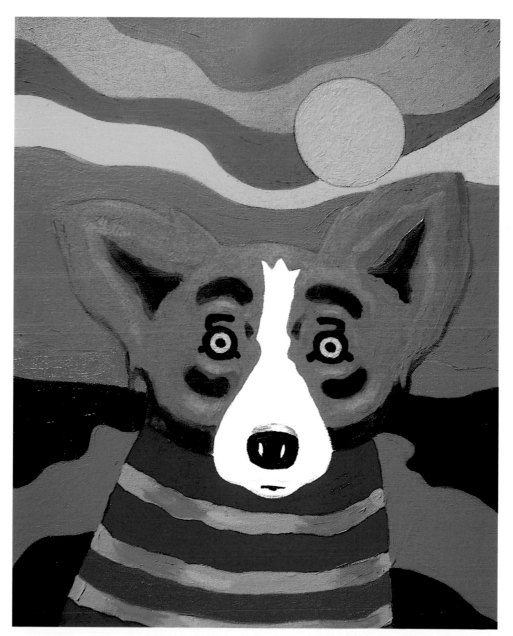

439

Guess Who's Coming to Dinner

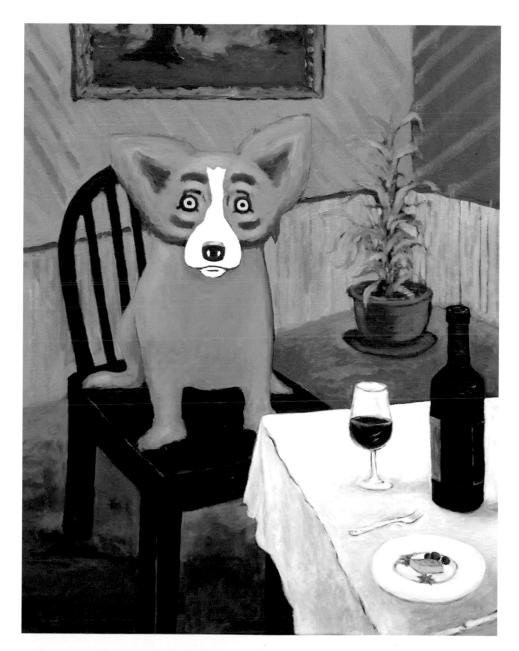

441

Jackpot

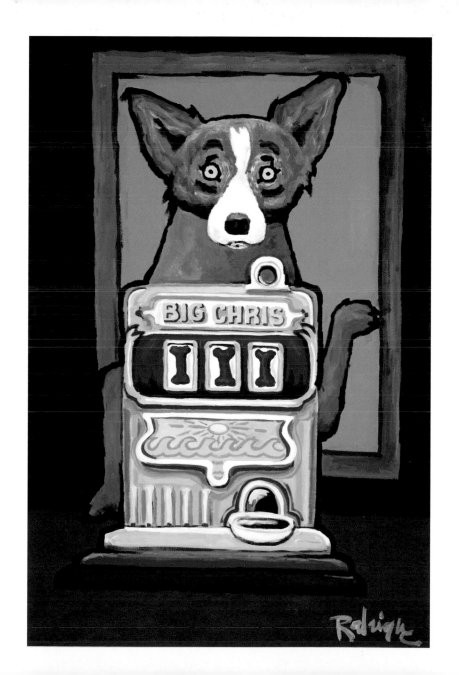

443

The Wild Blue Yonder

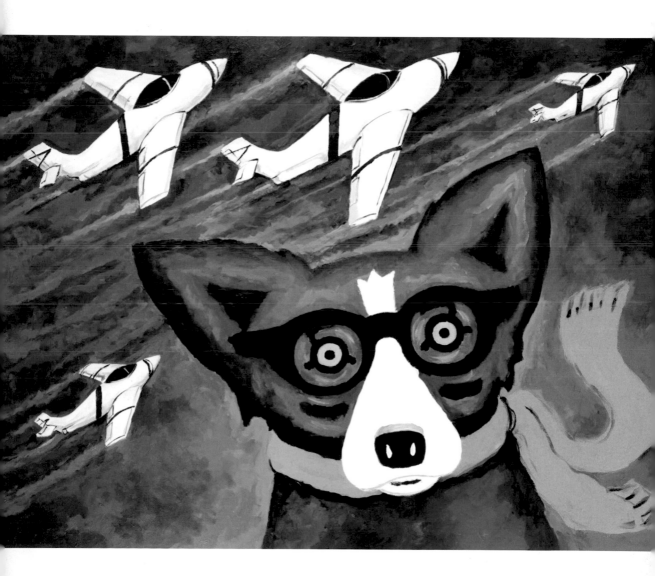

445

Life's a Blast

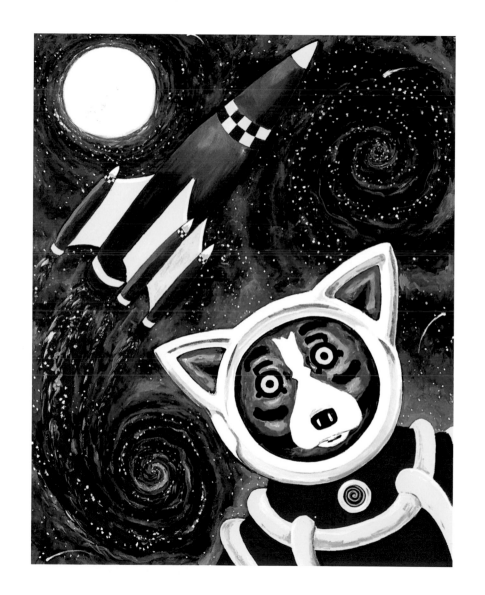

447

Star-
Hopping
(Export Business)

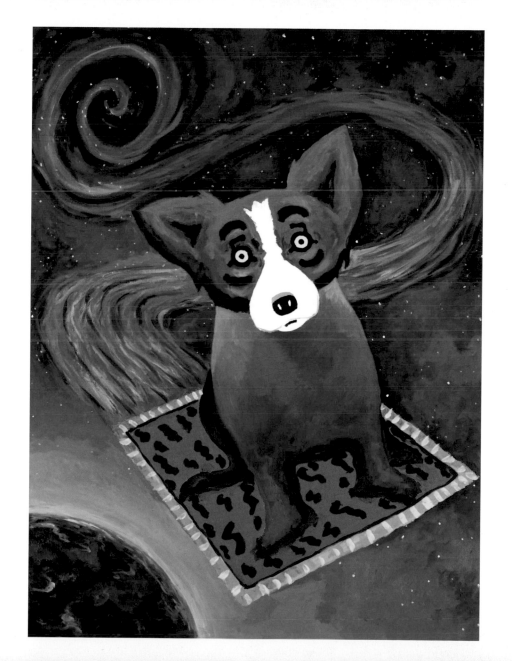

449

To Go Where No Man Has Gone Before

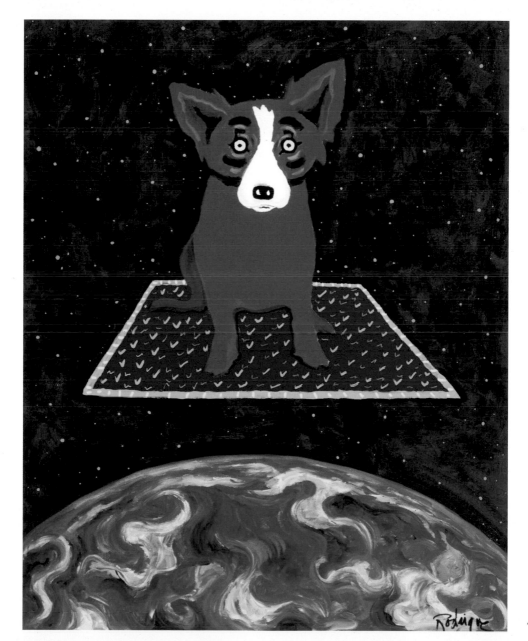

451

12

Taking Care of Business

My Blues Brothers

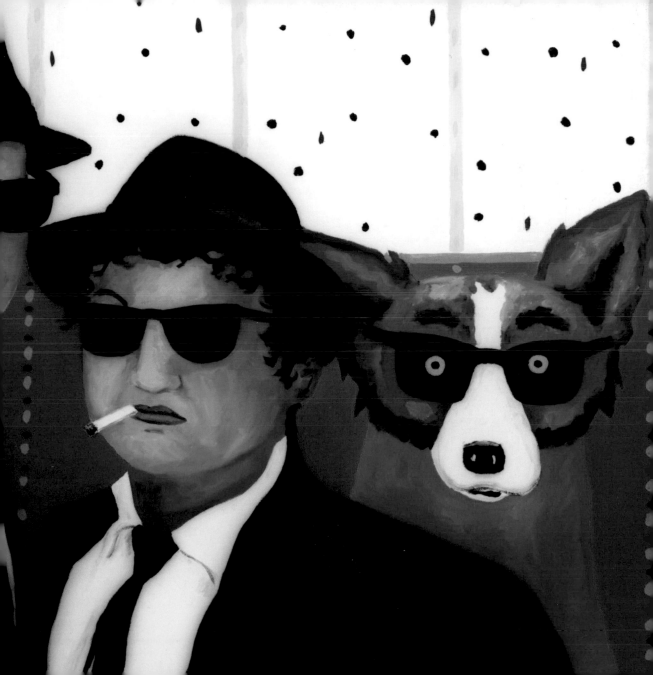

Big
Night

Tonight

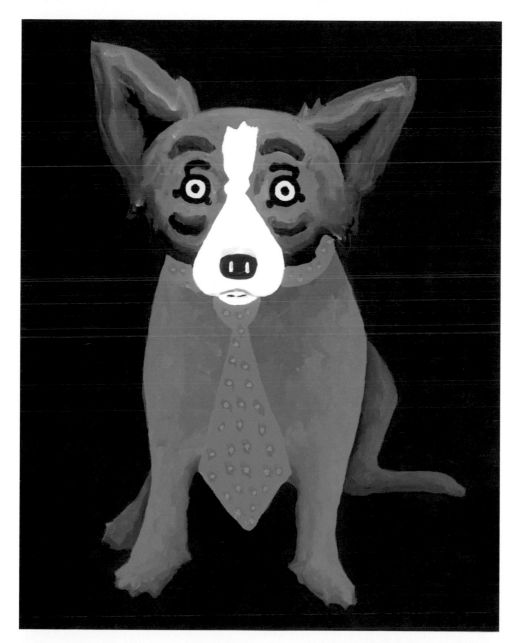

455

Hot Tubbin'

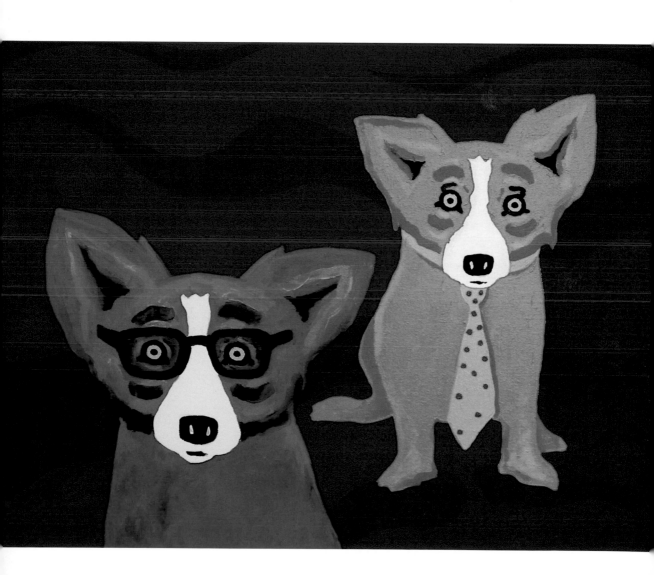

You've Got My

Heart

in Knots

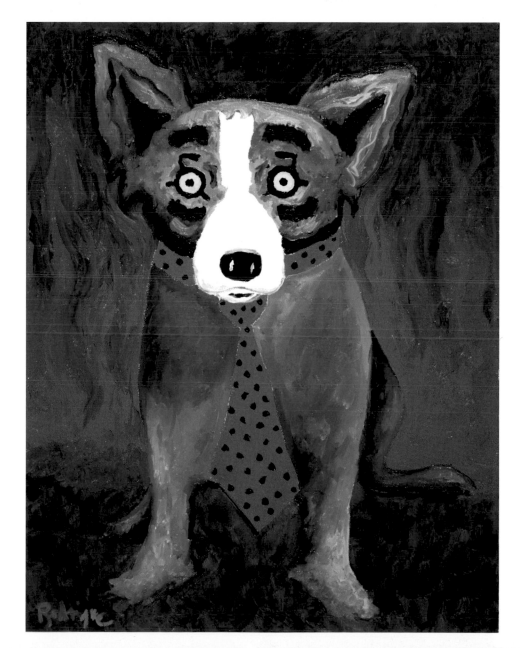

459

Can't
Tie Me
Down

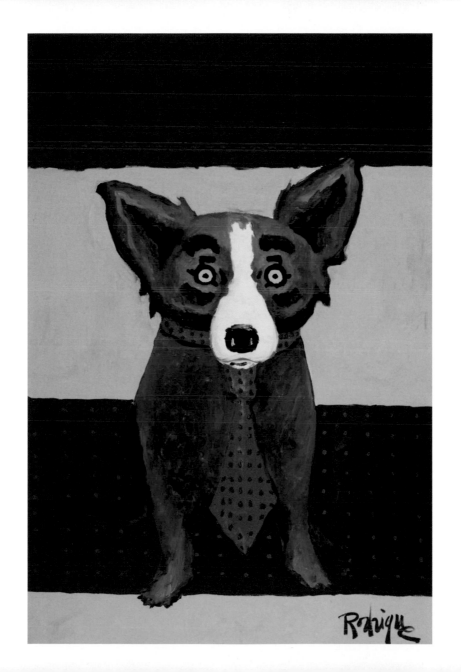

461

Don't

Tie

Me

Down

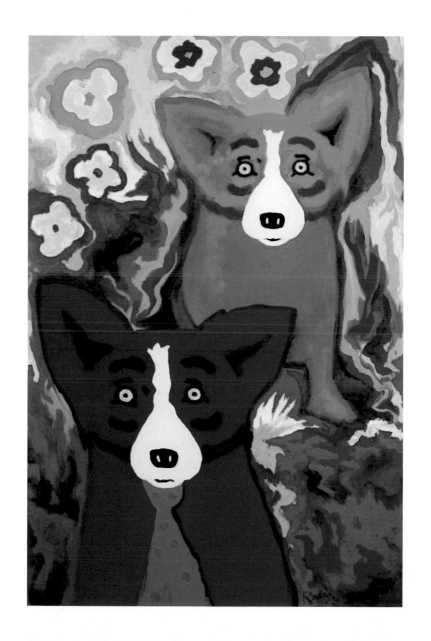

463

I Ain't No Cartoon Dog

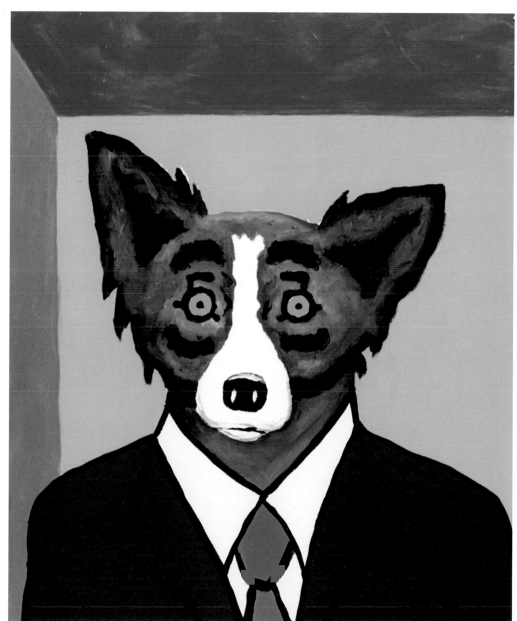

465

Secret

Service

Dog

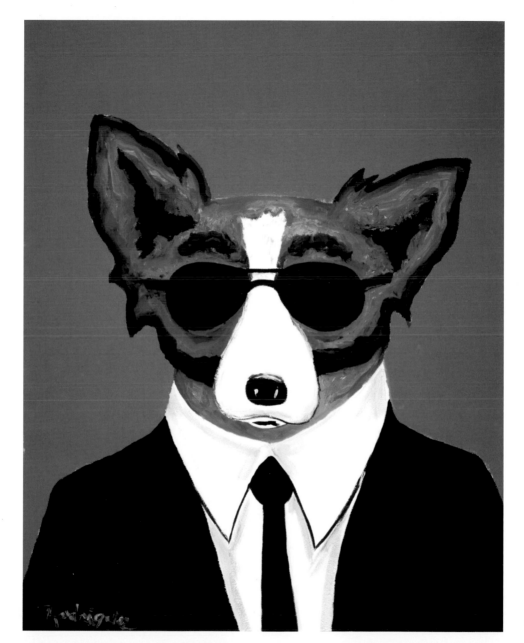

467

Yuppie
Puppy

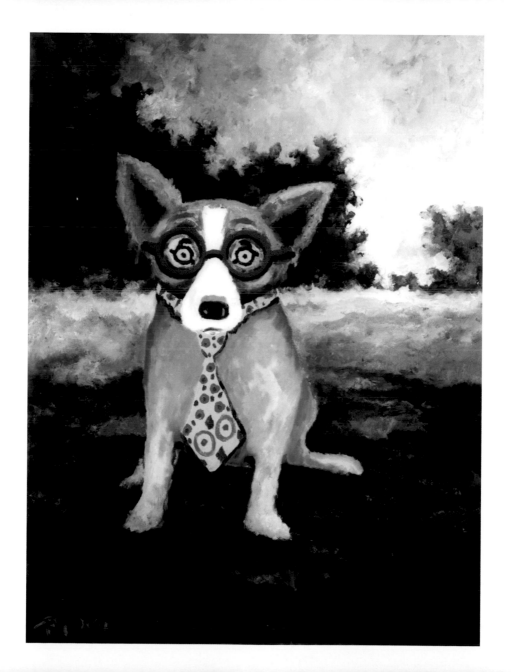

469

Wall

Street

Blues

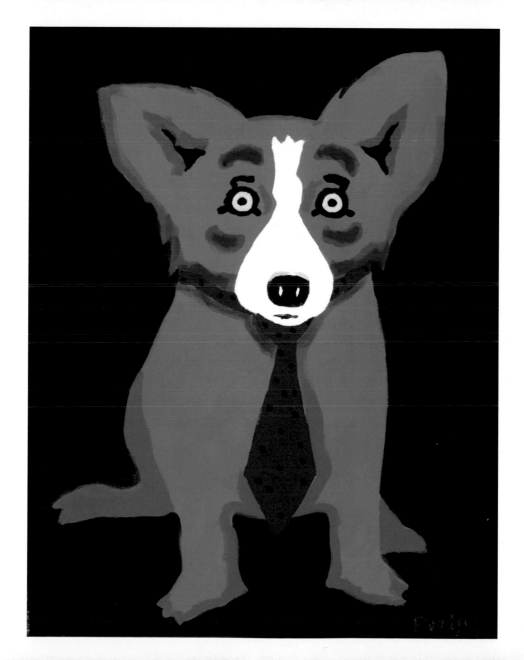

We Make Money

the Old-

Fashioned

Way

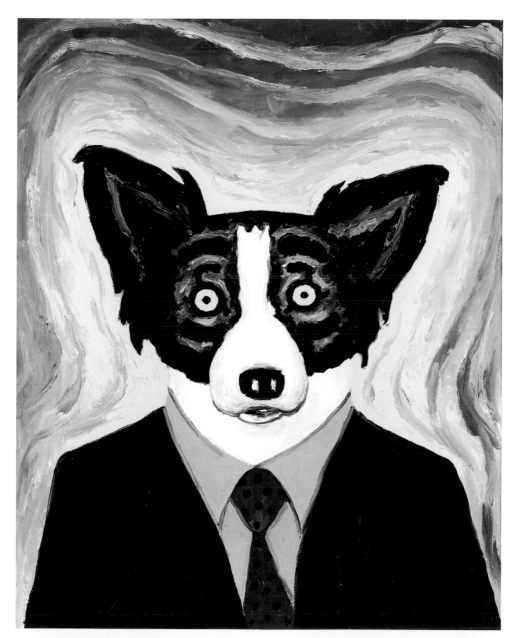

473

13
Hurricane

You Can't Drown the Blues

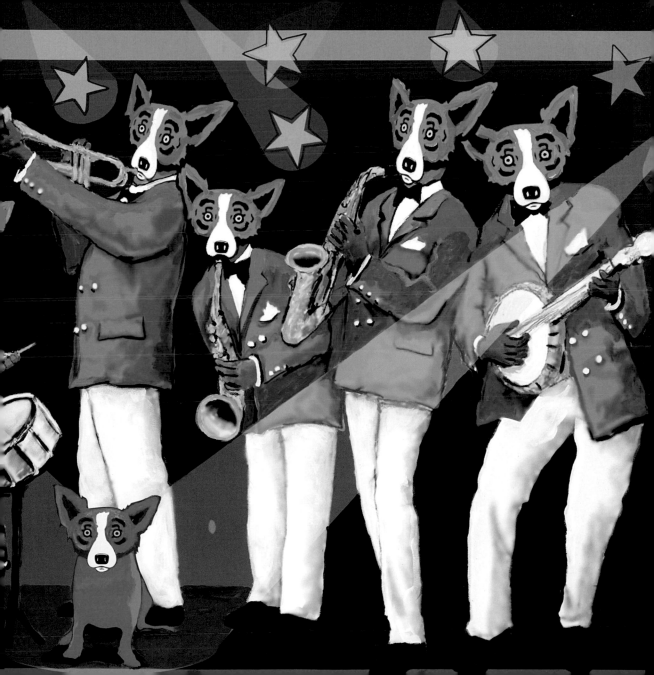

We Will Rise Again

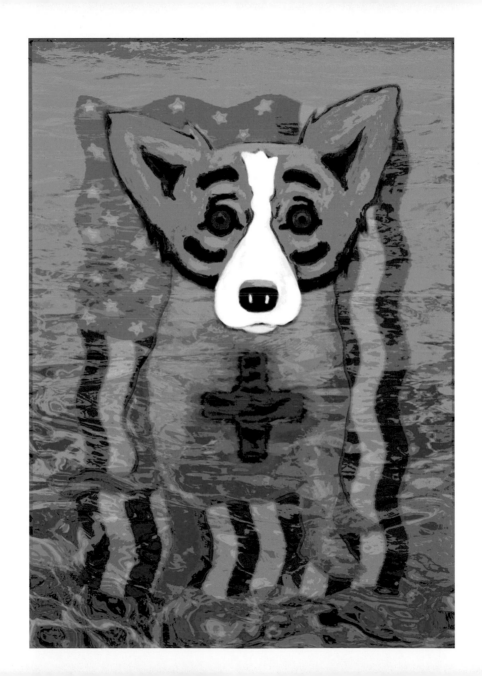

477

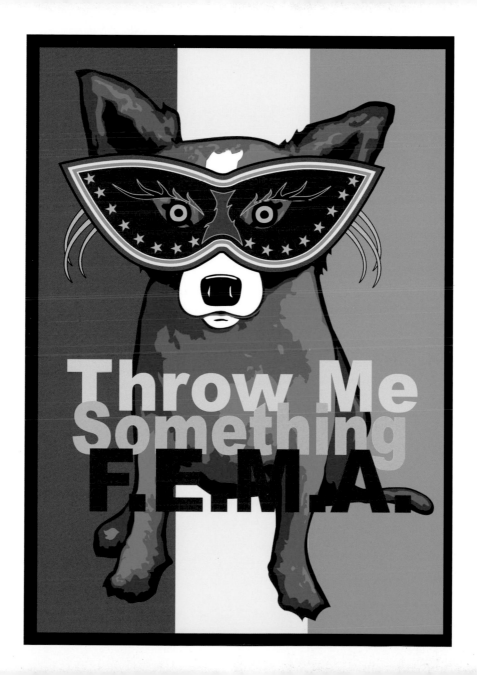

479

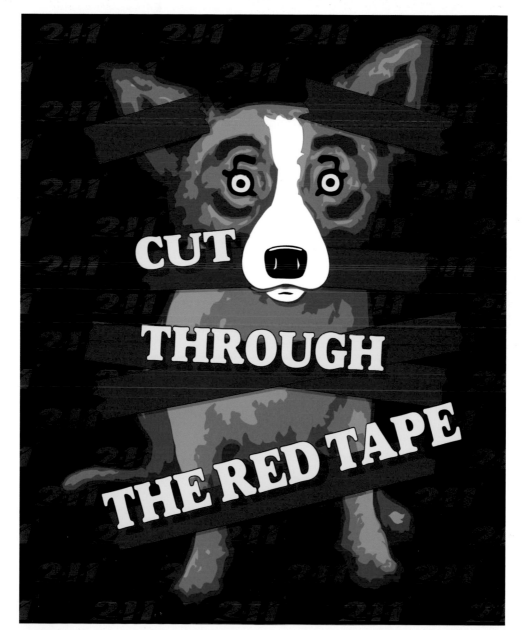

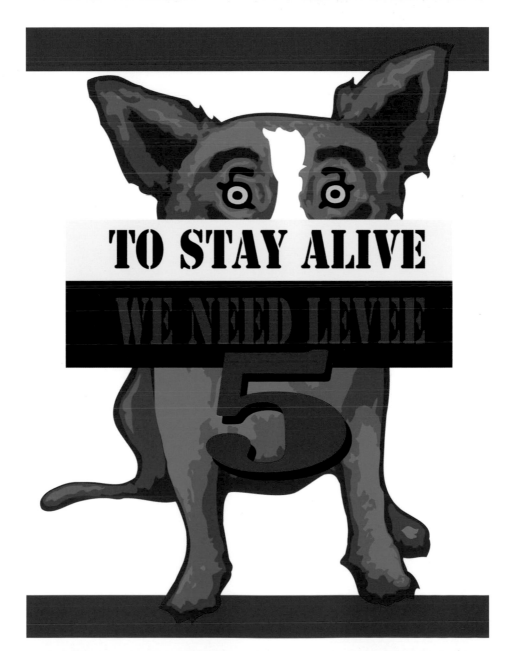

We Are Marching Again

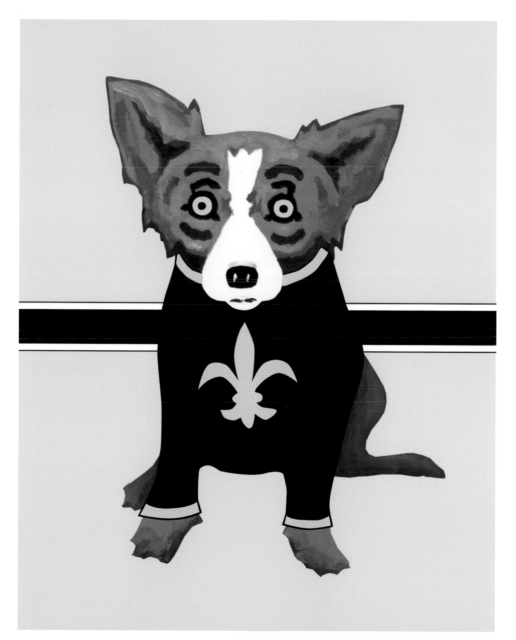

485

14
Red, White, and Blue

Paul Revere

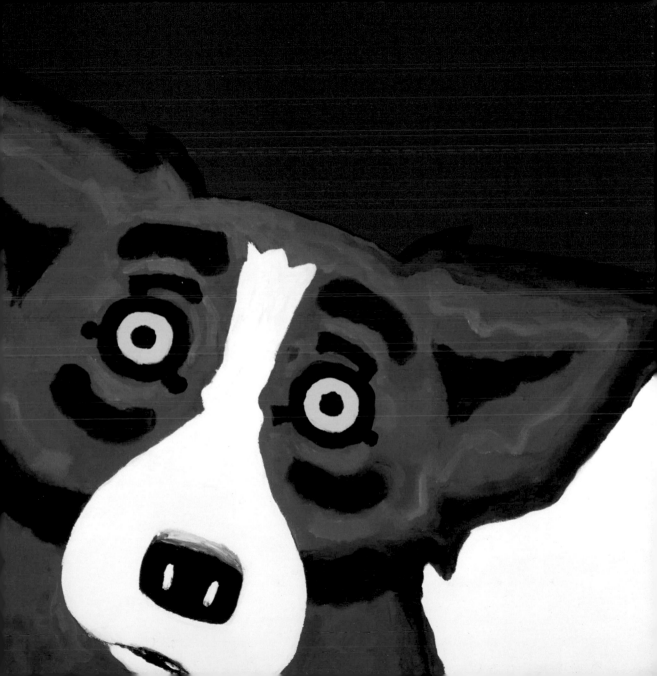

As Honest as the Day Is **Long**

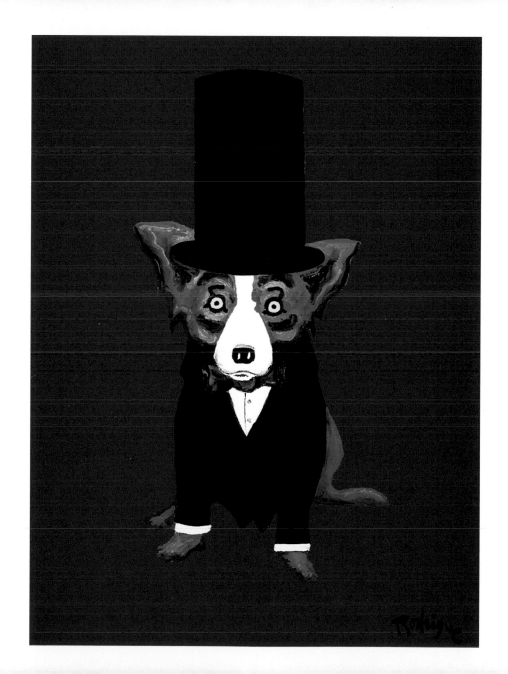

God Bless
America

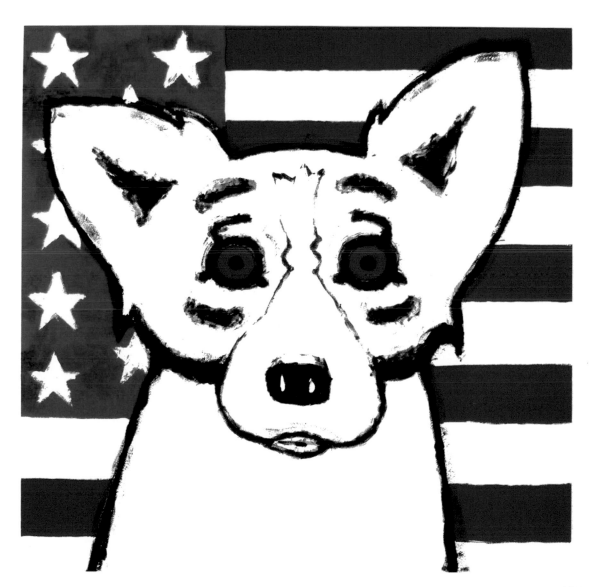

491

Star-spangled
Blue Dog

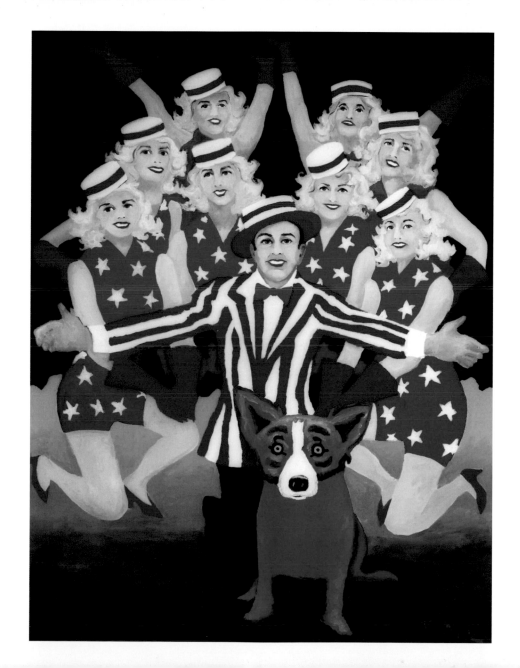

493

Star

Rising

Catch a

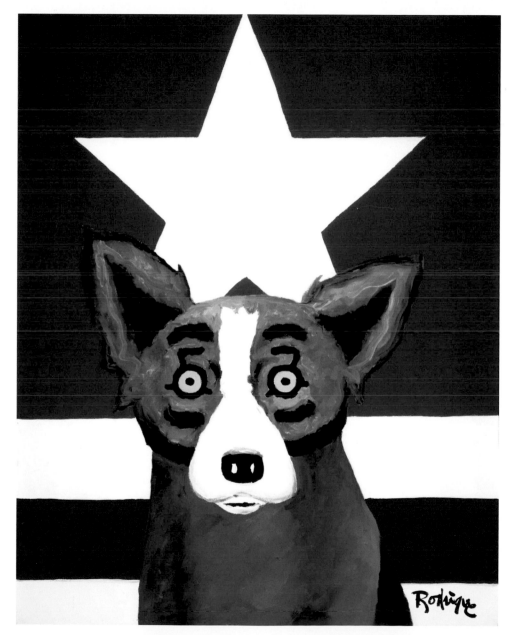

495

I Live for
My Country

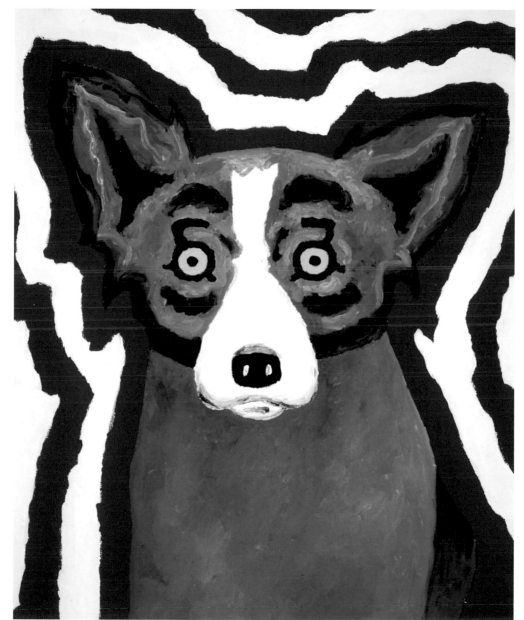

497

My

Mood

Changes

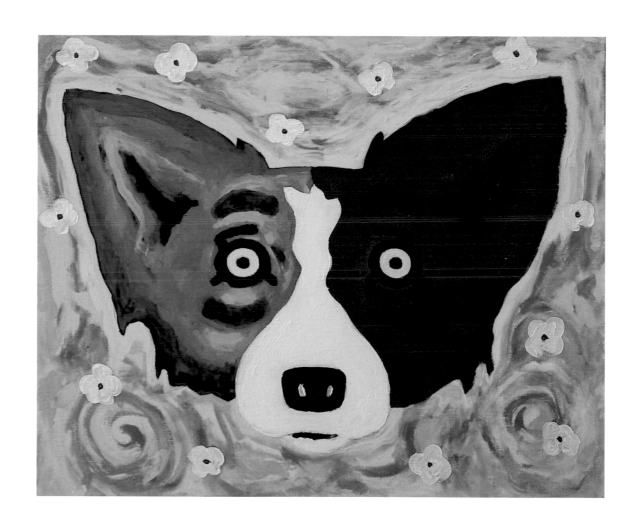

499

The USA

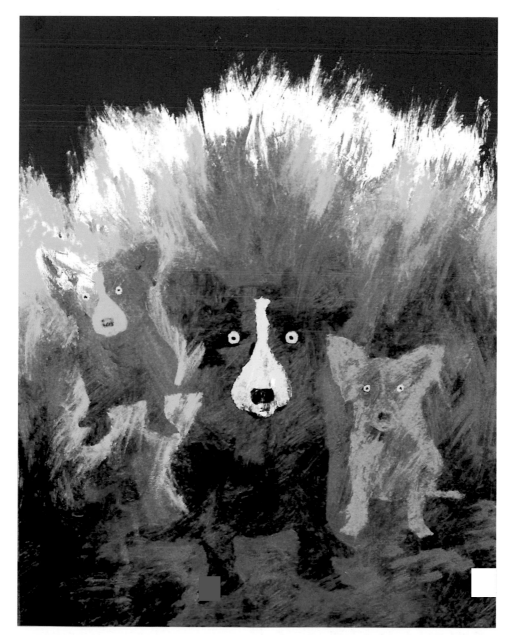

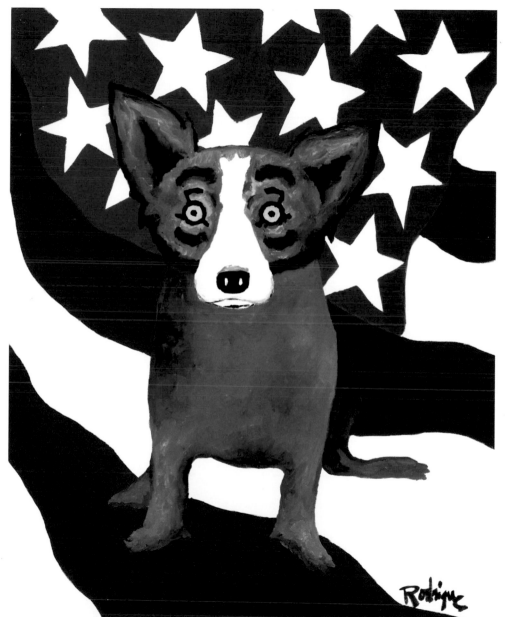

503

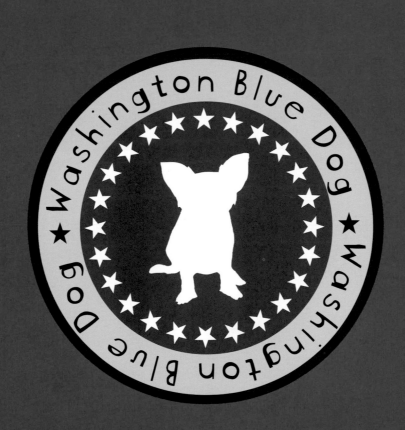

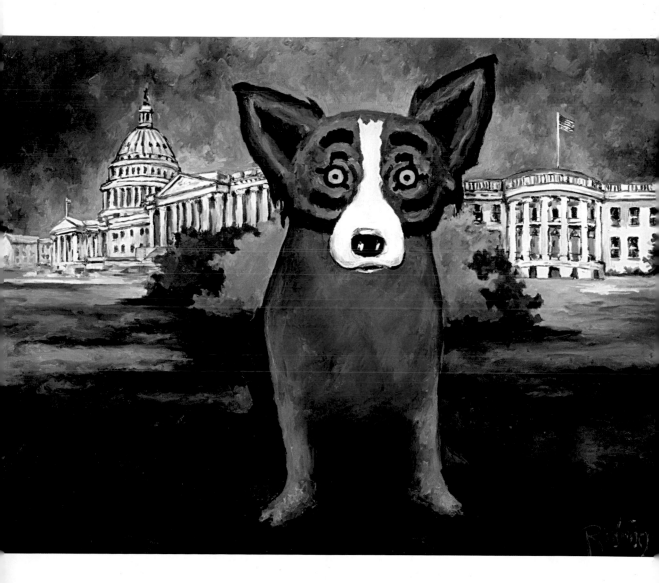

505

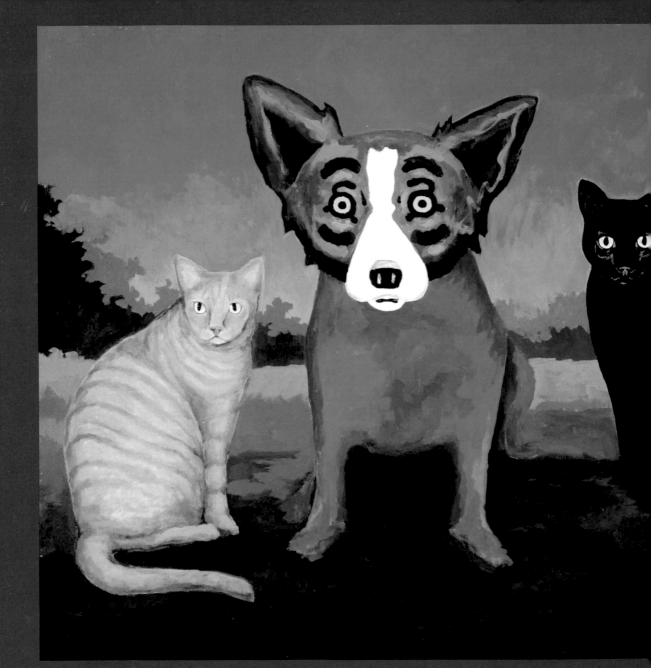

Friendly Cats

INDEX